After the Beautiful

After the Beautiful

Hegel and the Philosophy of Pictorial Modernism

ROBERT B. PIPPIN

The University of Chicago Press
Chicago and London

The University of Chicago Press, Chicago 60637
The University of Chicago Press, Ltd., London
© 2014 by The University of Chicago
All rights reserved. Published 2014.
Paperback edition 2015
Printed in the United States of America

21 20 19 18 17 16 15 3 4 5 6

ISBN-13: 978-0-226-07949-3 (cloth)
ISBN-13: 978-0-226-32558-3 (paper)
ISBN-13: 978-0-226-07952-3 (e-book)
DOI: 10.7208/chicago/9780226079523.001.0001

Library of Congress Cataloging-in-Publication Data

Pippin, Robert B., 1948– author.
 After the beautiful : Hegel and the philosophy of pictorial modernism / Robert B. Pippin.
 pages cm
 Includes bibliographical references and index.
 ISBN 978-0-226-07949-3 (cloth : alk. paper) — ISBN 978-0-226-07952-3 (e-book) 1. Hegel, Georg
Wilhelm Friedrich, 1770–1831. 2. Aesthetics. 3. Art—Philosophy. I. Title.
 B2949.A4P57 2014
 111'.85092—dc23

 2013022779

For Michael Fried and David Wellbery

Contents

Acknowledgments

An earlier form of this book was presented as the Adorno Lectures in June 2011 at the Johann Wolfgang Goethe–Universität in Frankfurt am Main. I am very grateful for the invitation extended to me by the Institut für Sozialforschung, by its director, Axel Honneth, and by Suhrkamp Verlag. Over the years, the lectures that I have delivered at Frankfurt have always prompted unusually productive and stimulating discussions, and this occasion was no exception. I profited greatly by the lively conversations after each lecture, especially with Axel, Christoph Menke, and Martin Seel, and have revised the manuscript substantially in the light of those questions and criticisms. I am especially grateful to Sidonia Blättler of the Institut for the efficiency with which the lectures were organized and for the warm hospitality that I received during my visit.

I gave different versions of the lectures at several universities in the United States, Europe, and Mexico and am grateful to several audiences for suggestions and criticisms. I gave the entire series in 2011 at the Johns Hopkins University as an associate member of their Humanities Center, and I benefited a great deal from many conversations with Hent de Vries, Paola Maratti, Yi-Ping Ong, Leonardo Lisi, Ruth Leys, Yitzhak Melamed, and Michael Fried. I gave the series again at the University of Essex in 2012 and am grateful for very fruitful discussions with David McNeill, Edward Pile, Béatrice Han-Pile, and Wayne Martin. At one point comments from Todd Cronan were very helpful about some issues in chapter 3. Two of the lectures were given as the Brian O'Neil Memorial Lectures at the University of New Mexico in the spring of 2012. I am indebted to Adrian Johnson and Iain Thompson for their comments and criticisms. Finally, chapter 2 was given as the Karl Jaspers Vorlesung at the Carl von Ossietzky Universität in Oldenburg in June 2012, and

chapter 4 was discussed as a *"Podiumgespräch"* there. I am grateful to both of those audiences and for the discussions with and the hospitality shown me by Reinhard Schulz and Rudolph zur Lippe. I was also able to discuss this material with my former colleague, the art historian Ralph Ubl, and his research group in the Ikones project at the University of Basel, and I profited a great deal from that conversation. The penultimate version of the manuscript was read by Terry Pinkard and Martin Donougho with great care and insight, and I benefited very much from their generous comments.

I owe a debt to Michael Fried that is impossible to acknowledge properly. Over the last decade, at several conferences and innumerable visits to museums and galleries all over the world, I have had the benefit of Michael's erudition and his synoptic and deep understanding of the course of modern art over the last five centuries. I could not possibly have entertained the idea of writing such a book as this without his generosity, his teaching, and the inspiration of his passionate commitment to the singular importance of visual art. The infelicities and mistakes in the following are all mine, but thanks to Michael, it became clear to me why Hegel could have thought that art was a way of understanding "the Absolute."

The privilege of teaching at a great research university, and especially the privilege of being a member of an interdisciplinary department, the Committee on Social Thought, have meant that I have been able to discuss the issues raised in this book with colleagues and students. I was able to discuss at length the theoretical material treated in the following with my friend and colleague in the committee David Wellbery, first in a two-quarter sequence, "The Modern Regime in Art," at the University of Chicago and then again in a six-week intensive seminar at Cornell University's School of Criticism and Theory in the summer of 2011. (I am very grateful to Amanda Anderson for the invitation to David and me to teach this seminar.) Again, I cannot properly acknowledge the debt I owe to David for what I learned from him about the German tradition in aesthetics, for his generous comments on drafts of these chapters, and for what I gained from our countless conversations about these issues. I want to express many thanks as well to the extraordinary students in both seminars.

1

Introduction

All effects of art are merely effects of nature for the person who has not attained a perception of art that is free, that is, one that is both passive and active, both swept away and reflective. Such a person behaves merely as a creature of nature and has never really experienced and appreciated art as art.

SCHELLING, *Philosophy of Art* (trans. Stott)

I

In the following I deal with a very small fraction of the European and American visual art now more or less commonly identified as "modernist," itself a fraction of the poetry, novels, drama, music, dance, and architecture often also so classified. That characterization itself is highly contested, much more so than other periodizations like "medieval" or "baroque" or even "romantic."[1] Even though most commentators would surely agree that much of the self-consciously advanced art made from the mid-nineteenth century on looks and feels and sounds and reads in a way radically, often shockingly, different from the entire prior tradition of art, so different that eventually the very distinction between art and non-art came under great pressure, the exact nature of and reasons for such differences are still subjects of intense disagreement. Perhaps the least (but by no means un-) controversial characterization would be simply to say that modernist art is art produced under the pressure of art having become a problem for itself, in a period when the point and significance of art could no longer be taken for granted. It is not just that the art of the immediate past had somehow ceased to compel conviction and so required some sort of renewal, but that the credibility, conviction, and integrity

1. Actually, one should probably say "was contested." The issue one sometimes sees summarized as "what was modernism?" has not been on the front page of aesthetic theory for some time, although now there is considerable interest in "alternate" or basically non-Western, noncanonical modernisms. For a useful summary of the different uses to which the "modernist" periodization is put, see Elkins 2005, 39ff. An ever more useful, bracing dose of skepticism about the category and "the modernist critics" can be found in Clark 2001, chap. 4, on Cubism, 169–224. Actually, see the whole book.

of art itself, especially easel painting now entering the age of the art market, all had to be addressed at a fundamental level in the art itself and could not be ignored.[2]

The point of view adopted here on such a turn of events is Hegelian, understood as an imaginative projection into the future of the position defended in Hegel's lecture courses on fine art in Berlin in the 1820s—projected, that is, into an assessment of pictorial art produced after 1860. This simply means offering an interpretation of the basic terms of Hegel's approach to the nature and significance of art, and what it means for art to have a history, and then arguing for the relevance and fruitfulness of that approach for understanding the startling innovations in painting introduced by Édouard Manet.[3] As we shall see, this will mean presenting and defending Hegel's concept of art, as well as his claim about what is at stake in the historicity of art, without accepting his own conclusions about what follows from such a concept and approach. This discussion will be the task of the next chapter. Besides the admittedly debatable value of such an attempt to time-travel with a philosopher, especially one whose work is self-consciously tied to his own age, this means addressing two other controversial issues. The first is a direct consequence of Hegel's approach: the claim that the achievements of modernist art (my main examples in this book are figures sometimes called, respectively, the grandfather and father of modernism in painting, Manet and Cézanne) should be understood as themselves philosophical achievements of a kind, even though such visual artworks are neither themselves discursive claims nor of philosophical relevance by "containing" or "implying" philosophical assertions.[4] There is something of philosophical importance at stake in pictorial achievements even if they are not—just because they are not—philosophy themselves. That is to say, the claim is not that such artworks are works of philosophy, or philosophy manqué, but that they embody a distinct form of aesthetic intelligibility, or an aesthetic way of rendering intelligible and

2. See Cavell 1969, 189ff., on the problems of "fraudulence" and "trust" in modernist art. See especially the discussion of modernist dramatists (210ff.). These issues seem to me analogues of what Fried calls the problem of defeating "theatricality," and in a different way analogous to what Clark calls a representation's failing "the test" of "social practice." See the discussion below in chapter 3.

3. I do not, of course, mean that Manet alone started everything. But his singular genius and the enormity of his accomplishments provide a useful focus for the complex "moment of modernism"—or so I will argue in chapters 2 and 3.

4. For a discussion of a very similar issue, the relation between philosophy and literature implied by Hegel's approach in his Jena *Phenomenology*, see Pippin 2011b. See also the fine study by Speight (2001).

compelling a variety of issues of the deepest importance to philosophy.[5] (That is, they do if these works succeed, a condition that itself raises a number of problems.)[6]

This is not to say that the approach—treating artworks as making ideas available to us that otherwise would not be, rendering matters of concern more intelligible to us in a distinctly sensible-affective way—treats artworks as instances of determinate, and certainly not accumulating, knowledge claims or as evidence or justification for knowledge claims, at least not in the way we understand empirical or mathematical or scientific or, if there are such things, moral or political or philosophical knowledge claims. I want to show that one of Hegel's greatest contributions is to have shown us that, understood as achievements of human self-knowledge, such ways of ren-

5. The stronger claim would be that whatever art makes intelligible is something that is essential for philosophy but that philosophy itself cannot supply; the *even* stronger claim would be that art renders intelligible what philosophy tries to reveal but does so better. (See the quotation below by Schelling.) I will not be arguing these latter claims, but it is striking that there are passages in Hegel that seem to note the limitations of thought and the advantages of art for what seem philosophical purposes. See Hegel 1975, 2:976 (hereafter, references to Hegel 1975 will be given in the text and in the notes in the form *A*, 2:976); here Hegel is clearly talking about a limited form of thought, *Verstand*, but this passage provides the basis for a claim for a deep relatedness (*Verwandtschaft*) between poetry and speculative philosophy. See also the passages at *A*, 2:1006, 1128.

6. Were this book intended as a commentary on Hegel's fine arts lectures from 1821, 1823, 1826, and 1828/29 (and it is not), serious consideration would have to be given at this point to the complex problem of the text of the lectures. In 1835, and then again in a second edition in 1842, one H. G. Hotho, working from Hegel's own notes (which are now lost) and transcriptions taken down by him and other students, compiled an edition consisting of what appears to be common material from the last three lecture series. This was then published in the Moldenhauer-Michelet edition, and it was the basis of Knox's English translation for the Oxford edition. Hotho's editorial decisions have been vigorously challenged for thirty years by the scholar who undoubtedly knows more about the issue than anyone alive, Anne-Marie Gethmann-Siefert, the editor of the critical edition of the lectures. In sum, she has claimed that what people treat as "Hegel's aesthetics" are to some degree, or at least more than is appreciated, "Hotho's aesthetics." This, though, has largely to do with what Gethmann-Siefert, with some justification, claims are Hotho's enthusiasms about particular art objects and individual artists (especially with regard to music and composers), and as far as I can determine, her specific suspicions do not materially affect this attempt to make further application of "Hegel's approach," broadly construed. It is certainly possible that research will establish that Hegel's Argus image is really Hotho's, or that his closing valedictory at the end of the last series was never given, and so forth. But the philosophical points made by such images and such speeches are amply present throughout the body of the lectures. The major points at issue here are not one-off formulations on which everything of significance must rest. Far and away the best treatment of Hegel and the arts in English that takes into account all the variances in the manuscript readings is Rutter 2010.

dering intelligible do not have the form of these other cognitive claims and have more the form of different sorts of claims about ourselves and others. I mean claims like "I had not thought I would be ashamed of that," "I saw that he would not do it, even though he clearly believed he would," "I was surprised to find that I did not trust him," or "It clearly all mattered to her a great deal more than she could admit to herself." We assume that much of human social existence would not be possible without insights like these, any of which could clearly be false but which do not have a firm or clear status in the strictly epistemological terms of modern philosophy.[7] It is difficult to imagine presenting empirical evidence for such claims or designing experiments to figure out who is good at making them. The logical peculiarities of self-knowledge and the deep link between the form of self-knowledge and knowledge of others' mindedness, and the relevance of both to understanding artworks, will be discussed in the next chapter.[8]

This is admittedly a somewhat obscure modality of intelligibility. As I shall try to sketch below, it has its origins in Kant's revolutionary explorations into the claims of beauty in aesthetic experience. Kant treated such experience as involving primarily a kind of pleasure, but not mere empirical pleasure, and he suggested a unique sort of intelligibility in the appreciation of the beautiful that involved our conceptual capacities, but not by way of the straightforward application of a concept, and so not available for expression in a standard assertoric judgment, and thereby not available for the conceptual role semantics (a concept is a "predicate of possible judgments") that Kant introduced in the first *Critique*. This meant that the content of such experience had to be described as somewhat indeterminate—but only somewhat, not completely, so that the question of the sort of determinacy it did possess, and the significance of such a possibility, quickly became the hottest of topics among the post-Kantian romantics and idealists. This was especially so when the uniqueness of such an experience suggested a model of discrimination and a

7. Cavell is also again relevant here, both on the importance of understanding our relation to artworks on the model of our relation to persons (which will have as its Hegelian analogue in the next chapter the connection between being able to understand some bodily movements as actions and others as not, and the sensibly embodied meaning of art objects) and on his distinction between "knowing" and "acknowledging."

8. For example, in the case of pictorial art, the ability of painting to arrest time and thereby to "make present" can render aspects of human action available that are not possible in drama, literary narrative, or poetic description. This is what Gehlen (1960) calls "Vergegenwärtigung," and what Fried (1998, 148–72) calls "presentness." Hegel can also be summarized by saying that art has the task of the "Vergegenwärtigung des Absoluten," the bringing of the Absolute to presentness. See Henrich 2003a, 78–79.

kind of normative claim on or appeal to others that other thinkers took to be also relevant to moral experience, the nature of sociopolitical unity, and the most important dimensions of self-knowledge.

And not just in these domains. When Kant realized that the uniquely determinate experience of the beautiful could not be understood as a mere, reactive empirical pleasure, nor the result of standard concept application, the general question—where then *are we* in the critical system?—opened the door to any number of questions, including reconsidering the question of the general possibility of conceptual content. Kant's unusual answer was that in an aesthetic experience we were in some state of reflective play, but this meant not merely being "carried along" by pleasant sensations but in some way reflectively attentive in such free play (even if just possibly alert to its significance), although again without the application of a concept of signifi-cance. If reflective judgments (the name he gave such aesthetic judgments) had such unusual features but could be further shown to be inseparable from ordinary determining (concept-applying) judgments, then even a precisely worked-out inferentialist account of conceptual content could not formalize or even methodologically render "explicit" the rules for such inferences.

This heightened significance was certainly true of the way Hegel treated art's significance. (It is also a prelude to Hegel's own speculative logic, where he claims constantly to be differentiating his approach from the fixed, formal-izable, stable, self-standing notions of "the understanding" and to be propos-ing a more dynamic, fluid, "animated" account of conceptual interrelation, and so conceptual content.) In its full Hegelian glory, the official formulation of the approach is that art embodies a distinct mode of the intelligibility of the "Absolute."

Now, Hegel and his generation used that forbidding term as easily and unproblematically as contemporary philosophers might use terms like "mod-ularity," "possible worlds," "the ontological difference," "rigid designators," or "ideal speech situation," but it has obviously ceased to be a current term of art in the way these are. It has something to do with what Kant called knowl-edge of "the unconditioned." Anything we know is known under various as-sumptions and by presupposing other epistemic commitments, and, Kant claimed, the question of how we might discharge those commitments and know unconditionally or absolutely is one that naturally arises for "reason." It has something to do with what is presupposed as counting for "reality" in our attempt to render the world intelligible (and so what is excluded as unreal). In this sense, one can say that philosophy began when "nature" (*physis*) was taken as "absolute," all there really was, real in a way that custom or nomos (and so in a way that the object of religious belief) was not. Or we could say

that for Platonists, the ideas were the Absolute, or perhaps *the* Idea of the Good, just as for Scholastic philosophers, the Absolute was God, pure actuality. For Descartes, at one level, the Absolute was the thinking subject (whose criterion of clarity and distinctness defined what could be said to be known as real), and at another level the Absolute had an unusual triadic structure, given his three substances—extension, thinking, and God—an unsustainable claim, as Spinoza tried to show, whose own "Absolute" was the famous monistic substance, *Deus sive natura.* For the early Wittgenstein, one could say that the Absolute was "all that is the case." The Absolute, in other words, is at issue wherever philosophy is at issue. (Quine and Sellars, say, do not want to write books about "reality, as it seems to me." They want to show us, of what is, that it is; and of what is not, that it is not. Full stop.)

Hegel especially has in mind a way of understanding ourselves, without an "antinomy" or contradiction, both as natural bodies in space and time and as reason-responsive thinking and acting agents, who resolve what to believe and what to do in a way for which they are responsible, in his language both as *Natur* and as *Geist.* (The common translation of Hegel's *Geist* is "spirit," but since that misleadingly suggests immaterial substances, or even ghosts, from now on I shall leave it untranslated, hoping that the context of the discussion makes clear what it means.) This is the issue that structures his entire *Encyclopedia of the Philosophical Sciences,* his most comprehensive picture of his systematic philosophy. When the intelligibility of this unity is expressed in its full, logical form ("the absolute idea" in a "logic of the concept"), Hegel makes clearer what underlies the basic duality. He says that "the absolute idea"

> is the sole subject matter and content of philosophy. Since it contains all determinateness within it, and its essential nature is a return to itself through its self-determination or particularization, it has various shapes and the business of philosophy is to cognize it in these. Nature and *Geist* are in general different modes of presenting its existence, art and religion its different modes of apprehending itself and giving itself adequate existence. *Philosophy has the same content and the same end as art and religion*; but it is the highest mode of apprehending the absolute Idea, because its mode is the highest mode, the Notion [*Begriff*]. (1969, 824, my emphasis)

Understanding the various relations between what Hegel calls the absolute-universal, absolute knowledge, the absolute, the absolute idea, and absolute spirit would require several independent studies. But if we just take our bearings from the basic structure of the *Encyclopedia*—Logic-Nature-*Geist*—or postulate that there is a logical position possible on, a conceptual clarifica-

tion of, the compatibility of Nature and *Geist*, we shall have enough for this account of Hegel's *Lectures on Fine Art*.

Likewise, we should pause briefly and note the audacity of the claim itself, that "*Philosophy has the same content and the same end as art and religion.*" For much of its premodern history, philosophy understood itself, when considered in the context of art, religion, or politics, as in a sometimes deadly competition with such other claimants to truth. The philosophical (or "Socratic") claim was that there were better and worse ways to live, and the best of all was *not* the life of a statesman or a life of piety or the life of a poet but the life of the philosopher. Other ways of life were inferior. This way of thinking has faded with the assumption of pluralism, the incommensurable plurality of lives that an individual might live, but the issue resurfaces periodically, especially when religious believers attack a secular society as not at all neutral about the good but promoting a way of life hostile to their own commitments—hence the renewed attention to "political theology" in the postwar years (or when a philosopher like Schelling insists that only in art could the Absolute be known). This is all obviously a very long story; but it is useful to remind ourselves how *radically* reconciliationist Hegel's claim about "same content" is, and how controversial it is if we focus attention just on that.

This comprehension of that "same content"—the achievement of which is understood to be the realization of human freedom—is understood by Hegel as a comprehensive form of *Geist*'s self-knowledge, where *Geist* is understood as a collective subject, a communal or common like-mindedness inheriting the aspirations of a distinct artistic, religious, and philosophical tradition and as finally fulfilling those aspirations (a Hegelian claim I shall dispute below). And since such self-knowledge requires above all else understanding how *Geist* can be both a natural being and a reason-responsive thinker and agent, such a comprehensive self-knowledge must involve a way of understanding the most difficult issue of all: how *Geist* can have such a natural and spiritual or free status at the same time. According to Hegel, art is an affective-sensible modality of such self-knowledge, playing its role together with, but categorically distinct from, the "representational" vocabulary of religion and the conceptual articulation, or "logic," of philosophy. It would be too crude to say that this means that art gives us to understand, first, what "it feels like" to occupy, at various stages, such an unreconciled status and then what it is to "live out" some achieved status that is, as Hegel says, more and more "reconciled with itself." But this crude characterization would be very roughly on the right track if we realize that this affective-sensible self-understanding is also a distinct mode of insight (in the unique way suggested above that self-knowledge and intuitive knowledge of others' mindedness are insights), that

such a mode is not merely sensually "reactive," and that this means that its content or meaning can be articulated in a way that is both philosophically and historically sensitive.

And right away, even at such a general, very abstract level of summary, controversy immediately erupts since Hegel is well known for apparently having claimed that, while for most of the history of human beings (understood as *Geist*) art *was* a necessary, complementary mode of Absolute Knowledge like this, in the modern period now coming into view, it no longer was, and had become a "thing of the past." In chapter 2, I present an interpretation of Hegel's aesthetics and this claim about the pastness of art, all hopefully in a way true to the spirit of Hegel's basic position about the nature of art, even while abandoning his "end of art's significance" idea, and try to show that his approach is still of relevance to the new form of art that began with Manet and that Hegel could not have anticipated. What should be immediately suggestive, however, is that, although overstated, Hegel's "pastness of art" claim lands him very close to, if not directly in, the historical situation—the crisis—of modernist art, having to confront, rather than simply assume, its continuing possibility and importance.[9] That is, Hegel was lecturing on art just before the treatment of art began shifting from "aesthetics" to the "philosophy of art" (i.e., from the sensible appreciation of beauty to art's interrogation of its own nature and possibility), in large part because of Hegel and his German brethren; just before the appreciation of art began shifting from a reliance on taste (and tasteful assessments of quality) to "criticism," with its focus on meaning and interpretation; and just before art itself simply began to *look* (and read and sound) radically different from art of the past.

The second controversial issue needing to be addressed in what follows is that an implication of such an approach is that any sort of critical attention to such works must itself be philosophically informed, attentive to the philosophical issues being raised, if the meaning of modernist experimentation is to be understood. Of course, many movements in modernism were just that: philosophically ambitious and manifesto-fueled movements, quite self-consciously addressing explicitly philosophical issues about perception, value, even ontology. (Indeed, for a variety of reasons that will be explored here, this "philosophical art" is something that Hegel himself argued we should now—in the modern context—expect.) But the philosophical criticism required need not at all be restricted by or even guided by such explicit programmatic

9. Cf. Henrich's (2003a, 70, 72) claim that at the time only Hegel was able to appreciate that, in the modern condition, art was faced with such a crisis that it might "end" as a significant vehicle of self-knowledge, might face "das Endstadium der Kunstproduktion."

pronouncements. Indeed, it can often go wrong if it is. In chapter 3, I shall discuss the critical writings of two contemporary art historians that seem to me to embody both the right register or inflection of philosophical and art-historical attention and to do so in a way that, I argue, should be understood as "left-Hegelian," a continuation of the approach I am defending: the works of T. J. Clark and Michael Fried (works that, I argue, should be seen as complementary to each other, not incompatible).

Finally, with respect to modernist art especially, there is a challenge to such a Hegelian framework, to the claim that the possible realization of freedom is at the heart of the matter, but a challenge making assumptions shared with Hegel about the historicity of art and its philosophical value, and so in explicit dialogue with Hegel's position. This is Heidegger's enormously influential 1936 lecture, later published as an essay, "The Origin of the Work of Art." By means of these common assumptions and contrasting conclusions, the philosophically ambitious and historically diagnostic approach pioneered by Hegel can come into greater relief.

II

But Hegel's own approach is properly accessible only in its own context, however brief the following sketch of that context must be. This is so because the period in the early nineteenth century when Hegel came to philosophical maturity was a period in German letters when more philosophical and even social and civilizational hope was placed in the achievement of art and in the right appreciation of that achievement than ever before or since in the Western philosophical tradition. (This fact is itself of great diagnostic value. We can ask: What was responsible for pinning such enormous historical and civilizational hope on fine art? What aspect of the emerging modern world was this aspiration responsive to?) Hegel embraces at some level such enthusiasm even as he tries to qualify and contain an aspiration—the turn away from philosophy to art, especially to literature, for illumination about highly speculative matters—that he clearly saw as also threatening to overwhelm the special task of philosophy. (This was the source of his suspicion and criticism of Schlegel.) As with so many other developments in philosophy of this time, this aspiration and heated discussion began with a reaction to Kant's critical philosophy.

For many of Kant's contemporaries, the impact of *Critique of Pure Reason* (1781, 1787) was devastatingly negative. Far more than his complicated deductive demonstration of the possibility of a priori knowledge about all objects of experience, his skeptical claim that human reason could never know "things

in themselves," and especially that we could never know whether human beings were in themselves free, self-determining subjects, whether there was a
God or an immortal soul, generated the most attention and reaction. Kant
seemed to leave us permanently cut off from what we most needed to know
as human beings; above all else and the most disturbing of all: unable to establish the reality of our claim to absolute worth and to respect from all other
subjects as the free and rational beings we take ourselves to be.

In this context, the appearance in 1790 of *Critique of the Power of Judgment* generated a much different and far more positive, hopeful, even revolutionary reaction that lasted for many generations afterward, especially in
the European tradition that includes and is oriented by the work of Schelling,
Schiller, Schlegel, Hegel, Schopenhauer, Nietzsche, Heidegger, Adorno, Benjamin, and many others.[10] Although Kant is widely thought to have argued for
a "subjectivist" aesthetics, relocating the beautiful in the distinct character of
a subject's aesthetic experience (and not, as in classicism, in the world), for
many of his first readers what was more important was that in his "analytic of
the beautiful," Kant seemed to establish much more. As noted above, although
he would not put it this way, one can, and many did, argue that what Kant was
defending was the claim that there was a *unique mode of human intelligibility*
altogether, aesthetic intelligibility, affective and largely sensible but uniquely
determinate and not merely a reactive response, and that such a mode of
awareness was in some, even if in a quite cognitively unusual and difficult
to categorize sense, *revelatory* in a still deeply important way. That deeply
important way involved what was revealed or, more accurately, exemplified
about the status of human freedom.[11]

That is, to a large extent Kant deserves his subjectivist reputation. For
him aesthetic experience was essentially hedonic; it consisted in pleasure,
not knowledge, given the way he understood the criteria for empirical or a
priori knowledge. But this pleasure was essentially different from empirical
pleasure, so different that Kant argued it ought to be regarded as that most
unusual of pleasures—"disinterested"—and of a sort that allowed aesthetic

10. This question—the reasons for the singular importance of art in the post-Kantian European tradition—is the subject of an important discussion by Bernstein (1992).

11. This was certainly reading Kant in a way that greatly inflated his own explicit intentions
(i.e., it tried for the "spirit," not the "letter," of the text) but it was not wholly ungrounded. See
Henrich 1992 on the origination of aesthetic judgments in "reason itself" and how Kant "first
provided tools for establishing the aesthetic attitude as self-contained and autonomous, thus as
the foundation for a conception of art that envisages art as a primordial way of being related
to and situated within our world, a way that can neither be replaced nor surpassed by other
achievements of man's rational capacities" (29–30).

judgments linked with such an experience (e.g., "This is beautiful") to lay some sort of binding claim on others for agreement. Such judgments had what he called "subjective universal validity." This was a kind of claim, or a suggestion about a validity status, that had not appeared anywhere in Kant's work prior to 1790, and it introduced the idea of (or what would be taken to be the idea of) a distinct sort of aesthetic intelligibility in the form of such unusual universal claims on others for agreement. (Were you not to agree that "this is beautiful," and it *was* beautiful, you would be *missing something*, failing at appreciating what you ought to appreciate, even though you would not be failing to know something true about the world. One could perhaps say: you would be failing *to be* "one of us," and at a level of importance crucial to our being able to be and sustain being who we are.)[12]

So even though aesthetic experience at its core involved the subject's experience of *itself*, of the play of its own experiential capacities, these were said to be in play in a way of quite general *significance* for our ultimate understanding of our unique destiny as human beings in the world, our moral destiny as autonomous agents, and the shared character of that status among human beings. The significance of the possibility of such a free play of faculties, occasioned by the formal properties of objects of nature and not by the application of a concept or norm, lay in a noncognitive but genuine and credible experience (a becoming intelligible, one can more generally say) of the purposiveness *of nature*. So what was ultimately at stake in aesthetic experience was the compatibility between nature (at least when, one has to say, *understood* aesthetically) and our moral nature as free beings. That nature was beautiful, and that we were able to appreciate that beauty in a way that was not merely hedonic or standardly cognitive, all meant something, was of some decisive significance, and what it meant involved a kind of attestation of our common destiny as free beings.[13] Nature was something more than its sensible features;

12. See, again, Cavell: "But this plural is still first person: it does not, to use Kant's word, 'postulate' that 'we,' you and I and he, say and want and imagine and feel and suffer together. If we do not, then the philosopher's remarks are irrelevant to us. Of course he doesn't think they are irrelevant, but the implication is that philosophy, like art, is, and should be, powerless to *prove* its relevance; and that says something about the kind of relevance it wishes to have. All the philosopher, this kind of philosopher, can do is express, as fully as he can, his world, and attract our undivided attention to our own" (1969, 96).

13. How this all plays out in the analytic of the beautiful is quite a tangle of textual threads. They are apparently all woven together (to Kant's satisfaction, anyway) in paragraph 9 of the third *Critique*. I defend an interpretation of this relationship (between the aesthetic experience itself and its significance) in Pippin 1996. In the case of Schiller, his search for an "objectivist aesthetics" in his Kallias letters (Schiller 2003), even while admitting that aesthetic experience

its "supersensible" features could be attested and appreciated in the experience of the beautiful, manifesting the supersensible dimension essential to considering ourselves free beings. (And it also did not escape the notice of philosophers like Schiller that if this claim about the significance of the beautiful was true, it should lead to a reconsideration of what human freedom consisted in, such that *its* place in nature could be aesthetically available in the appreciation of the beautiful. Thus, the idea of morality as essentially imperatival, as a commanding-to-sensibility duty, might also require rethinking.)[14]

To justify what he wanted to say about such significance, Kant himself certainly needed to rethink fundamental aspects of his own critical philosophy. He especially needed to reconfigure a core element of his entire conception of the possibility of intelligibility at all: his theory of judgment. (Judgment for Kant was the essential bearer of intelligibility, although, as the case of beauty made clear to him, that domain is not exclusively the domain of, paradigmatically, assertoric predication and its standard truth conditions.) This reconfiguration was necessary because a judgment like "this is beautiful," despite its surface logic, was not the application of an empirical predicate to a particular, or what he now called a "determinate" judgment. And despite the essentially hedonic character of aesthetic experience, that deeper logic of aesthetic judgments was not that of a merely expressive report of a distinct (disinterested) pleasure, with some unusual universal normative force. It had a logic all its own, essentially the logic or form of what Kant in effect invented as the capacity of "reflective" judgment. In the search *for* universals and not their application, the judgment also involved, he argued, the system-building integration of scientific laws and the ascription of teleological order to nature. Such capacities invoked the older sense of politically or practically wise judgment, with its resonance of a nonformalizable *phronesis* and Pascal's *esprit de finesse*, the capacity to discriminate and decide that did not involve, could not involve, the following of some rule or the mastery of some teachable

was not a cognitive experience, anticipates with his final account the appearance of Hegel's understanding of "the sensible appearance of the Idea." One could even say that the general idea—objective but not cognitive or mimetic—anticipates the modernist idea of a "realism" but not a "mimetic realism." See the discussion of Manet in the next chapter. For a good summary and analysis of the ambition of the Kallias letters, see Beiser 2005, chap. 2.

14. See especially the eleventh and thirteenth letters in Schiller 1982. The summary claim is in letter 25.6: "And just because it is both of these things at once, beauty provides us with triumphant proof that passivity by no means excludes activity, nor matter form, nor limitation infinity—that is, in consequence, the moral freedom of man is by no means abrogated [*aufgehoben*] through his inevitable dependence upon physical things" (187).

method. (And ever since, it has seemed to many philosophers that such an introduction must also have some "backshadowing" effect on the core doctrines of the first *Critique*, such that making Kant's epistemology consistent with what Kant was saying about reflective judgment and especially about its overall significance, now had to be on the agenda.) But for the purposes of the following discussion, what is decisive is Kant's idea that there is, as it were, some distinct way to render intelligible what the official doctrine of the first *Critique* seemed to rule out: a way of understanding (a way that could withstand skeptical challenge) that we were both naturally embodied objects in the world and, without inconsistency, practically free, responsible agents. There was some place to stand from which the compatibility, even unity, of such a duality (at what Kant called that supersensible level) could be made out, rendered intelligible and credible (even if not, strictly speaking, *known*), and that place or position was the aesthetic dimension, our experience of the beautiful.

The legacy of this unusual and unexpected Kantian argument, especially given the dispiriting restrictions imposed by Kant's theoretical philosophy, was to elevate the aesthetic dimension of human experience—and in particular this suggestion about a unique aesthetic mode of self-knowledge—to a far greater significance than it had ever had before.[15] It suggested that the deepest issue in the Idealist tradition—the problem of "the Absolute" (neither subject nor object)—could be addressed, rendered in some way intelligible, *only* aesthetically. Kant's restriction to the beautiful in nature as the primary or purest sort of aesthetic experience was quickly lifted, and the Kantian idea of the significance of the beautiful was expanded to include all the fine arts. In the most general sense of the terms, for a legion of philosophers, poets, and critics working in the wide and turbulent wake of the third *Critique*, Kant was understood to have enlisted art as a major element in the human attempt at the realization of freedom. It was through beauty and art (and again, for some, only in this aesthetic dimension) that we could in some sense understand the reality of and the realizability of freedom in the natural world we inhabited.

This legacy was complicated, since Kant had, as has been noted and as is clear from his subjectivist legacy, located the primary significance of aesthetic experience in the subject's free play of faculties, and so in beauty's subjective significance.[16] This seemed to say that whatever in nature occasioned this ex-

15. A possible exception is ancient Greek "political" art, a fact that, of course, also led to a profound philhellenism in post-Kantian aesthetics.

16. As noted above, this is Schiller's dissatisfaction with Kant as expressed in his early *Kallias, oder über die Schönheit*.

perience could not be said to be itself the intentional object of such an experience but was merely, in its formal features, its occasion and nothing more. And aesthetic experience, however significant in this reformulation, remained basically indeterminate, an appreciation of a very general sort, of nature's purposiveness, but, as he famously put it, an appreciation of a "purposiveness without a (determinate) purpose." In contrast to perfectionist or classicist aesthetics, Kant's aesthetic subject still primarily experienced *itself*, not aesthetic properties in the world (even if that experience was occasioned by formal features of nature) and not any intentional content in an artistic object. On the other hand, as we have already seen, the story of the significance of aesthetic experience, why it mattered, especially now, in the disenchanted world of natural science and Kant's compelling restrictions on philosophy, was still ultimately some sort of story about reality and the compatibility between our moral vocation as free beings and the natural world as that nature could be appreciated in aesthetic experience.

What lay behind this ambiguity (the subjective and objective sides of Kant's account) also involved a very complicated story about the fate of the Kantian understanding of the relationship between sensibility and the understanding, or our sensible, embodied, receptive, on the one hand, and, on the other, our spontaneous, active powers in experience, and so the proper way to understand the results of such cooperation: the "objects of experience," or "appearances." The debate about this relationship became the core theoretical issue in "German Idealism" and still stretches into some of the most important debates in modern epistemology: those concerning "the myth of the given," "nonconceptual content," skepticism, conceptual schemes, theory and observation, normative revolutions, and many others. The *official* Kantian position seems to be (or has seemed to many to be) that the faculties of sensibility and the understanding are not only distinct but also contribute independently to experience, that the direct and immediate deliverances of sensibility are then conceptualized by a spontaneous understanding (all as if in some sort of "two-step" process). Given this picture, for Kant, it had to follow that this aesthetic intelligibility, as I am calling it, since it is not the result of the application of a concept, had to be primarily sensuous and merely subjective, and therefore that had to mean, for him, nondiscursive, without a determinate intentional content, despite what aesthetic experience could be said to render intelligible. (An aesthetic judgment was not "This is a *beautiful rose*," as if it manifested "*rose*-beauty," but "This rose is beautiful," and so not beautiful "for a rose" but quite indeterminately even if importantly pleasing.)[17] The

17. This distinction is clearly explained in Saville 1993.

experience was still both delightful and significant because, while primarily sensuous, it possessed a harmony and unity in such a conceptually undirected free play, as if (but only *as if*) it possessed a conceptually organized unity. And this intimated a kind of natural purposiveness, its suitedness for us. This way of understanding the matter meant that Kant had to see the core of such aesthetic experience as a subject's nondiscursive and so indeterminate experience *of itself*, that is, a primarily subjective experience and having therefore a predominantly subjective significance (and, to repeat that phrase he invented, merely "subjective validity" even if also "universal").

Much of the story of German philosophy after Kant involves not only the expansion of this account to include the fine arts (until, with Hegel, the beautiful in nature was no longer of any serious significance), and not only a great intensification of the efforts to enlist art as a major factor in the self-knowledge necessary for the realization of human freedom, but an ambitious and far-reaching complication of the official Kantian picture[18] of the sensibility-understanding relation, denying this strict separability and so reevaluating art as something much more complex and more important in what it rendered concretely intelligible than any strictly nondiscursive and sensible, hedonic model could account for. If it could be shown that concept and intuition were indeed logically distinct, such that, as Kant put it, the contribution of one were not confused with the contribution of the other, but not actually separable in experience, if in fact there *could not be* conceptually unmediated sensible experience (i.e., conscious experience), *even hedonic experience*, then the status and significance of aesthetic intelligibility had to be rethought and its significance reevaluated.[19] Once Kant had, however cautiously and tentatively, introduced the idea of a distinct modality of aesthetic intelligibility, and especially once he had linked such a possibility to a possible self-understanding about what Kant rightly regarded as the decisive issue in all modern philosophy—the relation between (the modern understanding of) nature and our norm-responsive capacities, our freedom—a flurry of post-Kantian alternatives soon arose.

Many of them followed what they took to be Kant's lead and, in effect, raced ahead of him. Something indeed of *very* great significance was now at stake in the aesthetic dimension, and that was the promise of some way to understand (in some new aesthetic sense of "understanding") a reconciliation of sorts between the inescapably finite, constrained, natural, embodied

18. I say "official" here because I am not convinced it is Kant's actual position. See Pippin 1989, chap. 2.

19. I discuss the distinguishability-separability issue at greater length in Pippin 2005b.

features of human existence and the practically undeniable, meaning- and norm-responsive, reflective, self-determining features. (This is what some, like Friedrich Schlegel, understood as the relation between "finite" and "infinite" in art, both together uniquely comprehensible in literary irony, a kind of neither-the-one-nor-the-other "suspension.")[20] And this would be a genuine reconciliation (or the aesthetically intelligible sensible embodiment of such a reconciled state), not a reduction, or the "subservience" of one to the other or elimination of one in favor of the other, as in reductionist naturalisms or subjective idealisms. The possibility of sensibly embodied meaning in artworks and of our sensible and reflective capacity to appreciate and understand such meaning was of such significance that for the early Schelling (of the 1800 *System of Transcendental Idealism* and *The Philosophy of Art*) and the Schlegel brothers, this artistic attestation and comprehension of such unity was *more* significant than any philosophical articulation. Here is a typical passage from Schelling in the 1800 *System*:

> But from this very fact it can be understood that, and why, philosophy *as* philosophy can never become universally valid [*allgemeingültig*]. The one field to which absolute objectivity is given is art. Take away objectivity from art, one might say, and it ceases to be what it is, and becomes philosophy; grant objectivity to philosophy, and it ceases to be philosophy and becomes art.—Philosophy attains, indeed, to the highest, but it brings to this summit, so to say, the fraction of a man. Art brings *the whole man*, as he is, to that point, namely to a knowledge of the highest, and this is what underlies the eternal difference and the miracle [*Wunder*] of art. (Schelling 1993, 233, translation altered)

That is, the claim common to Fichte, Schelling, and Hegel, the inseparability of concept and intuition,[21] understood either as a revision of Kant (an attempt to capture his spirit rather than the letter of his texts) or as an extension of his own (true or deep) position, greatly altered the status and significance of fine art. It meant that even though artworks could not be understood as judgmental claims of any sort, or not as the conceptualized intuitions that count as the objects of empirical experience, they could be understood as (conceptually) contentful in their own distinct way and so as modes of rendering *Geist* in-

20. See, inter alia, Athenaeum Fragment 121: "An idea is a concept perfected to the point of irony, an absolute synthesis of absolute antitheses, the continual self-creating interchange of two conflicting thoughts" (Schlegel 1971). Two very helpful discussions of German Idealist and romantic irony are Norman 2000 and Bubner 2003, 201–15.

21. Or, said in a different way, the denial of the possibility of nonconceptual content in conscious experience and the subsequent attempt to differentiate the uniquely aesthetic dimension of such conceptually mediated intelligibility could now be placed on the philosophical agenda.

telligible to itself. In this sense such works had to be understood as aspiring to what Schelling is calling in the quotation above "objectivity," and Kant's flirtations with the universal significance of the aesthetic could be embraced wholeheartedly, and his restriction of the aesthetic to subjective significance could be overcome. As we just saw, philosophers like Schelling thought that once we understood the mode of rendering intelligible that is unique to artworks, we could even appreciate their superiority to philosophy.

What exactly this unique way of rendering intelligible amounted to (conceptually informed, but not in the way of ordinary objects of experience), and just *what* was "objectively" disclosed by art and in aesthetic experience, were characterized in many different ways in the post-Kantian tradition of aesthetics, too many ways to summarize here. I present a case for the suggestiveness, power, and limitations of Hegel's contribution in the next chapter. I want to close here with some more general remarks about the role of art in his overall position.

III

I am especially concerned with Hegel's most important innovation in his treatment of art, a dimension of his approach that also amounts to his most important innovation in philosophy in general. Hegel was the first philosopher to demand of philosophy a historically diagnostic task; he famously claimed that philosophy is "its own time comprehended in thought" (1991a, 21). In effect, Hegel insisted that the meaning and normative status of any of the fine arts—like the meaning and normative status of the state, of religion, or of philosophy itself—were necessarily historical, that no aspect of whatever it was that the fine arts rendered intelligible could be made out properly without the right appreciation of that aspect *then*, both in the course of art history itself and, even more ambitiously, within some proper understanding of the long historical struggle of *Geist* to understand itself. This meant locating art history within the basic Hegelian narrative about the struggle for collective understanding, itself the crucial element in the realization of human freedom, the effort to *become* the collective subject we take ourselves, ever more adequately, as Hegel tried to show, to be.

This sort of systematic ambition requires a flight at a far, far higher speculative atmosphere than anyone would dare to fly at today. But there are elements of Hegel's account that are still quite valuable. There is first of all the enormous importance and influence of the idea that artworks are best understood and studied as "art history," now the chief organizing principle of academic research on art. No less a figure in the field than E. H. Gombrich

famously credited Hegel with this development, calling Hegel the "father of art history." (Even though Gombrich always sharply criticized Hegel's progressivism, he was still willing to call himself a "runaway Hegelian.")[22]

But an art-historical approach requires some narrative or other, or one is just recording what happens after what, not explaining what happens because of what. The core of Hegel's narrative is the "realization of freedom," and there are a number of innovative and philosophically rich aspects of that account that remain valuable and will be important in what follows. For one thing, he has an account of the differing notions of the nature of freedom, the free person, the free citizen, and the like that have gripped the Western imagination across historical time. This account tries to make sense of why there should have been such differing notions, what the relations might be among them, what sorts of societies or forms of ethical life or religious self-understandings might have both helped inspire and also been guided by such differing notions, and so what status the modern notion of the free, reflective, rational, and responsible individual has among such alternatives.

To many philosophers, this sort of approach is immediately suspect because it seems to them that, like the "sociology of knowledge" approach or the "critical theory" approach, it confuses the so-called logic of discovery or of development or the question of the right sociohistorical explanation of what alternatives should have looked attractive when and to whom and why (in a social and psychological sense of "why") with the "logic of justification," the proper (and presumably socially independent, autonomous) philosophical or scientific case for the truth of some such alternative notion of freedom. Hegel's argument is that this disjunction is a choice between false alternatives, and he insists that without a way of understanding the inseparability of the historical and normative, ideals like the liberal-democratic ideal will be posed in ways that lose touch with the actual, practical world that the ideals are supposed to inform and inspire. Supposedly pure or a priori idealistic arguments about responsibility, agency, duty, obligation, legitimacy, and so forth will more likely be simply unacknowledged expressions of historically specific premises and assumptions and will result in nothing more than various moves in a sterile game. This is obviously a huge question, but I shall simply assume here that Hegel's historical approach to the problem of freedom is, at the very least, worth taking seriously and exploring.[23]

22. Gombrich 1984, 59. See also Summer's discussion of Gombrich and Hegel in Summer 2007, 39ff.

23. I discuss this issue at greater length in Pippin 2006, 2010a, and 2010b.

But why should the fine arts be an element of *that* story? To understand this, we need a few more details about Hegel's theory of freedom and why the history of the fine arts should be involved. Although Hegel's position shares a number of elements with a classical, paradigmatically Socratic notion of freedom (freedom as self-knowledge, understood primarily as the knowledge of what it is to be a human being and therewith how to live well) and with Christian-Kantian notions (Hegel too insists on the subject's mindedness, her intention, as criterial for the deed being a deed at all—"intentional under some description"—and as essential for the assigning of responsibility) and even with empiricist accounts (if the deed is to reflect me, be mine, it must reflect my cares and desires, what matters to me), he does not have a Socratic-philosophical notion of self-knowledge (which, he thinks, does not reach the concrete individual and the self-knowledge *she* requires as such an individual) or a causal theory of agency wherein an inner event or state is supposed to cause bodily movements, and he does not think reflective soul-searching is the way to understand how we come to know what matters to us, which he treats as a more complicated and difficult question than the empiricists. The most common labels for his account are roughly accurate: he has an "expressive," a "social," and a "self-realization" theory of freedom. In the most general sense a free action is one that fully expresses me, as I have come to understand myself, such that I can fully recognize myself in the deeds I bring about, and so it represents the realization over time of some intention in my bodily movements and ultimately the realization of *Geist* as self-forming in time. (Expressed negatively, I am free if I stand in a nonalienated relation to what I have brought about, a standard that places a great deal of weight on achieving the right sort of understanding of "who I am.") But for Hegel there is another crucial condition that must be fulfilled: those bodily movements count as the deed I intend only if that act description is one recognizable as such in the community in which I express and realize myself. (I cannot be *doing X* if the community in which I act takes what I am *doing to be Y*.) However, not just *any* social arrangement of norms and collective self-understanding are relevant to the deed's being truly mine and so free. The basic network of social relationships that serve as conditions for the collective intelligibility of my deed represents the results of, and an ongoing struggle with, a large-scale social contestation across historical time about relative statuses of independence and dependence (power) in some social world, organized in some specific way, relationships themselves realized in the institutions of power at a time. (These are essentially relationships involving who gets to subject others' wills to one's own, who gets to take what from whom and to constrain what others would otherwise be able to do, and so forth.) Only in a social world that has achieved

some mutuality of recognition or mutuality of recognitive institutional statuses can social norms play the appropriately constitutive role they do in my own attempts to count this as such and such a deed, in which my own self-understanding reflects the communal self-understanding achieved at a time.

Here is a summary of the main points of the doctrine of freedom that Hegel provided for his students in the introductory remarks to his *Lectures on Fine Art*:

> Freedom is the highest destiny of the spirit. In the first place, on its purely formal side, it consists in this, that in what confronts the subject there is nothing alien and it is not a limitation or a barrier; on the contrary, the subject finds himself in it. Even under this formal definition of freedom, all distress and every misfortune has vanished, the subject is reconciled with the world, satisfied in it, and every opposition and contradiction is resolved. But, looked at more closely, freedom has the rational in general as its content: for example, morality in action, truth in thinking. But since freedom at first is only subjective and not effectively achieved, the subject is confronted by the unfree, by the purely objective as the necessity of nature, and at once there arises the demand that this opposition be reconciled. (*A*, 1:97)[24]

One of the points I shall try to make in the next chapter is that Hegel understands there to be a deep connection (a relation closer even than analogy) between the conditions for the possibility of rightly understanding some bodily movements as deeds, not mere events (my raising my arm, not my arm going up, as in Wittgenstein's famous example), and the conditions necessary for apprehending artworks as such, and not as mere empirical objects (avoiding mere "objecthood," in Fried's [1998, 148–72] terms). The essential point of contact is what he calls the "logic" of the "inner-outer" relation crucial to each possibility or, more precisely, the identical "logic" in the two cases. Bodily movements bear meaning as deeds (they have an "inner" meaning) in the same way that sensible objects like paintings can be said to bear meaning as artworks: not by the subjective projection of observers and beholders and not by being caused in some way by mental states that must be appealed to in order to explain intentional meaning and certainly not by having anything literally "inside." In both cases the intention is only "realized" (*verwirklicht*) as the intention it determinately is *in* the deed or in the work, *as* that deed or work counts as this or that *to* a community at a time; before that realization, it is only provisionally and putatively the determinate intention or meaning. (In his *Phenomenology*, he frequently uses "work" [*Werk*] as a term of art for a

24. See n. 5 above for the abbreviation.

deed,[25] thereby emphasizing this commonality with artworks.) He starts in on this theme right away in the lectures and at what must have been a bewilderingly high level of abstraction for his poor students:

> The inner shines in the outer and makes itself known through the
> outer, since the outer points away from itself to the inner. (*A*, 1:20)[26]

Indeed, this insistence on art as the achievement of a speculative identity of inner and outer plays a crucial role when Hegel defends his claim that late romantic art is in the process of transcending the revelatory power of art altogether:

> Therefore we acquire as the culmination of the romantic in general the contingency of both outer and inner, and the separation of these two sides, whereby art annuls itself and brings home to our minds that we must acquire higher forms for the apprehension of truth than those which art is in a position to supply. (*A*, 1:529)

This whole framework is particularly important for Hegel's understanding of painting (essentially a "romantic" art for Hegel; the "real content" of painting "is the feeling of the individual subject," by which he means the sensuous embodiment of subjectivity understood, as he does, as self-realizing freedom; *A*, 1:803–4). This is so because of the way he links painterly meaning to "love." In the 1828 lectures he even characterizes the "fundamental trait" (*Grundzug*) of painting as "love."[27] He means not only that the most appropriate subject of successful paintings (where "successful" again has something to do with sensuous or intuitive credibility, compellingness, convincingness) is love (love itself as in Venus, in Madonna and child, or in the tradition of the nude) but also that successful paintings demand an attention and involvement at a level of intimacy (*Innigkeit*) that is inseparable from a relation that evokes the "self-in-other" dynamic of love. (All this will also be relevant, as we shall soon see, when a painting does not fail but succeeds in intimating the ever more difficult realization, perhaps impossibility, of this ideal.) And painting, understood as a romantic art and an address to the other, has to embody an aspiration toward an intimacy of mutuality and reciprocity that is, at its purest or most paradigmatic expression, love.

25. See, inter alia, Hegel 1998, 278–316.

26. See also: "the purposeful correspondence of inner and outer should be the immanent nature of the beautiful object" (*A*, 1:59).

27. Cited in Rutter 2010, 72. Rutter's chapter on Hegel on painting is one of the best expositions. For the relevance of Rutter's account to the discussion of Fried in chapter 3 below, see especially Rutter's (2010, 92ff.) treatment of Hegelian "liveliness" as "absorption."

So while Hegel reminds us again that art cannot truly embody "absolute spirit," the actual achievement of such a reconciliation or the grasp of the reconciliation (only philosophy can accomplish this), he goes on to say, in a passage again of particular relevance to painting because of painting's romantic status,

> But if *Geist* in its affirmative reconciliation is to acquire through art a spiritual existence in which it is not merely known as pure thought, as ideal, but can be felt and contemplated, then we have left as the sole form which fulfils the double demand (that of spirituality on the one hand and comprehensibility and portrayability by art on the other) only the deep feeling of *Geist*, or the soul and feeling. This depth of feeling, which alone corresponds to the essential nature of *Geist* which is free and satisfied in itself, is love. (*A*, 1:539)

And he then gives his familiar account of this aspiration and its realization (all in the section "Concept of the Absolute as Love"):

> The true essence of love consists in giving up the consciousness of oneself, forgetting oneself in another self, yet in this surrender and oblivion having and possessing oneself alone. This reconciliation of the spirit with itself and the completion of itself to a totality is the Absolute. (*A*, 1:539–40)

How modernist painting will begin to work out, in its uniquely aesthetic mode of intelligibility, the historical fate in modernity of the social subjectivity necessarily at issue in *the paintings' address to the beholder* (and so how the logic of social subjectivity central to Hegel will play out in artworks) will be a major topic below.

This is also the beginning of the culmination of his entire narrative of the history of art, all of it framed essentially by this notion of inner-outer. In pre-Greek art, including Egyptian statuary and architecture, for example, the outer form—the stone and marble—was experienced as resistant to the expression of a human "inner," hence the stiffness and coldness of such art. In Greek art, which Hegel considered the perfection of art as art, this inner-outer harmony, even identity, is without remainder or tension; Greek art is perfectly and completely embodied meaning, inner as wholly outer, outer as complete realization of inner. He understands romantic art as the beginning of the realization that *Geist* does not require a material embodiment to be fully realized *Geist*; it needs only to be reconciled "with itself."[28] I shall suggest in the next chapter that this conclusion is not moti-

28. See Pinkard 2007 for a valuable guide to this historical narrative. The inner-outer formulations also structure the discussion of the differences among the various arts considered system-

vated by anything essential in Hegel's account and represents a misstep, not an inference consistent with Hegel's overall project.[29]

But the point here is to emphasize how similar are his accounts of embodied meaning in action. There are several passages in *Phenomenology of Spirit* that make use of the same terms:

> An individual cannot know what he is prior to having brought himself to actuality through action. (1998, 356)

> In its deed, ethical self-consciousness now experiences the developed nature of *actual* action, indeed, as much as it did when it submitted to both the divine and the human law. (1998, 421)

> The way a man is externally, i.e., in his actions (not of course just in his merely corporeal externality), that is how he is internally; and if he is *only* internally virtuous or moral, etc., i.e., *only* in his intentions, and dispositions, and his outward [behavior] [*sein Äußeres*] is not identical with those, then the former is as hollow and empty as the latter. (1991b, 210)

The full speculative formulation that covers both exemplifications of this logic is also given in *The Encyclopaedia Logic*: "Hence what is only something inner is also thereby external, and what is only external is also only something inner" (1991b, 210).[30]

atically and not just historically. Gehlen (1960, 94) ties the problem of the split, or diremption, between inner and outer that he sees portrayed in modernist art to the unique properties of a mass, industrialized society. I will discuss something like this claim in chapter 3, when considering Clark.

29. Were there world enough and time, it would also be important to understand why the lectures are not, strictly speaking, a truly *scientific* treatment of art, for reasons Hegel suggests in this passage: "Philosophy has to consider an object in its necessity, not merely according to subjective necessity or external ordering, classification, etc.; it has to unfold and prove the object, according to the necessity of its own inner nature. It is only this unfolding which constitutes the scientific element in the treatment of a subject. But in so far as the objective necessity of an object lies essentially in its logical and metaphysical nature, the treatment of art in isolation may, and indeed must, be exempt from absolute scientific rigor; art has so many preconditions both in respect of its content and in respect of its material and its medium, whereby it always simultaneously touches on the accidental; and so it is only in relation to the essential inner progress of its content and means of expression that we may refer to its necessary formation" (A, 1:51).

30. Here is a fuller statement from the "logic of essence": "We are accustomed to say of human beings that everything depends on their essence [*Wesen*] and not on their deeds and conduct. Now in this lies the correct thought that what a human being does should be considered not in its immediacy, but only as mediated through his inwardness [*Inneres*] and as a manifestation of that

Finally, these notions of an "identification" with deeds and practices are not meant to rely on matter-of-fact psychological or social-psychological accomplishments. "Comprehending an age *in thought*" (understanding this struggle for identification) for Hegel meant, roughly, "assessing the *rationality* of the authoritative norms of a time," where "rationality" meant "more successfully rational" (or not) than *what we had been doing*, not as measured against a Platonic or Kantian ideal. True identification is rational identification, and the sorts of failures in social norms that interest Hegel are historical breakdowns in the capacity of subjects whose actions affect what others would otherwise be able to do to justify what they do to those others. At this point, this kind of account by Hegel is best viewed as proceeding along a two-track analysis. On the one hand, he has a grand philosophical theory about such developments, breakdowns, and recoveries, a retrospective account of the way in which the status of our understanding of nature, of religion, of authority, and so forth form a whole that can suffer an internal crisis because of what, from this philosophical point of view, are the specific limitations of *Geist*'s self-understanding at a time (viewed, again, from some later and presumably privileged position of assessment, where *Geist*'s self-forming or self-legislating character has been properly appreciated). The paradigmatic explanation of the experienced failures of irrational institutions (institutions that confuse the exercise of power with the claim to authority) is probably the most famous passage in Hegel: the "Master-Slave" dialectic in *Phenomenology of Spirit* (1807) and the account there of "the paradoxes of the Master," who demands recognition from one whom he does not recognize and so, again paradoxically, fails (*for himself*) to be a Master.[31]

But, obviously, understanding this Hegelian theory of historical reason is not what is appealed to by participants *in* a practice as they attempt to justify themselves to each other, hence the other "track."[32] For the participants, there are all sorts of considerations they can appeal to in justification to others.

inwardness. But with that thought we must not overlook the point that the essence and also the inward only prove themselves [*sich bewähren*] as such by stepping forth into appearance. On the other hand, the appeal which human beings make to inwardness as an essence distinct from the content of their deeds often has the intention of validating their mere subjectivity and in this way of escaping what is valid in and for itself" (Hegel 1991b, 177–78, translation altered).

31. For a fuller discussion, see Pippin 2011a; and for a literary exemplification of the issue, see Pippin 2010c. The clearest and most unequivocal expression of the "master's impasse" is in §192 of *Phenomenology*.

32. The paradigm is again *Phenomenology of Spirit* and its distinction between what is "for consciousness" and what "we" understand. See Pippin 2010b.

Practical reason in this sense is understood by Hegel as a historical social practice, not a formal methodology or pure decision theory or calculation or, as in Kant, "the form of pure practical reason." And these substantive considerations suffice for them, at a time, as justifications in the social world in which they come to have whatever normative force they do. These are considerations like "because he is the prince" or "because the ancestors would be angry" or "because I am his sister" or "because you are not a citizen of my country." To many critics of Hegel, it has seemed potentially relativistic and philosophically confused to claim that more straightforwardly philosophical considerations like "because I have a natural right to" or "because that would not be fair and equal treatment under the law" are of the same status, but for Hegel, that claim just expresses the confidence (which he shares) that we moderns have gotten better at this practice than our forebears and not that we have stumbled upon, finally, the eternal land of true normative rectitude.

All these claims, as I have stated them, involve very controversial interpretations of Hegel and very ambitious philosophical claims that would require volumes of clarification and defense: that philosophy has a historically diagnostic task; that this task is the comprehension of the rationality of the normative practices of an age; that the chief, central norm in any such account involves the aspiration to freedom, and so the account involves the history of attempts at the realization of freedom; that there are social conditions— public, institutional achievements—necessary for any such realization; that these ultimate conditions involve the achievement of mutuality of recognitive status (Hegel's version of equality); that the rationality on which such mutuality rests must be understood as a historical social practice of practical justification.

We need some picture like this (however controversial and however preliminary and so unavoidably abstract and incomplete) of the Hegelian project to understand what follows, and I hope this is sufficient. The larger picture is necessary because so many elements of it are in play in Hegel's account of art. That is, the idea is to follow Hegel in seeing artworks as elements in such a collective attempt at self-knowledge across historical time, and to see such self-knowledge as essential elements in the struggle for the realization of freedom, where freedom is understood in this identificatory, expressivist sense, dependent on the collective achievement of a certain form of rationality for the nonalienated relation to deeds required by the ideal. The regime of art, its production and reception, involves one crucial aspect of this struggle, in many ways, especially in modernity, the crucial aspect: the right comprehension of our status as natural beings who, as such natural creatures, are capable of recognizing embodied meaning in our deeds and sensible, material

artworks. Artworks are produced in a community at specific times that com-munity is to be understood as having achieved some degree of the realiza-tion of freedom and so some degree of the self-understanding necessary for rational social relations, and artworks must be understood as indispensable components of that achievement. Paintings, for example (a genuinely fine art only in the modern period, according to Hegel), especially presume a certain relation to the beholder that has to reflect some collective understanding of social relations in general (at their core, for Hegel, a struggle for recognition), and they imply by their very existence some assumption about their possible meaning (the shareability of such embodied, sensible meaning) and their meaningfulness, their importance for such collective self-understanding.

There is no reason, certainly no a priori reason, to assume that this elabo-rate interpretive structure should be of any use in understanding visual art-works produced not only after Hegel but also after what appears to be a gap, a serious discontinuity, in the history of art, the usual way in which all mod-ernist art is characterized (the "Manet to American Abstract Expressionist art" cycle), or that the approach is a more fruitful framework than competing accounts of the philosophical significance of pictorial art, like Heidegger's. Showing that such claims are true is the task of the following.

Philosophy and Painting:
Hegel and Manet

Vous n'êtes que le premier dans la decrepitude de votre art.
BAUDELAIRE, letter to Manet, May 11, 1865[1]

I

In 1863 the French painter Édouard Manet caused a public scandal when he exhibited his large painting *The Luncheon on the Grass* in the Salon des refusés. He caused an even greater scandal two years later when he exhibited the startling *Olympia* in the Paris Salon (figs. 2.1, 2.2; pls. 1, 2). The nature of and the reasons for the controversy have been told several times from a number of points of view by distinguished art historians. In hindsight, it has seemed to many of these commentators (though certainly not all) that something unprecedented and revolutionary in the history of painting began with Manet, a development that would eventually coalesce into what came to be characterized as a movement or epoch in virtually all the arts: "modernism." Of course, Manet did not spring ex nihilo into history. The narrative that we need for modernist painting begins with the reaction against the rococo in the 1750s and became something truly revolutionary only after the impact of Impressionism in the 1870s. That is a long story, but only a few would deny that Manet is a pivotal figure.[2] Whether there is anything to such a categorization or not (and periodization in art history is notoriously controversial), the mise-en-scène, the technique, and what might be described as the mood or tonality in each painting are so odd that something uncanny and unprecedented

1. Cf. Fried's (1996, 164–68) discussion of the Baudelaire-Manet relation.
2. Various commentators have argued for Manet's centrality. See the quotations at the beginning of the next chapter. Fried has presented a compelling argument about the relation between Courbet, Manet, and the Impressionists in the formation of modernism (or "formalist modernism")—what he calls a "complexly recursive, three-part hingelike structure" (1996, xx)—as all are jointly necessary to account for this formation.

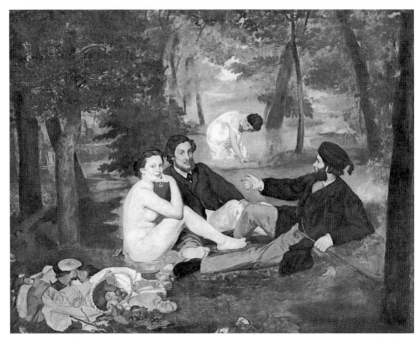

FIGURE 2.1. Édouard Manet, *The Luncheon on the Grass*, 1863.

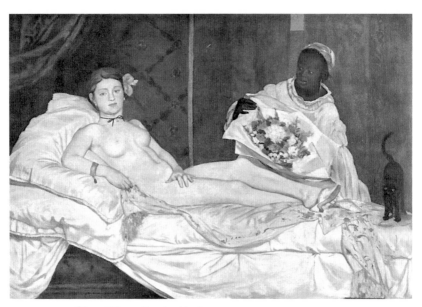

FIGURE 2.2. Édouard Manet, *Olympia*, 1863–65.

is clearly going on, something that seems to be about and a challenge to paint-
ing itself, to the conventions of meaning in easel painting.[3] Normal perceptual
apprehension and representational understanding are not so much intensi-
fied, as we might expect in a great work of art, as rather in some way inter-
rupted and challenged, for reasons that were clear to almost no one at the
time.[4] The challenge is strikingly clear in the startling looks of the two women
(the same woman, actually; Victorine Meurent, Manet's favorite model) (figs.
2.3, 2.4), looks that all at once destroy the convention of pictorial illusionism
(the illusion that we are looking into a three-dimensional space and not at
a flat, painted rectangle), seem to address the beholder (of the painting, not
the scene) with a confrontational challenge (as if to ask, "Just what is it you
are looking for?"), and thereby also thematize the *painting*'s facing position
opposite the beholder,[5] suggesting questions about the psychology of mean-
ingful beholding and the status of the very social conventions assumed in
understanding the point of easel paintings.[6] It is a kind of original interroga-

3. The oddities in *Luncheon* have been much remarked on. The woman bathing in the back-
ground (or whatever it is she is doing, which seems vaguely postcoital) is the wrong size, too
large for her distance from the viewer. The speaking man has, apparently, no auditors. His part-
ner is gazing off absently, clearly not listening. Neither of them is attending to the naked woman
in their midst. There are intimations of an iconography that cannot be clearly interpreted: a
framing by the small bird at the top, the small frog at the left bottom. The list could go on.

4. See Arnold Gehlen's (1960, 61) apposite remark that artists like Manet seemed to be pro-
ducing "intuitions" (*Anschauungen*) for which there were no "concepts" (*Begriffe*), a link with the
central issue in the Kant-Hegel relation already mentioned and one that I shall exploit more later.
Gehlen's description of what he is after in his approach to modernism—"Bildrationalität"—also
has a nice Hegelian echo. On the perception issue, see also Gehlen, 1960, 63–64.

5. This broaches the issue—the painting's "facingness"—that is the center of Fried's (1996)
interpretation and that I shall discuss at length in the next chapter. See also Pile 2004 and the
interesting discussion there about the famous painting's reversal of sorts in the polarity of
subject-object, with the spectator gazed at and thereby included in the painting's meaning. Pile
also makes several connections with a pragmatist account of painterly meaning (Dewey) that
parallel many of the Hegelian points that follow, especially about the provisionality of painterly
intention and the retrospectivity of ascribable meaning.

6. Nehamas (2007, 117) notes that Olympia's gaze does not quite meet the gaze of the be-
holder with clear directness; her "eyes are focused almost infinitesimally off to the side and not
at the viewer directly." He then infers from this a great deal about the role of and reference to
photography in the painting and goes on to suggest that this allusion (to Olympia's "being pho-
tographed") helps explain why the narrative coherence of the painting fails *as a painting*. This
may be so, but I am suggesting that much larger issues are also at stake in whatever failure of
(or lack of complete success in) narrative coherence is staged in the painting, something like the
conditions of social subjectivity necessary for mutual intelligibility. (It is also unclear to me what
it might mean that Manet is painting "in a photographic way," if he is; that is, what the point
would be, beyond registering the impact of photography on the condition of painting.)

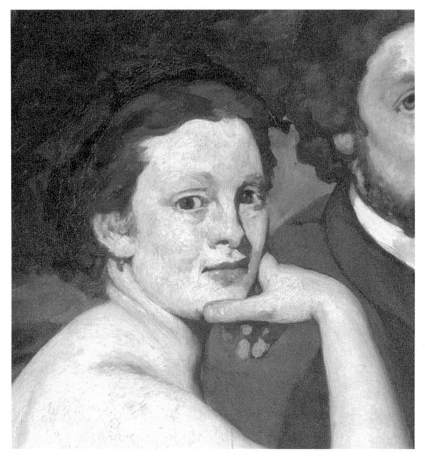

FIGURE 2.3. Detail from *The Luncheon on the Grass.*

tion that Manet had already used to great effect in *The Old Musician* of 1862 (fig. 2.5) and that other painters were also exploring, such as Fantin-Latour in his *Homage to Delacroix* (where almost everyone is looking out of the picture frame, and, in this "homage," no one is looking at Delacroix) (fig. 2.6).

Of course, there are innumerable examples in art history of subjects gazing out of paintings. It is inevitable in self-portraits, for instance, and not uncommon in devotional paintings.[7] And there are other examples of deliberate indifference to perspective, unusual coloration, narrative confusion, elements

7. To put it in the terms used by Fried (2010, 73–74, 77, 99, 206) to describe the earlier "moment" of attention to the issue of absorption (in Caravaggio), although there were plenty of examples of depictions of absorbed activities before Caravaggio and his generation, with his work, that depiction was "thematized" and became "a pictorial resource in its own right." On the

FIGURE 2.4. Detail from *Olympia*.

of the bizarre, and so forth. But the distinctive interconnected features of Manet's two controversial paintings, and the number of violations, oddities, and the unusual tonality, have seemed to many to have no precedent. The subjects are not captured at certain angles looking at something beyond the scene, and they are not posed for a portrait. They seem to address the beholder, and with a shocking, defiant boldness.

I am neither an art historian nor an art critic, but I am interested in a kind of philosophical attention to artworks, especially to visual artwork and the meaning of normative change in visual art. As noted in the last chapter,

importance of the right way of understanding the painting's "address" to the beholder (and so the dialectical relation between absorption and address), see Fried 2010, 108ff.

FIGURE 2.5. Édouard Manet, *The Old Musician*, 1862. Courtesy of the National Gallery of Art, Chester Dale Collection.

this interest is largely inspired by the approach taken in a series of lectures on fine art given four different times by Hegel in Berlin during the 1820s. Very roughly, Hegel's view was that the production or "externalization" of our ideas in artworks represents a distinct and, until very recently, indispensable form of self-knowledge. His unusual phrase is that the human being, understood as *Geist*, must "double itself" (*sich verdoppeln*) (*A*, 1:31) in order to be able to experience and understand itself in its deeds and objects. (And with that one characterization, we are already in uncharted waters; art does not double or imitate reality as in so many mimetic theories, but rather in art, *Geist*, some sort of achieved collective like-mindedness, doubles *itself*.) And this occurs within an ongoing collective, continuous attempt at self-knowledge over historical time,[8] a project one had to understand in the light of interconnected attempts at such knowledge in religion, philosophy, and even in the social and political practices of an age.[9]

8. Hegel means *Geist*'s knowledge of what it is to be *Geist*, and that primarily means what it is to be collectively and individually responsive to reasons, and so in what sense and with what authority we make rational claims on each other and hold each other to account.

9. See Hegel's full remark on *Geist*'s "doubling": "The universal and absolute need from which art (on its formal side) springs has its origin in the fact that man is a thinking conscious-

FIGURE 2.6. Henri Fantin-Latour, *Homage to Delacroix*, 1864.

Although Hegel was very clear about the differences between the concep-
tual articulation of this self-knowledge at some level of achievement in philos-
ophy and the intuitive (*anschaulich*) representations of such self-knowledge
in art, his position also had as its consequence a consideration of artworks,
and not just epics and great tragedies but visual and plastic and musical art-
works as well, as limited forms of, and deeply continuous with, philosophy—
historically inflected "philosophy by other means," let us say. Otherwise
expressed, art, at least for most of its existence, had for Hegel a kind of philo-
sophic work to do; in his language, that work was a particular way of what
he also called "working out" (*herausarbeiten*) modes of self-understanding
with respect to the basic problem introduced in the last chapter, what phi-
losophers took to calling the issue of "the Absolute," that "subject-object"
problem. Acknowledging this great difference (between minded agents and
public deeds, between subjects of knowledge and the material world) while

ness, i.e. that man draws out of himself and puts before himself what he is and whatever else is.
Things in nature are only immediate and single, while man as *Geist* duplicates himself, in that
(i) he is as things in nature are, but (ii) he is just as much for himself; he sees himself, represents
himself to himself, thinks, and only on the strength of this active placing himself before himself
is he *Geist*" (*A*, 1:30–31).

 Again, he clearly means *Geist*'s self-knowledge about what it is to be *Geist*, not art's dawning
knowledge of what it is to be art, as, say, in Danto's appropriation of Hegel.

denying any metaphysical dualism was the Holy Grail of the period, and the
problem encompassed everything from how subjects can know objects, how
material states and events, especially art objects and bodily movements, could
be said to bear meaning (something already implicitly interrogated or even
challenged by those facing looks in Manet's famous paintings), to how in the
broadest sense reason-responsive subjects could also be material objects in
space and time.

Hence the obvious Hegelian question for Manet and for the entire epoch
he seems to have had an early role in helping to initiate: is there anything in
the spirit of Hegel that one can say about the sort of self-knowledge realized
(*verwirklicht*) or worked out in the modernist art produced a generation after
Hegel died in 1831, anything consistent at least with the broad spirit, if not
the letter, of Hegel's own account of the problem of "the Absolute"? Could
that very abstract problematic, the legacy of Kant's Third Antinomy, Schiller's
Letters, Schelling's 1800 *System*, and Schlegel's reflections on irony and "the
infinite," be of any use in understanding the work of urban French culture in
mid-nineteenth-century Paris? Hegel certainly showed that he could put his
framework to brilliant use in unusual aesthetic contexts. If, for example, the
classical Attic tragedies meant what Hegel said they meant, that a great crisis
in the basic institutions of that society had arisen and could not be resolved,
that contradictory justifications for actions had somehow both become right,
then what, if anything, is revealed in some corresponding way about a society
whose painters begin to make paintings where objects seem to be demateri-
alizing over historical time in succeeding generations,[10] first as sensory im-
pressions, then as occasions for artistic and often elaborate geometric recon-
struction, and finally as absent in wholly nonrepresentational experiments,
a society that also makes self-referential and ironic literary works, art music
without conventional harmony, and, eventually, architecture in which archi-
tecture is, simply, "structure"?[11] Is it even plausible to try to understand nor-

10. There is a prescient comment about this made in Schelling's 1802–3 lectures, *The Philos-
ophy of Art*: "Matter gradually dematerializes into the ideal; in painting as far as the relative ideal,
through light; then, in music and even more so in speech and poesy; into the genuinely ideal, the
most complete manifestation of the absolute cognitive act" (Schelling 2008, 200).

11. Any narrative of modernism, even one that accepts the by now conventional Manet–
Abstract Expressionism periodization, is bound to be extremely controversial. Indeed, the very
idea of a narrative of an art-historical movement is controversial, not to mention the details. In
the next chapter I shall discuss the approaches taken by T. J. Clark and Michael Fried, which not
only seem to me the most credible and philosophically interesting but also, I argue, can both be
viewed as "left-Hegelian" extensions of the Hegelian approach sketched in this chapter. And I
do not, of course, mean to ask what the historical person, Hegel, would have actually said about

mative change in the practice of art by understanding these alterations within broader social, religious, and even philosophical changes? Could such an approach do justice to the distinctly aesthetic meaning of these innovations, or is it already bordering on some form of thematic reductionism?

II

There are many reasons to be skeptical that anything of value can result from trying to project Hegel into the future like this.[12] After all, anyone who has heard anything about Hegel has probably heard that he said two things: that philosophy was its own time understood in thought, and some summary of the following remarks.

> In all these respects art, considered in its highest vocation, is and remains for us a thing of the past. Thereby it has lost for us genuine truth and life, and has rather been transferred into our *ideas* instead of maintaining its earlier necessity in reality and occupying its higher place. What is now aroused in us by works of art is not just immediate enjoyment but our judgment also, since we subject to our intellectual consideration (i) the content of art, and (ii) the work of art's means of presentation, and the appropriateness or inappropriateness of both to one another. The *philosophy* of art is therefore a greater need in our day than it was in days when art by itself as art yielded full satisfaction. Art invites us to intellectual consideration, and that not for the purpose of creating art again, but for knowing philosophically what art is. (*A*, 1:11)[13]

the art of the later nineteenth century. That is an unanswerable question, even though the odds are high that he would have been horrified. (His heroes in painting were Raphael, Titian, and the modern Dutch painters.) I mean only to ask if, in trying to understand this epoch, there is anything of value in the approach that Hegel pioneered.

12. I make this assertion despite the compelling attempts of Dieter Henrich to do something like this, even as he argues for the severe limits of such a possibility. See Henrich 1979; 1985; 2003a, 65–125; 2003b; 2006a; 2006b. For a valuable summary of Henrich's position, see Rush 2007. Rutter (2010, 78ff.) makes an interesting case that seventeenth-century Dutch art, which Hegel admired so much, provides another example of a possibly postromantic art that Hegel would recognize as art, and he tries to defend Hegel from Henrich's claim about Hegel's "Biedermeier" taste. Also indispensable are the essays by Donougho (1999, 2007a, 2007b).

13. Here is another often-cited passage: "Therefore we acquire as the culmination of the romantic in general the contingency of both outer and inner, and the separation of these two sides, whereby art annuls itself and brings home to our minds that we must acquire higher forms for the apprehension of truth than those which art is in a position to supply" (*A*, 1:529). In a way, for Hegel, art can be said to have two "endings." The art of classical Greece represented the culmination of art's possibilities as a mode of absolute spirit, and its decline into comedy represented already the "beginning of the end." See also Hegel's views on the limitations of Greek thought

If one considers the history of modernist art after Hegel, there is something both ominously prophetic and yet clearly hasty about Hegel's remarks. The tone of pessimism in the remark can seem to us more like something simply obvious. It seems trivially true that the fine arts do not and cannot matter to us as they mattered in the tragic festivals of ancient Athens or in religious practices or in the dreams of the *Frühromantik*. We have invested our hopes in science, technology, medicine, market capitalism, and, to some lingering extent, in religion, but certainly not in art. And Hegel had not even anticipated two other threats to the vitality and autonomy of art: that an art-buying leisure class of the bourgeoisie would become the principal patrons of the arts, nor did he anticipate how mass consumer societies would radically alter the conditions for art's production and appreciation. Yet, on the other hand, the revolutionary vitality of the modernist moment itself and the continuing vitality of art forms like film and photography are evidence enough that art has not become a thing of the past.

However, we can begin to see the opening to answer our Hegelian question about modernism if we recall that this claim is not an isolated one in Hegel's books and lectures. After all, Hegel also did not believe that there was any world-historical work for philosophy to do; its content was also its past, now understood in the right way within a comprehensive philosophical system. And there are to be no world-historical developments in religion either, beyond the doctrinally thin, humanist Protestantism Hegel preferred. And the institutions of modern "ethical life" (*Sittlichkeit*), the distinction between the state and civil society and the basic structures of modern civil society, all also represent for him the achievement of reconciled relations of genuinely mutual recognitional status.[14] That is, Hegel believes what he does about the finality of the achievement of romantic art *because* he is convinced of all these other claims as well, not because of some internal aesthetic feature of late romantic art that required such a reduced significance. (Indeed, according to Hegel, late romantic art, however much it represents the self-transcendence of

in general, given this view of art. From the philosophical point of view, art has to seem a "veil" over the truth (*A*, 1:51). See also Taminiaux 1982, 180. The inwardness required by Christianity (especially, ultimately, Protestant Christianity) is a radical acceleration of this "disintegration" (*Zerfallen*).

14. Hegel was also not the only important contemporary to hold that there is a connection between the kind of society one lives in and the kind and quality of art that can be produced, that the former is some sort of condition of the latter. The Schlegels were both pessimistic, and Friedrich (Schlegel 2003, 289), speaking of the art of his day, wrote that "what has grown in such a sickly environment naturally cannot be anything else but sickly."

art, still enacts such transcendence *as art*.) Paradigmatically he believed that the basic structure of modern society had become at least incipiently rational, and rational in a way that no longer required a distinctly sensible-affective comprehension. Romantic art had already embodied the fact that we had "liberated" ourselves from our natural home and had successfully created another. That modern shape of spirit (*Gestalt des Geistes*) was a world of freedom realized, or reconciled social relations of persons who are free because they actually stand in relations of at least institutionally secured mutuality of recognition. We have reached a form of self- and other-understanding where there is nothing substantial left to be "worked out," no fundamental residual irrationality in the way we make claims on each other and about the world.

In a word—and I shall simply assume that this does not need to be argued—this is all clearly false as a claim about European modernity in the first third of the nineteenth century, and its being false means that the *particular* failure and partial success of the modern attempt at the realization of freedom would *still* require, in Hegel's own terms, an attempt at the sort of understanding just referred to: an objective embodiment and self-recognition, or the world of art. Everything Hegel wants to say about what we are left with in our "artistic situation" historically follows from this quite sweeping claim about rationality and so freedom realized.[15] The realization that no reconciliation has been achieved (but that Hegel is fundamentally right about the nature of art) would mean an embodiment both of still-unresolved dualities (required or unavoidable but incompatible commitments, let us say as a kind of shorthand) and of some presentiment of their overcoming, but in an aesthetic form responsive to a historical situation Hegel had not properly conceptualized. It should not be surprising, in other words, if there is a connection between Hegel's account of our sense-making practices with respect to the products of *Geist* in general (human doings and makings) and his account of the distinct sort of intelligibility required of aesthetic objects. And since the core of that general account involves a social theory of meaning (the meaning of intentional action, for example, embodied in bodily movements), it will not be surprising if that account is also of continuing relevance to the social dimensions of aesthetic meaning, especially with respect to such things as *the relation to the beholder* presumed in different ways at different times in visual art; the interpretability of *the human actions depicted in paintings*; and the artwork itself understood as *the result of the intentional action of the painter*. And all this is of relevance only as historically inflected, for a community at a time.

15. I mean his remarks about the modern interest in irony and his affirmation of the comedy of "Humanus," the representation of the prosaic bourgeois world.

So my hypothesis is that if one can understand the persistence of the kind of conflicting commitments in intellectual, cultural, and political life required by rapidly modernizing European societies, the kind Hegel thought had been overcome, one will be in a better position to begin to understand the aesthetic experimentation that seemed to begin with Manet. Hegel, in other words, may have provided the resources for an approach to modernism and a way of understanding its relation to the self-knowledge problem without having understood the potential (and limitations) of his own approach. He may be *the* theorist of modernism, *malgré lui* and *avant la lettre*.[16]

Put in Hegel's own words from the preface to *Phenomenology*, and taking the word "work" or "task" (*Arbeit*) to include works of art, there is no good reason to suppose that we do not face the same historical problem that Hegel describes here, in contrast to the work in the ancient world:

> Nowadays the task before us consists not so much in purifying the individual of the sensuously immediate and in making him into a thinking substance which has itself been subjected to thought; it consists to an even greater degree in doing the very opposite. It consists in actualizing and spiritually animating the universal by means of the sublation of fixed and determinate thoughts. (2012, §33, p. 29)

These formulations, of course, only gesture at those theoretical resources, and it would take several books to spell them all out.[17] But the heart of the matter, the central claim of Hegel's idealism, anticipates, in its very formulation, the issue of the conditions of the possibility of the intelligibility of modern fine art in general and, given the increasing pressure modernist art places on conceptual articulation, or what we now call criticism, of modernist art in particular. That central claim is one introduced in the last chapter: the distinguishability and, more radically, the inseparability of concept and intuition in experience and, similarly, a form of practical mindedness, intentions, *in* bodily movement *in* action. Hegel denied that the basic capacities needed to understand what we experience and what we do, active and passive capacities, were separable or separately contributing components of experience and action, as if in some two-step process. He maintained that,

16. It is certainly true that Hegel's central category—that nominalization that actually arose out of eighteenth-century physics and the problem of opposing forces, "negativity"—is the one we need in order to understand modernism. Cf. Clark's (2001, 302) gloss from his chapter on Pollock: "An art of high negativity—books about nothing, paintings done with consciousness deliberately on hold."

17. I have tried elsewhere to provide an interpretation of these theoretical resources: Pippin 1989 and 2008b.

especially, any sensible passivity or sensible inclination could play whatever role it was to play only if conceptually informed, already determined in a way, by some spontaneous discrimination. This claim—the centerpiece of the issues now called "German Idealism"—required a thorough reconsideration of the very possibility of intelligibility in experience and action (Hegel's major project, as I understand him), and it meant a major disagreement with (even as he was enormously influenced by) Kant's original arguments about how thoughts can be said to inform sensibility in perception and how thoughts can be said to be in, be at work in, the bodily movements we count as ascribable actions. In aesthetic terms, this position required of Hegel a rejection of rationalist, classicist, and perfectionist aesthetics (in which "separable" ideals are dimly if pleasantly intimated in sensuous experience), empiricist aesthetics (where sensual pleasure is considered a directly reactive nonconceptual phenomenon), and Kantian and Schillerian aesthetics (where the harmony or free play of faculties intimates a purposiveness that cannot be rendered conceptually determinate). As we shall see, the position especially associates the intelligibility of artworks with the intelligibility of the bodily movements we count as actions, where successfully circulating social norms are necessary for the content and the ascribability of the action to be fixed.[18] So one question that will emerge in our counterfactual exploration of what would be Hegel's account of Manet is what such a requirement "looks like" when those social norms (the ones that allow shared act descriptions and ascription of agency) begin to break down internally and lose their grip.

III

So let us return to the striking claim that art has become for us *ein Vergangenes*, a thing of the past, not capable of functioning for us with the power and importance it once had. Of course, by claiming this, Hegel did not mean that art will not be produced, that it will somehow be discredited, like astrology or alchemy, or that it will come to seem a primitive version of philosophy.[19] To understand what he means, we have to recall that Hegel's treatment of art itself, in whatever period, had already throughout all the *Lectures* steered fairly

18. I mean simply how we easily and immediately come to understand bodily movements as praying, working, protesting, playing, and so forth. The key first step in getting from Kant to Hegel to the intelligibility of artworks is how one understands thoughts to inform sensibility and how one understands how thought bears on, informs, bodily movements, the two most obvious instances of what Danto (1994) calls "embodied meaning."

19. For example, "We may well hope that art will always rise higher and come to perfection, but the form of art has ceased to be the supreme need of the spirit" (*A*, 1:103).

clear of many of the traditional aesthetic categories. When he is discussing the notion of "true beauty," for example, he says such unusual things as "Works of art are all the more excellent in expressing true beauty, the deeper is the inner truth of their content and thought" (A, 1:74). It is important to emphasize this unusual gloss on the beautiful because while Hegel will occasionally invoke the ineradicable commitment to the ideal of the beautiful if art is truly to be art (e.g., when he is describing the radically new situation of the modern, postromantic artist, he notes that while the artist is no longer restricted to subject matter or national interests, he insists that the artist must nevertheless not "contradict the formal law of being simply beautiful,"[20] and the material must be such that it is "capable of artistic treatment" [A, 1:605]), such remarks must be interpreted so as to be consistent with his revolutionary indifference to the beauty of nature (A, 1:2) (*the* theme for prior aesthetics), his de-aestheticized account of the experience of the beautiful in art (his lack of interest in pleasure and taste), and such unusual quotations as the one just cited.[21]

Moreover, such invocations of the beautiful do not amount to a form of "classicism," because Hegel does not consider artworks to be representations of an independent, objective Ideal, "the" truth, in the normal sense, but, as we shall see in more detail, he considers artworks to be vehicles for the practical realization of the relevant speculative truth.

Partly this is because of what he believes about the unique logical status of self-knowledge, even at the collective or civilizational level. And this is another crucial theoretical presupposition of the *Lectures* that requires an all-too-brief gloss. Whether as collective or individual, such self-knowledge does not, for Hegel, take an object in the usual intentional sense. The issue in question is not self-knowledge in the empirical sense, the question of matters of fact about my psychological dispositions or biological traits. Rather, the

20. Hegel writes as if throughout the lectures he had been going on about such a "formal law," but aside from remarks like this, and the famous (and disputed as probably Hotho's and not Hegel's) one about "the sensible shining of the Idea," he has not formulated such a formal "law."

21. One can imagine what he might mean, but Hegel never makes clear why the sensible appearance of the Idea should be in any recognizable sense (i.e., a sense continuous with past uses) "beautiful." What he seems interested in is the former, and he just *counts* that as the latter. We shall return to the large and ancient question of the relation between truth and beauty in chapter 4, on Heidegger. And this is all not to mention mysterious formulations like "beauty is born of the spirit and born again" (A, 1:2). I *think* Hegel is referring here to the fact that any artwork is, first, "born of the spirit," is a product of the artist's intention (mind), but then also "born again," in that the content of such embodied intention depends on the reception and circulation of such a provisional claim to meaning. It is born again in that moment. This sort of belatedness, characteristic also of Hegel's thought on action (as in the social nature of an action's content), will be discussed more extensively below.

self-knowledge we care most about is a question of what some have called our "practical identity." This concerns a self-image of some sort that we take to be fundamental in any self-definition: "who I really am," in the sense of devoted father, philosopher, patriot, committed scientologist, journalist who "speaks truth to power," and so forth. It is in these senses that, for Hegel, what we take ourselves to be is an avowal or commitment, a pledge about what we shall keep faith with, and is not a simple self-observation. Or, said most broadly, self-knowledge is self-constituting in Hegel, as we collectively struggle actually to become who we take ourselves to be.[22]

This feature of self-knowledge has an even more important implication for art. Here is the passage, quoted in the previous chapter, where Hegel distinguishes himself from traditional classicism in the clearest terms. He is discussing classical art, naturally the favorite period for classicist theories, and he notes something about the way classical art should be said to reveal the truth. What he says here is extremely important, for not only does it distinguish his position from traditional classicism, but he relies on the same logical structure in understanding the expressive and "actualizing" function of artworks as he does in understanding the relation between subjective mindedness and deed, a connection, we shall soon see, crucial to his approach and connected to the problem described above as the Idealist problem of "the Absolute."

> And it was not as if these ideas and doctrines were already there, *in advance* of poetry, in an abstract mode of consciousness as general religious propositions and categories of thought, and then later were only clothed in imagery by artists and given an external adornment in poetry; on the contrary, the mode of artistic production was such that what fermented in these poets they could work out *only* in this form of art and poetry. (*A*, 1:102)

There is a great deal more to say about this very interesting phrase "to work out" (*herauszuarbeiten*). For one thing, this way of talking makes clear why Hegel might think that the externalization of our ideas about ourselves in artworks is essential, not merely exemplifying. We don't know, in any determinate or "living" detail, who we actually take ourselves to be except *in* such externalization, either in action or in such material productions as artworks. As he says, there are no "ideas" or "doctrines" before art[23] but only (first) *in*

22. The fact that Hegel speaks of the gradual "actualization" (*Verwirklichung*) of truth is another book-length topic. A typical formulation is "For us art counts no longer as the highest mode in which truth fashions an existence for itself" (*A*, 1:103).

23. He must, of course, mean that there are no reliably determinate ideas. The artist does not just wildly and blindly attack a piece of stone willy-nilly and then inspect what results.

art (another implication of his claims about the concept-intuition relation). As just noted, in the case of individual self-knowledge, this knowledge is inherently first and not third personal and it is *self-constituting*; it cannot be a mere self-discovery or self-report. In any significant sense of self-knowledge beyond a report of empirical facts (the sense relevant to our practical identity mentioned earlier), we *are*, at least provisionally, *what we take ourselves to be*. I say "provisionally" because Hegel adds to this self-constitution notion the claim that such avowals are real (*wirklich*) only as realized (*verwirklicht*) in a world at a time. He agrees with Goethe that "in the beginning was the deed" (*im Anfang war die Tat*), that the deed is the measure of the genuineness and indeed the true content of a subject's commitments. Hegel also adds to this picture of self-knowledge the controversial notion that something like our *collective* identity, *Geist*, is distinct from the mere sum of, or is not some direct function of, such individual avowals. The common and the individual are famously for him dialectically intertwined, and that common project is subject to the same logic. That is, any such individually self-constituting identity is not possible except within a continuing effort at a commonly achieved self-knowledge and so self-realization. It is the very broadest of such projects aimed at commonly realized self-knowledge that we are asking about: *modern*. There is much more to say about this point, but it is the most important Hegelian contribution to a theory of art, and we shall be returning to it frequently.[24]

Second, when Hegel notes that in our age, "art invites us to intellectual consideration, and that not for the purpose of creating art again, but for knowing philosophically what art is" (*A*, 1:11), not only is he already undermining his own narrow account of art appreciation as essentially intuitive and affective, but he also could easily be taken to be introducing the possibility of a different *sort of art*, capable of meeting this new expectation, an art of the explicitly self-reflexive and exploratory sort one begins to see with Manet, an art requiring from the beholder interpretive interrogation of a new sort. (Such an "interrogation of a new sort" required by Manet, say, is the target of our inquiry, now framed more determinately by these notions of provisional self-avowals, externalization, and realization.) This is suggested in many rich but not well-worked-out claims like "In this way romantic art is the self-transcendence of art but within its own sphere and in the form of art itself" (*A*, 1:80) as well as in his claim that "for us" now, art provokes a philosophy of art, a "scientific treatment," and not so much a distinct aesthetic, sensual pleasure.

24. With respect to the working out of this use in the practical philosophy, see my discussion in Pippin 2008b.

Moreover, Hegel also notes that the situation of the modern artist (by which he means basically late romantic art) has liberated the artist from the burden of any dependence on a received national or artistic tradition. There is nothing any longer in either sense that the artist is *bound* to take up, on pain of falling outside what is recognized as conforming to the norm, art. As Hegel says frequently in the *Lectures* (in ways that almost sound like a celebration of postmodernism), for the contemporary artist, anything from the past is available, any style, tradition, technique, any theme or topic.

IV

Admittedly, these suggestions about Hegel's relevance come at the price of reconfiguring some of Hegel's own formulations. There are two serious divergences and both have to do with inherent, finally irresolvable tensions in Hegel's account.[25] That is, such divergences are necessary if the core of Hegel's approach is to be rendered coherent. The first concerns something I want to count as a great virtue of his approach: the absence of an essentialist approach and the promotion of a historicist approach. Art, in other words, is not a natural human kind, no more than opera or film is. It is a practice invented under certain conditions, sharing properties with other similar practices, like decoration, political self-glorification, religious rituals, and so forth, but Hegel wants to count it as a distinctive practice. Its norms are collectively self-legislated over time; in other words, in the same basic way that the rules for a game could be formulated collectively over time. (For example, one of Hegel's most intriguing claims in his *Lectures* is that painting, as we understand it, a fine art, not decorative, not a work of craft, nor ultimately a religious enhancement of worship, is possible only in a Christian culture, with its understanding of the relation between inner and outer.) Such rules are not, though, arbitrarily or merely contingently formulated, and they even

25. There is also a very broad third issue, which I will not be able to deal with here. This concerns Hegel's own "recuperation" of art (apparently an issue only in the late lectures on art) as what he calls "objective comedy" and as an art with "Humanus" as its central subject. His paradigm for such a possibility is Goethe's *East-West Divan*. The problem is how Hegel tried to think through his own characterization of the modern age as "prosaic" and so not a fit subject for poetry, except for a certain kind of comedy. As usual, the best account of the various dimensions of Hegel's thoughts about "art production in the terminal phase of art" (*Kunstproduktion in der Endzeit der Kunst*) is Henrich 2003a, 90–111. An invaluable, complementary but different analysis, in effect from the point of view of the *Divan*, is Wellbery 2009. For Henrich's own reformulations of basic principles in Hegel's project in order to help Hegel out of the dead end he seems to have gotten himself into, see Henrich 2003a, 135ff.

can be said to have a kind of internal necessity, given the large-scale project of self-knowledge attributed to Hegel earlier and the indispensability of some form of "intuitive" (*anschauliche*) understanding (or, perhaps, an intuitively oriented conceptual comprehension). That is, Hegel may think that there are a priori reasons for there *being* art, such as the reason just cited: any adequate understanding of the Absolute must include an intuitive-sensible-affective mode of understanding. (Without this, any understanding of the Absolute would not be complete.)[26] But the spirit of his enterprise should mean that there cannot be any a priori reason to exclude postromantic art from the tradition of art. It would obviously be more consistent to say that art *can come to be* something quite novel under the novel historical conditions of modernity, perhaps so novel as not to be recognizable to anyone in the prior tradition as art. (Put another way, the answer to the question of why artists could at some point no longer credibly *be* romantic artists has something to do with their self-understanding being insufficiently modern. For that we had to wait for Manet.) The fact that Hegel thinks that any art that does not conform to what had been understood as the task of an intuitive manifestation of the Absolute should no longer be counted as of any strong importance not only betrays an odd, inconsistent essentialism but blocks a consideration of the fairly natural way that his remarks about the fate of romantic art open up onto the distinctive features of modernist art, as his own remarks about a new "philosophical treatment" suggested.[27] (The *extraordinary* difficulty of this position, the more historicist one, is that we still want to be able to retain the ability to say that something can, in some historical period, "pose" as art and yet not be art, that it can be produced and viewed as art, be treated as art by the relevant authorities, and yet still not be art. For some, doubts about whether we can make such a claim begin long before Duchamp or Warhol. The question arises for some already with Kandinsky, Malevich, and Mondrian. And it is a fair question.)[28]

26. Understanding the radicality of Hegel's historicist (anti-essentialist) approach is also the central issue differentiating this (my) kind of interpretation of Hegel's possible relevance to post-Hegelian art from Henrich's, who sees much more limited possibilities. This is demonstrated in compelling detail by Donougho 2007a. Also, for an interesting discussion of the relation between the strains of essentialism and historicity in Hegel (with reference to Danto's theory), see Hilmer 1998.

27. I try to demonstrate these affinities in what can be taken to be the extreme and, in all traditional views of Hegel, most implausible case: abstraction in modern painting. See Pippin 2002. For a response to (and interesting criticism of) this suggestion, see Donougho 2007b.

28. For evidence that Hegel wanted to maintain the art/non-art discussion, especially with regard to the novels of Jean Paul, see the manuscript citations by Rutter 2010, 20ff. Rutter's discussion of Hegel on, in effect, bad art, pre-art art, non-art art, and anti-art art is also very helpful.

The second revision required to make Hegel more Hegelian involves passages like the following:

> Art by means of its representations, while remaining within the sensuous sphere, liberates man at the same time from the power of sensuousness. Of course we may often hear favorite phraseology about man's duty to remain in immediate unity with nature; but such unity, in its abstraction, is purely and simply rudeness and ferocity, and by dissolving this unity for man, art lifts him with gentle hands out of and above imprisonment in nature. (A, 1:49)

There is nothing problematic or in tension with other things central to Hegel's project to say that art is one of the ways in which the hold of any notion of being in some way *nothing but* natural creatures, burdened by a biological destiny, or, as he says, "befangen" by a fixed species essence, is transcended. But in these and many other contexts, he does not qualify his remarks this way and seems to speak instead of a liberation from our sensible embodiment altogether. The idea of being wholly liberated from a nature-prison is obviously quite a nondialectical notion and would make understandable, but not persuasive, some sort of claim that we have reached a kind of self-understanding that transcends our need to understand ourselves "aesthetically" at all, as corporeally embodied, to understand ourselves sensorially.[29] And a person with such a view might argue that, given this achievement, we no longer find the primarily sensual experience of ourselves—perceptual, affective, passionate—as important or central. (It is perfectly Hegelian to conceive of a "history of the senses.") That is, the more extreme, triumphalist readings of the end-of-art claim (we don't need art as such anymore) presuppose this undialectical, rather than a more properly Hegelian, formulation. Hegel's confidence that art itself has been transcended, rather than that our current self-understanding requires a radically altered form of art, is clearly tied to such unqualified remarks about liberation from a natural prison. So "breaking free" of the myth of the given in empiricism, the myth of immediacy in romantic intuitionism, the dualistic myth of mental states causing bodily motions, or the myth of self-reductive naturalism, and so forth is not, cannot be, breaking free of our own sensible embodiment. What we need is a new intuitive-affective understanding of such an em-

29. In the same way, we obviously, no matter our level of philosophical self-knowledge, do not cease to be corporeally embodied beings, and the "affective-sensible" meaning of such corporeal experience would then still be a concern, especially under changing historical conditions, conditions Hegel could not have imagined. Even abstract painting is, after all, the expression of abstraction *in a sensible medium*.

bodiment consistent with the sort of freedom we have achieved (or failed to achieve).

And this is an indication of a blind spot in his treatment of modernity, his failure to anticipate the dissatisfactions that this "prosaic" world (as he often called it) would generate, or his failure to appreciate that there might be a basic form of disunity or alienation that his project could not account for, for which there was no "sublation" or overcoming yet on the horizon. The duality is basically the same one he had been worried about since his Jena period; in the lectures on aesthetics he puts it in terms of a very striking image:

> Spiritual culture, the modern intellect, produces this opposition in man, which makes him an amphibious animal, because he now has to live in two worlds which contradict one another. The result is that now consciousness wanders about in this contradiction, and, driven from one side to the other, cannot find satisfaction for itself in either the one or the other. (A, 1:54)

It is striking to note that Hegel does not say here that human beings have been and always will be such "amphibious" animals; rather, he says that "spiritual culture, the modern intellect" (*die geistige Bildung, der moderne Verstand*) has "produced" this wandering soul. Such a state of being is a historical phenomenon. This claim returns us yet again to a decisive aspect of Hegel's treatment of "the problem of the Absolute" that we have been stressing. The problem our amphibian faces is not a metaphysical problem about substance, how immaterial and material could interact. We have produced such a being (*der ihn zur Amphibie macht*), and so the problem our subject faces is not the proper philosophical account of interacting substances, hylomorphism, emergent properties, or anomalous monism, but a problem of "satisfaction" (*Befriedigung*). This in effect redefines the problem rather than addresses it in its conventional form. How can a subject of thought and deeds that always experiences itself as beyond or more than its material states come to any resolution about who or what it actually "is"; how can it find satisfaction in the absence of any such resting place like its biological species-form?[30]

The premises for this sort of treatment by Hegel are quite complicated, both historically and systematically. Basically, Hegel is not treating the German Idealist problem of the Absolute—the account of a possible subject-object identity, how subjects can also be objects—as a problem of some prior ground (of the original unity of both) to be recovered in some intellectual intuition or aesthetic experience. He follows Schiller instead in "reversing" the direction

30. For a fuller account of how Hegel understands the relationship between consciousness and its material embodiment, see my discussion in Pippin 2011a.

of the question, forward, not backward, where subjectivity is understood as a status, a mode of comportment toward each other and the natural world "to be achieved"; such a status and practice reconcile and integrate our experience of ourselves as sensible, material creatures as well as minded and active beings. Schiller's useful example is one Hegel also occasionally uses: romantic love, and especially romantic love in the family, which is neither the mere imposing of an ethical form on to sexual need nor a merely instrumental strategy for the satisfaction of such a need. Everything in this tradition of philosophical value comes down to the proper understanding of such a formality-materiality relation (neither is what it was understood to be outside of their interrelatedness), but what we need now is a general sense of this notion of a reconciled "*Geist*" *as an accomplishment*. Or, as Hegel says frequently, *Geist* is "a product of itself."[31]

But Hegel also, repeating in a different register what I am saying is his cardinal error, now insists, in spite of these "amphibian" remarks, that philosophy (and only philosophy) *has* succeeded in overcoming this tension, and it is under that assumption that he ascribes to art the task that leaves so little room for much with any life or interest in it:

> Against this we must maintain that art's vocation is to unveil the *truth* in the form of sensuous artistic configuration, to set forth the reconciled opposition just mentioned, and so to have its end and aim in itself, in this very setting forth and unveiling. (*A*, 1:55)

If we change the key word in the quotation to "unreconciled," as, by any reasonable account of modernity, we must, a different picture of a possibly modern art opens up.[32]

V

But to appreciate Hegel's relevance, consider again the "Manet moment," first in the light of traditional accounts of the beautiful and of art prior to Hegel and then from the perspective of Hegel's very different suggestion.

It is immediately apparent that philosophical aesthetics from Plato to Kant and Schiller is pretty much helpless with paintings like those by Manet, and

31. E.g., Hegel 1978, 1:6–7.

32. This is also connected with his apparent reluctance to consider any possible form of aesthetic expression of the realization of human freedom other than a figural painting of recognizably human figures and deeds; his reluctance, that is, to consider a possibly nonfigurative "expression" of possibly new strategies in the struggle for the realization of freedom in a natural or material world. Appreciating this, I want to suggest, will help at least a bit in trying to answer our Hegelian question about modernism.

eventually by Cézanne and Miró and Picasso and Pollock. Clearly the tone of both of Manet's original, revolutionary paintings is far from idealizing; if anything, it is anti-idealizing, even ironic. There is no serious attempt at verisimilitude in the depiction of the sensual properties (Olympia's skin has nothing of Titian's lush, pink, living quality; it even seems a bit dirty, almost dead)[33] and so no invitation to any experience of sensual-intellectual harmony. Indeed, in the case of both paintings, there is a reference to past paintings that do clearly aspire to the ideal of the beautiful. For *Olympia*, it is Titian's *Venus d'Urbino*; and for *Luncheon*, Marcantonio Raimondi's print after Raphael's now lost *Judgment of Paris*.[34] But calling those references to mind only serves to highlight the fact that Manet's paintings do not share that idealizing aspiration. As we shall see with more examples in a moment, the effect of the paintings is rather something like cognitive or musical dissonance, almost as if both paintings were intended as a kind of affront or at least challenge, "turned" in toto *toward* the beholder with a strange, flamboyant indifference to that beholder.[35] In a striking departure from what Fried has called the absorptive tradition of the eighteenth and early nineteenth centuries, the subjects in Manet's paintings often look out of the picture frame toward the beholder, inviting what would have been "theatricality." But the uncanny effect of this "facingness," as Fried calls it, is that such beholders—us, *standing right there*—are as if invisible or at the least irrelevant, occupying no important presence in the subject's vacant or bemused look. This absence of even the possibility of mutuality (between the subject of painting and the beholder) suggested by this invisibility or irrelevance—not its simple failure, not just misrecognition (and the air of unmistakable unease that this creates)—is what helps to suggest the incomplete and fragmentary atmosphere in many of the paintings. And while there are elements of great beauty in Manet's work, and a kind of pleasure in the sheer boldness of the painting, the romantic categories, even the whole notion of the beautiful, all seem simply beside the point.

But what *would* be, then, the point?

33. Cf. Hegel's remark: "Thus the truth of art cannot be mere correctness, to which the so-called imitation of nature is restricted; on the contrary, the outer must harmonize with an inner, which is harmonious in itself, and, just on that account, can reveal itself as itself in the outer" (*A*, 1:155).

34. Fried (1996, 515n56) establishes another important and neglected (or hitherto-unknown) source for *Olympia*: the Jacopo del Sellaio *Venus*, originally thought to be a Botticelli *Venus*, and he reprints an interesting discussion of it by Manet's friend, the critic Zacharie Astruc. Astruc's striking remarks about Venus's gaze call the *Olympia* issue immediately to mind.

35. This is a point (about the painting's "facingness") made in detail in Fried 1996. There is an interesting discussion of Manet's effect as a kind of disorienting combination of both the beautiful and the sublime in Pile 2004.

I am tempted to rest my whole case for the relevance of Hegel to these questions on one passage from the *Lectures*:

> So, conversely, art makes every one of its productions into a thousand-eyed Argus, whereby the inner soul and spirit is seen at every point. And it is not only the bodily form, the look of the eyes, the countenance and posture, but also actions and events, speech and tones of voice, and the series of their course through all conditions of appearance that art has everywhere to make into an eye, in which the free soul is revealed in its inner infinity. (*A*, 1:154–55)

The idea that visual art can be said to transform the surface of every object, even the appearance of actions, events, speeches, and so forth into a thousand-eyed creature is also a claim that the reception and appreciation of the work should be understood not as an inspiring intimation of the ideal nor as the occasion of an inner harmony or unusual, disinterested pleasure. After all, even when confronted by a *two*-eyed creature, the task of figuring out what is revealed in someone's eyes is obviously not straightforward. It can be much more difficult than understanding what that person says. A response appropriate to the ambition of the work thus must be an interpretive accomplishment of sorts, one that begins in some interrogative, not merely receptive or affective or even contemplative, relation to the object, a feature of the aesthetic experience that Hegel suggests is spectacularly more difficult than often appreciated because it imagines an artwork as a *thousand*-eyed Argus. (Early on Hegel had characterized all of art in a way that can sound like boilerplate unless we note how unusual the formulation is: "it [the work] is essentially a question, an address to the responsive breast, a call to the mind and the spirit" [*A*, 1:71].) Such an attempt must be responsive to evidence but can never be settled by any fact of the matter, can always remain open, and contentious.

Moreover, the image itself suggests that we think of the difference between seeing a painted surface in an artwork and seeing the object itself as like the difference between seeing a person, or a person's face, *as an object* like any other and seeing it as a *face* of a person, requiring a completely different relation between beholder and beheld. This also suggests again that there is a deep connection between understanding meaningful conduct, actions, and expressions of persons and understanding expressive meaning in artworks.

And this all at least suggests something more determinate about the distinct category of sensual and especially visual intelligibility that Hegel has tried to differentiate from what he calls "representational" and "conceptual" intelligibility in religion and philosophy. Such a form of discrimination, obviously of great relevance to pictorial intelligibility, is certainly not, cannot be, nonconceptual in Hegel's account, but the modality of its less determinate

conceptual determinacy addresses the beholder in a unique and, as he says, interrogative way. Perhaps one way of understanding Hegel's point is to call to mind a feature of social interaction quite prominent, interestingly, in many modernist novels: the suggestion that there is a unique form of visual intelligibility in the human face. In Proust's novel, Swann can see "in" Odette's face that she is lying about an assignation. He does not see some evidence, on the basis of which he makes an inference. He is said to see the lie in her face. Or in a conversation in a Henry James novel, a character A can see in the face of character B not only that B knows that A has revealed some confidence, but that B knows that A knows that B knows. And again, whatever this form of intelligibility is, it is not inferential, is in some literal sense "seen," and is at work when a painting arrests us, compels our attention, and raises the kind of "question" Hegel has noted.

That is, as Hegel understands it, the making and especially the displaying of artworks cannot but express an underlying assumption about the possibility of some public, shareable meaning and so involves the status and role of the beholder, any putative addressee of such an expression of meaning. (The satisfaction of these conditions would form the basis of any criterion of aesthetic success.) This assumption would have to be congruent with assumptions about agency (a possibly public meaning embodied in bodily movements) and about those for whom such a "display" is intended, at least on the assumption that such a performative and public dimension is at the heart of Hegel's account of subjectivity in agency.[36] And given the way Hegel approaches such questions, we have to say that he means the satisfaction of these aesthetic and performative conditions *at a time*—that is, in our time, under the conditions of modernity.[37]

If this is a feature of art as such, then it might also be said that under some historical conditions the capacity to fulfill these requirements, in *both* its manifestations (social and aesthetic), could come to be experienced as deeply problematic or at least a great deal more difficult, requiring a different sort of relation between beholder and beheld, agent and others, than ever before, a new relation that is more an aspiration than a presentiment. Then,

36. I defend this claim at length in Pippin 2008b.

37. The conditions of agency are thus understood as a social status instituted and sustained by a community at a time. These conditions—who can be counted an agent, what may be attributable to an agent, how far the scope of an agent's responsibility extends, and so forth—vary as much as, and in a way deeply connected with, the conditions of aesthetic success. Pinkard's (1996) notion of what he calls "the social space" of such agency and "assuming positions" in such space are important ways to understand what Hegel is getting at, and for the relation between that theme and the problem of nature, see Pinkard 2012.

something like the resistance of much modernist work to conventional ap-
preciation and interpretation, the unfamiliarity and opacity we often see in its
thousand "eyes," can be understood as something like the culmination of this
difficulty, now made much more explicitly self-conscious and insistent, and
so is responsive to altered conditions of such public intelligibility. The same
could be said, mutatis mutandis, for the aspirations of much of modernism to
forge a new and revolutionary understanding of these conditions, to *demand*
that we understand each other, and thereby understand and appreciate art,
in a new way. This is the Hegelian link I want to insist we should retain in an
aesthetic theory, even if we abandon Hegel's triumphalism.

And, to make the point in a more literal, rather than figurative, sense, where
else is the beholder's eyes drawn in the two Manet paintings than to the face
and expression of the two naked women? Both expressions seem opaque to and
even somewhat contemptuous of the beholder's own gaze, raising the stakes
considerably in trying to answer "what is expressed in their eyes." This sort of
question (and its obvious relation to "What is expressed in the painting, in its
'face'?") is particularly important in Manet because there is so often an air of
mystery and opacity in the expressions of his subjects in several different con-
texts and in the unusual settings, a challenge that resists direct, immediate un-
derstanding, as if designed to prevent now-inappropriate conventional "read-
ings." Some of these are quite famous, of course, like the fatigue and especially
the vacancy in the expression of the girl in *A Bar at the Folies-Bergère* (figs.
2.7, 2.8; pl. 3), but these "eyes" are everywhere in Manet (figs. 2.9–2.14).[38] Once
that issue is dramatically in play, every other aspect of the paintings becomes
a question (in Hegel's terms, "an eye," a face) in the same way: why naked at a
picnic, why are the men talking to each other and why do they seem to ignore
her, what does the position and gesture of Olympia's left hand mean, what
effect does the presence of the maid and the presentation of the flowers have,
why a black cat, the flowers?[39] And finally: under what historical conditions
would this aspect of a painting's meaning (a kind of allegorized puzzled resis-

38. To be sure, this characteristic, what the French critic Chesneau in an 1863 essay called
"looking without seeing," turns up in other French realists too. See the citation of the essay and
discussion in Fried 1996, 74ff. And I do not mean to suggest that Manet had any copyright on
such looks. See Whistler's *White Woman* and, later, Degas's *Le café, ou l'absinthe*. It is the extra-
ordinary repetition of the theme in Manet that makes it almost a mythological donnée. See Fried
1996, 74, on the "looking without seeing" theme in many realists.

39. We must not of course be *too* literal. Hegel's claim is that painting turns *every* surface
into an eye. As we shall see, sometimes a direct address to the beholder, by its attempt to direct
and determine the beholder's understanding, can obscure much more than reveal (it "theatrical-
izes" the encounter). More on this in the next chapter.

FIGURE 2.7. Édouard Manet, *A Bar at the Folies-Bergère*, 1881–82.

tance to direct appreciation, even a somewhat contemptuous challenge to the
beholder's expectation of meaning) become so thematized and problematic?

VI

One reads frequently that the issue in modernist painting has a great deal
to do with "the problem of subjectivity," and this certainly seems connected
with the problem crudely sketched before as the German problem with "the
Absolute."[40] Such a problem certainly has something to do (in painting after
the Renaissance) with working out what it means in the modern age to paint
gallery pictures for beholders, what assumptions about the mindedness of
beholders (their expectations about interpretability and meaning) and the
portrayal of human mindedness in the painting are relevant, now that vari-
ous institutional contexts and assumptions no longer inform the interaction
between painting and beholders as they once did. And the same was true in
the rapidly changing context also expressed in modern drama, poetry, and
philosophy. (This is the country in which Michael Fried works and it is every-
where relevant to these concerns. It is perfectly consistent with Fried's art-

40. See Henrich 2003a, 70ff.

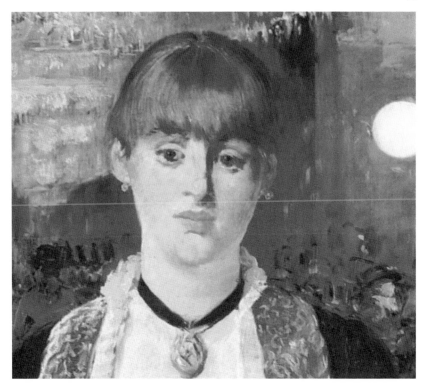

FIGURE 2.8. Detail from *A Bar at the Folies-Bergère*.

historical project to emphasize not only this theme as a visual motif—*what is it* to be a minded corporeal being, what, in a sense, *does it look like*—but, as here, that this status can change and even have degrees of attainment and begin to fail.) It certainly has something to do with the appropriate portrayal of the mind-world and subject-subject relationship in perception, reflection, and action.[41]

I have claimed that we can begin to develop a Hegelian understanding of post-Hegelian art if we take into account his project as a whole and appreciate the limitations of his diagnosis of the state of modern societies. So *what*, in his terms, did he fail to see, and how is that apparent in an art that, thereby, he could not have appreciated? Here is one of his most sweeping characterizations of the state of late romantic art, art in the process of becoming *ein Vergangenes*:

41. None of these problems is merely an isolated intellectual puzzle; the formulation of the problem and various of its dimensions have histories and contexts that implicate many other issues as well.

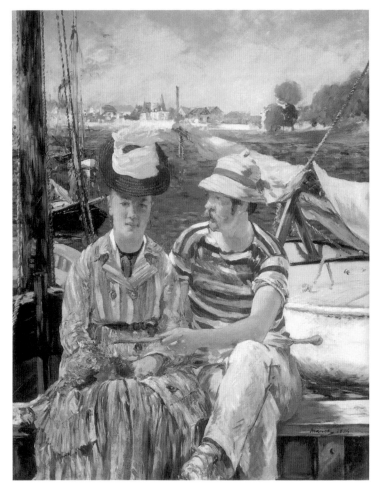

FIGURE 2.9. Édouard Manet, *Argenteuil*, 1874.

Yet there is something higher than the beautiful appearance of *Geist* in its
immediate sensuous shape, even if this shape be created by spirit as adequate
to itself. For this unification, which is achieved in the medium of externality
and therefore makes sensuous reality into an appropriate existence [of spirit],
nevertheless is once more opposed to the true essence of spirit, with the result
that spirit is pushed back into itself out of its reconciliation with the corporeal
into a reconciliation of itself with itself. (*A*, 1:517–18)

It is already controversial to suggest that this is even on the right track.
There are many—Adorno, for example—who argue for some retrieval, or
memory, of sensuous particularity as the proper function of modernist art
and who see in such statements the signs of "identity thinking." I agree with

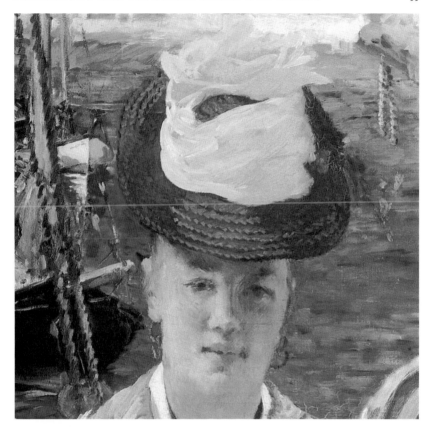

FIGURE 2.10. Detail from *Argenteuil*.

Hegel, though, that this would be romantic regression and is not borne out in the trajectory of modernist art. But what then is spirit's "reconciliation of itself with itself," such that the failure of this reconciliation illuminates anything about painting after Hegel?

In the painting tableau we are restricted to the visible surfaces of things under certain conditions of light and shadow, or human faces and bodies, frozen in moments of time in action. If the tableau depicts people, then the question of the meaning of what they are doing, simply the right act description, arises immediately. We are usually aided by the title, the names of the persons portrayed, and perhaps some standard biblical or historical setting. But we must try to understand various gestural moments and something about the organization of the space within the picture frame. (Why just *that* way?) As was noted in discussing the Argus passage, to a certain, very general extent, we can say that the complex relation between the materiality of paint itself and painterly meaning mirrors or echoes the relationship between visible cor-

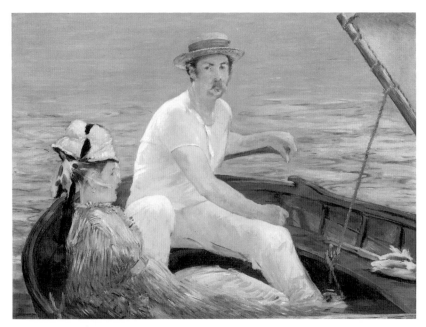

FIGURE 2.11. Édouard Manet, *Boating*, 1874. The Metropolitan Museum of Art, H. O. Havemeyer Collection, Bequest of Mrs. H. O. Havemeyer, 1929 (29.100.115).

poreal surface and human intentionality generally. (And it will give rise to the same skeptical problems.) We can say that we "take" the painted surfaces that we see to mean what they do in something like the way we comprehend the mindedness we take to be expressed in corporeal movement and visible facial surface. And again, the way we do so is not fixed as a kind of eternal Platonic problem. We ascribe intention, motive, reaction, and purpose in ways broadly governed by norms at a time. In the most obvious case, coming to see persons not as primarily instances of psychological types or representative of family destiny, or as exemplifications of a natural social class, but as absolutely distinct individuals first and foremost is an ascription of meaning with a complex modern history.[42]

 This ascription of meaning is not an inferential or two-stage relation. We don't see bodily movements and then infer intentions, any more than we see painted canvases and infer represented objects and intended meaning. But such intelligibility is a conceptual articulation that is an *achievement* of some sort; understanding what we see is always in some sense provisional and re-

42. For a compelling example of the kind of historical and analytical work necessary to understand the painterly representation of such a notion of individuality, see Koerner 1997.

FIGURE 2.12. Detail from *Boating*.

visable (especially, contestable with others), and that characteristic is an as-
pect inherent in seeing or understanding itself. (Kahnweiler's phrase, from
his 1946 book on Juan Gris, about a "peinture conceptuelle" is relevant here;
see Gehlen 1960, 59.) In the simplest sense, *not being able to do this with any
confidence* is what it means for there to be no "reconciliation of *Geist* with
itself," no confident self-understanding in the face of contesting claims or in
the face of a confusion about how, in such a world, even to begin to try to
achieve such an understanding. So the "weakened presence" of animated sub-
jectivity in those expressions is not a sign of some discovery about *the* absence
of human subjectivity in favor of merely corporeal bodies but the failure of
the historical world to allow for the realization of such subjectivity in the only
way it can become actual.

 Summarized one last time, I am suggesting that Hegel is asking us to
understand the historical and social dimensions of the production and ap-
preciation of artworks in the way that he understands the social meaning of

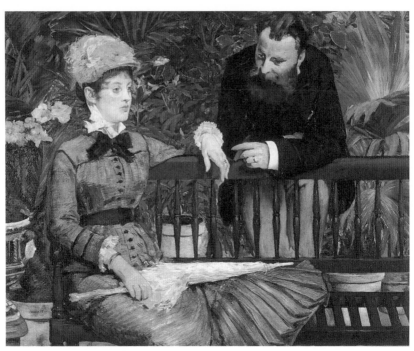

FIGURE 2.13. Édouard Manet, *In the Conservatory*, 1879.

individual actions (and, especially in this context, vice versa). We are willing to concede (or at least more willing to concede in this case) that an artwork can be said to embody "the artist's intentions" (what she must have intended given what is there) in a way not necessarily tied to what explicit intentions the artist herself might have been able to formulate, and we understand that artworks mean what they do only with the institution of art in a society at a period. There is, of course, great commonality across epochs and societies, but we also struggle with historical works to understand what they meant at a time, in an "age," as well as for us. I think it is clear that Hegel thinks of actions as also having such a public, performative, and so sociohistorical dimension. (Something like the realization of this is what "turning" the painting plane and the expressions of the depicted subjects so confrontationally toward the beholder raises as a challenge.) This feature means that agents can sincerely avow intentions that are not "in" or are even contradicted by the deed (as that deed comes to mean what it does for others at a time) and that individual agents no more own the appropriate act description for what it is that they have done than artists have such proprietary relations over the meaning of what they have produced. To be beset with such worries is to fail to achieve "reconciliation with oneself."

FIGURE 2.14. Detail from *In the Conservatory.*

In this context, we might say that just to the extent that under new, rapidly changing historical conditions we come to be more dubious, unsure, confused about *the sense we make* in seeing intentions "in" deeds (the less confident we are that we know how to do this), the less stable we might also expect the conventions governing pictorial success to be. The mark of this challenge and this difficulty is captured in those vacant looks in so many Manets and in many other paintings and in the implicit paradox that, on the one hand, the subjects are looking at the beholder (or out of the picture plane in the general direction of the beholder's space), but, on the other hand, they seem to have no hope in a beholder's response; some even "confront" the beholder but as if he or she were not there, as if they do not expect, could now not expect, anything satisfying in return. (By "success" in this gesture I mean that the modernist equivalent to beauty as the "promise of happiness" is this *promise of meaning*, perhaps under ever more intense pressure.[43] In these paintings, it

43. I do not think that the significant hermeneutical demands placed on the beholder by this painting (and every painting by Manet for that matter) should be understood as setting up the sort of dichotomy that informs Nehamas 2007, between a critical-analytic or judgmental re-

is a promise that frames the paintings but is not, perhaps cannot be, realized within such a frame. That appears to be the point.) An apt name for what it means to *fail* to acknowledge and appreciate this situation properly is the one made such fruitful use of by Fried: Diderot's "theatricality"; a brilliant early exposition of the increasingly unsecured nature of mutual interpretability is Diderot's *Rameau's Nephew*.[44]

But Hegel himself, in his greatest failure, never seemed very concerned about this potential instability in the modern world, about citizens of the same ethical commonwealth potentially losing *so* much common ground and common confidence that a general irresolvability of any of these possible conflicts becomes ever more apparent, the kind of high challenge and low expectations we see in all those vacant looks. As we have seen, he does not worry much because of his general theory about the gradual actual historical achievement of some mutual recognitive status, a historical claim that has come to look like the least plausible aspect of Hegel's account and that is connected with our resistance to his proclamations about art as a thing of the past.

It is, of course, not yet clear *why* such a difficulty or instability has arisen. A cautious and reasonable inference might appeal to features that will be prominent in the next chapter: the inevitable—inevitable because of the demystifying, disenchanting, secularizing dynamic of modernity—emergence of a logic of social subjectivity in which the starkness or nakedness of relations of independence and dependence is ever more visible, unhidable, and, in various novel ways, resisted (subjects who engage others as objects; who allow themselves to be, or refuse to be, treated as objects). The ethical forms of material life that Hegel counted as successful mediations of the basic tension inherent in our amphibian status—our naturalness and our mindedness— forms like contract, crime, police, morality, corporations, estates, and legisla-

sponse and a "passionate engagement" response, as if we could "opt" for the latter instead of the former. (For one thing, a passionate engagement with *what*, exactly? What intentional content?) As noted in the previous chapter, we are caught up in the same complexity every day simply in trying to understand our own or another's mindedness, and this in a way often suffused with a "passionate" interest. The palpable strangeness and anxiety in modernist paintings would not be comprehensible otherwise.

44. There is no question that Hegel was familiar with Goethe's translation of Diderot's *Essais sur la peinture*. See Stemmrich and Gethmann-Siefert 1986, 139–40. And, of course, the treatment of *Rameau's Nephew* in his *Phenomenology* makes clear how interested he was in that book. I have tried to show the link between this general issue and literary modernism (and so a way of acknowledging and living out this situation without skepticism or despair) in studies of Henry James (Pippin 2004), Proust (Pippin 2005c, 307–38), and film (Pippin 2012a).

tures, even "forgiveness," were not successful and proved inadequate to serve such a role, given the massive social consequences of societal modernization. In this context, what we can call the painting's refusal to be a "mere object *for the beholder*" is not a representation of this fact but an exemplification of it, a moment of such defiance, in some cases by mimicking and so challenging being *just* that.

Since freedom (also known as "self-reconciliation") in Hegel's expressive account has to do with an ability to "see myself in my own deeds," to experience them as legitimately mine, to stand behind and defend them, a growing skepticism or uncertainty about being able to do this (even about the simplest self-understanding) might be expected to cast its skeptical shadow on various other forms of embodied expressions of human meaning. This is what it is to see what Hegel missed, but see it in *his* terms, and make use of that to understand the conditions of modern painterly meaning.[45] Hegel's sense of the successful resolution of the question raised by trying to understand someone's deed or by the question posed by a thousand-eyed Argus has both a subjective and an objective side, a way of understanding both the provisional and unstable subjective side, the intention, motive, or reason, a meaning actual only in the deed (or the aesthetic object), and the objective social conditions of an age, especially the struggle for recognition inherent in social conflict and the ever more unstable interpretive conventions of modern societies. It is now generally acknowledged that Hegel's understanding of these objective social conditions was prematurely optimistic, but his explanation of *what we need to take account of* in understanding subjective intention and mean-

45. I take this as a response to Donougho's (2007b, 92) criticism that "despite Fried-Pippin's situating of art in a historically contingent 'grammar,' it remains obscure how that bears upon history in concrete and detailed fact (as opposed to generalized 'historicality')." For that matter, Fried's own detailed narrative of the fate of the absorption episteme already seems to me a clear answer to such a question about "detail." Fried's "presentness is grace" is not a kind of transcendent moment outside time, since the content and force and claim of presentness always have a particular historical shape. Everything about its achievement in Fried's account is deeply historically inflected and has quite a specific place in the narratives he provides. His account (2010, chap. 4) of the coincidence of the thematization of painterly address (and its relation to motifs of absorption) with the kind of dawning skepticism that Cavell describes as occurring in Shakespeare is a compelling example of such historically inflected analysis. That said, I doubt *any* narrative is ever going to get us fine-grained answers to Donougho's question. Exactly what (in a significant Hegelian sense, not just an internal art-historical sense) led from Impressionism to a moment in post-Impressionism, and why the Nabis or Blaue Reiter *just then*, does not seem a fair demand placed on the approach. (I am also trying to respond as well to Donougho's worries in this piece about Hegelian intersubjectivity.) See Gehlen's (1960, 14–15) remarks, which seem to me quite reasonable.

ing and his insistence on a link with the objective conditions remain a kind of modern fate, and one that needs to be set inside the later context of the fractured and prosaic character of the emerging, industrialized, bourgeois, eventually consumerist nation-state world coming into view in the nineteenth century.[46] We get an "intuitive view" of the result in different ways in different nineteenth-century painters "after the beautiful."

46. See also Gehlen's (1960, 94ff.) remarks on this issue.

3

Politics and Ontology:
Clark and Fried

It was the moment in the history of the art of painting
When the weight of the broken water rushing out to sea exactly counter-
balanced the force of the waves rushing in.
"*Le déjeuner sur l'herbe*" for T. J. Clark
(Fried, *The Next Bend in the Road*)[1]

I

Many commentators have noted that in Manet's pictures of the 1860s and
beyond, the hard-won discoveries of modern painting since the Renaissance—
vanishing point and aerial perspective, the sculptural modeling of figures to
evoke solidity, a variety of conventions about pictorial composition, and so
forth—are not simply ignored by Manet but, one seems compelled to say, at-
tacked by him in a way that understandably confused almost everyone. Many
agree with T. J. Clark that "something decisive happened in the history of art
around Manet which set painting and the other arts upon a new course" (1999b,
10), but there is much less agreement about what happened. The negative mo-
ment, the fact that it seems that Manet *opposed* or objected to or is actively
rejecting these conventions, is prominent in many accounts. Georges Bataille
claimed that "Manet has a place all his own in the history of art. Not only was
he a very great painter, but he cut himself off from the painters who preceded
him, opening up the age we live in today, the age we call Modern Times" (1955,
15). Contrastingly, Michael Fried has demonstrated the extraordinary extent
of Manet's involvement with and citation of the great art of the past, but he
goes on to show that Manet and his co-generationists were concerned with
"not only a systematic connection with the art of the past but also a drive to
establish *a new type of connection with the beholder*" (1996, 21, my emphasis).[2]

1. See Bann's (2007, 46–58) interesting use of Fried's whole poem as a way of framing the
interpretive problems raised by Manet's *Luncheon on the Grass*.

2. Actually, the situation described by Fried is typically quite complex. Fried argues that while
Manet's art of the first half of the 1860s "may be seen as an attempt to reclaim the past, to re-

Jean Clay goes so far as to say that "Manet does not have a style; he has all of them" (and so Manet's oeuvre is "indescribable"), that there are elements in Manet "of inventing painting while also destroying it," and that Manet "would not be a painter. But discrepancy at work in painting" (Clay 1983, 8–9). Stanley Cavell, citing Fried, claims that "painting, in Manet, was forced to forego likeness exactly because of its own obsession with reality, because the illusions it had learned to create did not provide the conviction in reality, the connection with reality, that it craved" (1979, 21). For Clement Greenberg, the foremost critic of modern art of his time, Manet began the "positivist" reduction of painting to its essence: flatness and the delimitation of flatness. According to him, "Manet's became the first modernist pictures by virtue of the frankness with which they declare the flat surfaces on which they were painted" (1995, 86). Michel Foucault (2010, 28) speaks of the deep "rupture" in painting that is Manet and then emphasizes most of what attracts Greenberg's interest: flatness and the visibility of paint. Theodor Adorno notes that with Manet and painting after him, we have the "emergence of radical modern art," an "opposition" to "traditional rules of pictorial composition" (1984, 291), and so the "paradox" in modernism that "all art is no longer self-evident to itself" (1984, 22). And there is Baudelaire's severe judgment in his famous Brussels letter to Manet: "you are only the first in the decrepitude of your art" (1973, 496–97).

One could extend such a list of citations almost indefinitely. What commentators are noticing is that Manet's paintings seem to declare that the norms of pictorial intelligibility and credibility established by conventional techniques had begun to fail and that what was required now was an approach that engaged and in some sense worked through not just the modern threats to pictorial intelligibility and the credibility of paintings but perhaps new, more general threats to the shareable intelligibility of human deeds altogether and even to shareable claims for the legitimacy of human practices as such. But what would it mean for such conventions to begin to fail? If so, was it only a matter of pictorial conventions? *Why* would they fail? Just how might that be visible in the most ambitious paintings of the age?

My argument in the last chapter was that Hegel can be considered *the* theorist of modernism in the visual arts (even if, as noted, *avant la lettre* and

possess it, and thereby to establish its presence in his art in a new way—explicitly, specifically, comprehensively," he also notes: "But there is also a sense in which that enterprise may be seen" as an attempt "to liquidate the past and so enter a new world. It is as though by 1860 the past of painting was no longer present as it had been, in continuity and return and revolution" (1996, 127). For the importance of Fried's concentration on Manet's sources, see the discussion in Bann 2007.

malgré lui), and this formulation is already a Hegelian way of putting the problem that modernist art raises—that is, posed in terms of *the conditions of visual credibility in painting* or the nature of painterly meaning (not in terms of beauty, pleasure, and taste). Although Hegel has a rather minimal theory of aesthetic experience (centered on the issue of the "liveliness" [*Lebendigkeit*] of the experience), he emphasizes much more the struggle to understand the work as the center of aesthetic intelligibility, and so he anticipates with remarkable prescience a central issue in what modernist art begins to demand of its beholders. For that art seemed to require a new form of sensible and intellectual engagement that Hegel's account of the inseparability of concept and intuition had already embodied, but the demand was made under a new and different sort of pressure, to the point of some sort of crisis, more extreme than Hegel could have imagined. This then suggests four other crucial dimensions of Hegel's account: (1) that these conditions of credibility (challenges to possible, shareable understanding) can change, (2) that these changes can be understood, are part of a continuous narrative ("the realization of freedom"), (3) that a proper understanding of the general sociality of meaning (not just linguistic meaning but how shared "embodied" meaning is possible at all) is necessary before we can understand such changes, and (4) that ultimately the aesthetic problem is a manifestation of the deepest problem in modern self-understanding, what Hegel called our "amphibian" status, our ability to understand ourselves as both corporeal bodies like all others and yet also meaning-making and reason-responsive subjects, not merely objects.[3]

Hegel had some sense that an epochal change in the institution of art was upon us, but he misread the situation as the end of art's world-historical importance, the end of the era of great art as an indispensable vehicle of human self-understanding. He famously thought that it had become a "thing of the past." He did so, I suggested, because he had no way of knowing how much more, rather than less, severe the incompatible strains of modern culture would become and especially did not anticipate that the institutions he believed would objectively realize genuine mutuality of recognition would fail to do so, rendering problematic the realization of freedom at the heart of his narrative. At a deeper level, Hegel did not sufficiently take into account the inherently unresolvable or perennial character of the problem of freedom, and because of that, he thought that something like the need for an "intuitive"

3. I will be formulating these issues in Hegelian terminology but there is considerable congruence with Fried's characterization in *Manet's Modernism* (1996) of Manet as standing somehow in between an earlier "corporeal," or bodily, realism in Courbet and the coming "ocular" realism in the Impressionists, where the latter figures our amphibian's *geistig* world.

comprehension of the Absolute could be overcome.[4] The question before us now is whether the course of painting after Manet can shed any light on such a problem and especially on what the aspiration of "spirit's reconciliation with itself" had come to mean, and what prevented it.

The situation, in other words, is similar to that sketched by Adorno:

> Hegel was the first to realize that the end of art is implicit in its concept. That his prophecy was not fulfilled is based, paradoxically, on his historical optimism. He betrayed utopia by construing the existing as if it were the utopia of the absolute idea. . . . Through the irreconcilable renunciation of the semblance of reconciliation, art holds fast to the promise of reconciliation in the midst of the unreconciled. (1984, 32–33)

But Adorno approaches this issue at such a level of abstraction that, with the exception of music, he fails to make much or frequent contact with the determinate and experiential dimensions of this crisis. (This abstraction is one of the reasons the ideal of utopia arises so naturally for him. The idea of utopia has nothing to do with Hegel.)[5]

In this chapter I want to consider two different but, I want to show, compatible and usefully complementary accounts of the crisis of credibility faced by modern painting (or whatever it is that can be called on to explain the radically different look of modern European painting after the mid-nineteenth century): those presented in works by T. J. Clark and Michael Fried.[6] These art-historical accounts reflect the fact that any understanding of the historical conditions for the shareable meaningfulness and credibility of easel paintings—now understood as involving a distinct mode of aesthetic intelligibility—must take into account both the "problem of the beholder," the question of *what it is like for a beholder* to confront the painting then and there, first-personally, experientially (and so what it is for the painting already to "presume" anything about such a beholding in its implied address to an audi-

4. In Hegel's formulation of his amphibian analogy he seems to presume that such a "wandering" creature is inherently a homeless and unsatisfied creature. Another way of understanding the image, though, would simply be to point out that there *are*, after all, amphibians, who live quite successfully with such a stereoscopic perspective. For further discussion of why Hegel's position should be understood as more consistent with something like an "unending" modernism, rather than anything "closed," see Pippin 1999.

5. Cf. Henrich 2003a, 130, on Hegel's "Verzicht auf Utopie," and Clark 2001, 306, on the modernist "nightmare" side of utopia.

6. On the complementarity issue, see Fried's (1996, 288) own discussion of how his and Clark's accounts might be considered two different sets of questions that nonetheless depend on each other.

ence), and the "objective" world of convention, social relationships of depen-
dence and attempted independence, distribution of power, and so forth, un-
avoidably presupposed and always already at work in any such first-personal
aesthetic perspective. The fact that both art historians raise the issue of Manet
and modernism in terms of both such issues and their interconnection, with
Fried emphasizing more the former dimension and Clark the latter, is what
provides such a clear link with the Hegelian concerns we have been track-
ing. (In the next chapter, I examine an influential position that launches this
whole set of issues into an almost unimaginably ambitious, sweeping account
of any such conditions for meaningfulness as such, one that claims to tran-
scend [and to provide the basis for a criticism of] both these subjective and
objective dimensions: Heidegger's position in his 1936 lecture "The Origin of
the Work of Art.") The approach I am suggesting will make reference to what
are for me the two most powerful and carefully worked out accounts of the
issues posed in this Hegelian way. The idea is that both Fried's and Clark's
narratives implicitly address, by means of extraordinary readings of central
paintings of the era, the "Hegelian" struggle to achieve genuine mutuality of
recognition (and so the realization of freedom), in both its institutional and
its more existential manifestations (even though neither has formulated the
issue in those terms).

A claim for the compatibility and complementarity of these accounts also
raises another large issue that I can only mention here. It can best be ex-
pressed by reference to the basic antinomy in Adorno's aesthetics—on the
one hand, his continuation of the attempt to regard artworks as connected
to and potentially in a critical relation to the sociohistorical reality of the age
and, on the other hand, especially in his account of music, his insistence on
something like the formal purity of the modern aesthetic as such, autonomous
and self-defining. (On Adorno's account, only this autonomy allows a purely
aesthetic expression of distance from, and so implicit rejection of, absolute
noncomplicity with, the consumerist exchange values of the modern age.)
This is an antinomy in Adorno because he does not take sufficient account of
the revolution in all modernist aesthetics announced and theorized by Hegel,
in terms that make the framework of Adorno's approach a residue of an es-
sentially Kantian aesthetic. Indeed, the antinomy itself is based on a premise
about the separability of sensible and intellectual faculties that came under se-
vere and sustained attack after Kant, above all in Hegel, and the implications
of that revision are visible not only in the philosophy and art theory of Hegel,
and not only in the complementarity of Clark's and Fried's accounts, but in
the demands placed on the beholder by modernist works themselves. As I
have been arguing, modernist art has largely (but, of course, not completely)

de-aestheticized the primary relation to the artwork (so the concept of aesthetic or sensual purity buys into a misleading or even regressive framework), diminished the importance of the notion of some isolated aesthetic experience as such, heightened the interpretive and so philosophical dimension of understanding artworks, and so allowed a distinctly act-centered sort of intelligibility (the artwork as interpretable act or gesture, not occasion for a purely aesthetic response). As we have seen, that is Hegel's signal accomplishment and what makes him the potential theorist of modernism in the way Kant and the *Frühromantik* were for romantic art.[7]

II

At this point, in order to better understand the somewhat disorienting and novel elements in paintings by and after Manet, we should concede the obvious and introduce the issues of importance for Clark: that one can frame the whole problem in a less speculative-logical and more sociopolitical way. That is, our central Hegelian frame, the "amphibian" problem, has, as it should if it is to be a Hegelian inheritance, a sociopolitical dimension to the materiality side of the duality, a different but related notion of objective necessity. On the broadly left-Hegelian assumption that specific forms of social order and organizations of power constitute themselves (define their normative identity), understand themselves, and sustain themselves and their legitimacy through some regime of communal or shared self-representation (from constitutions to mythic accounts of origins to advertising to popular culture to fine art), and that they must do so,[8] then such regimes generate an obvious question. It concerns the relation between the actual exercise and distribution of such power—whose wills are in material fact subject to whom, who is coerced to

7. Of course, the German romantics themselves, according to Lacoue-Labarthe and Nancy (1988, 2), had already established what Lacoue-Labarthe and Nancy call the "theoretical project in literature." They argue that, while, in response to Kant's Third Antinomy, philosophy invented a dialectical logic, the romantics invented literature as a distinct and superior mode of the intelligibility of the Absolute, neither subject nor object.

Fried anticipates the relevance of Hegel on "the priority of action" for understanding the dynamic of modernism and the logic of the painting-beholder relation (the logic of social subjectivity) in a suggestive passage in Fried 1992, 276–78.

8. That is, such practices are constitutive, not merely supportive or expressive; they are relevant to the ontological possibility of a social regime and address the issue of how there could be such a thing as a social regime. Here is a summation in Clark's 2001 book: "one main hypothesis of this book has been that painting's public life is very far from being extrinsic to it, *ex post facto*" (305).

do what, and who gets to take what from whom, and how is this all accomplished?—and representations of the meaning, purpose, and legitimacy of these states and actions. In our case the type of self-representation at issue is high-culture visual art at the onset of modernism.

This version of the "material" and "ideal" dimensions of the amphibian problem asks what we mean when we say that some organization of power constitutes and sustains itself through or by means of some regime of representation. The question is inspired by the realization that as material and finite social beings, we seem *as* subject to a kind of social necessity as we are when considered biologically or chemically. This need not be understood in crudely causal or any reductionist terms. The "struggle with necessity" can be understood as both involving purposive and norm-directed actions and yet also being severely constrained under a variety of notions of constraint. Most obviously, as Marx pointed out in the *18th Brumaire*, we have to labor cooperatively (as Marx says, "make" our own history) under actual "material" conditions not of our own "choosing"[9] to produce the means of our own sustainability and flourishing. It is quite reasonable to think that even as these conditions of social self-reproducibility become ever more complicated, an adequate explanation of social developments must be an extension of the explanations we give of any entity subject to, constrained by, natural necessity, under any number of interpretations of "subject to" or "constrained by." Normative self-representations, while they play an important actual role in sustaining some organization of power (in its collective acceptance, say), are on such an account to be considered means or even "ideology"—epiphenomenal in some broad sense.

On the other hand, we experience such normative orders of self-representation as appeals to legitimacy—and that has to mean appeals to rationality or rational acceptability (even, as Hegel would have it, in art and in the conditions of its "success")—that can succeed or fail, and we intuitively think that organizations of power and control can themselves fail *by* failing to meet the requirements that result from such appeals or such demands for coherence and justifiability, expressed in many different reflective representational regimes. Moreover, the intelligibility, power, and credibility of aesthetic objects

9. I mean the usual by such conditions: the level of technological development, available material resources, the body of acquired productive knowledge, conditions of health and control of disease, and so forth. What Marx says in the *18th Brumaire* (1913, 9) is: "Men make their own history, but they do not make it as they please; they do not make it under self-selected circumstances, but under circumstances existing already, given and transmitted from the past." Many have placed the emphasis on the issue of constraints and not so much on what Marx could have meant by "men *make* their own history."

can also, we think, be interrogative of and even critical of social orders and embody a dialogue with their own traditions that seems sui generis, an aspect simply of the ambition to make great art, and not epiphenomenal effects of such social orders.

But there are many variations on this theme: that is, the question of the credibility, and so the success, of representational strategies. *Causal* explanations are only one version and have sometimes tended toward so-called vulgar Marxism or scientism. T. J. Clark, the art historian whose approach I consider left-Hegelian in the above sense, is not one of these reductionists. In his 1984 book, *The Painting of Modern Life*, he sets out what seem to me reasonable criteria for the success of his whole enterprise, a project that extends through and beyond his 1999 book, *Farewell to an Idea: Episodes from a History of Modernism*. After arguing that what we count as a "social order" consists "primarily of classifications," with these understood as "a set of means for solidarity, distance, belonging and exclusion," he then says,

> Orders of this sort appear to be established most potently by representations or systems of signs, and it does not seem to trivialize the concept of "social formation"—or necessarily to give it an idealist as opposed to a materialist gloss—to describe it as a hierarchy of representations. That way one avoids the worst pitfalls of vulgar Marxism, in particular the difficulties involved in claiming that the base of any social formation is some brute facticity made of sterner and solider stuff than signs—for instance the stuff of economic life. (1999b, 6)

The sense in which both Clark's approach and that of Fried can be considered left-Hegelian as I understand it can be made clearer with a brief contrast to the well-known approach to modernism taken by Arthur Danto. First, Danto (1990, 338–40; 1997, 3, 46) accepts a lot of Vasari's famous narrative, which has become widely influential, even conventional. After art broke free from its religious tasks and became art in itself in the Renaissance—that is, a distinct self-regulating practice—it committed itself to the technical mastery of mimetic representation as such. This was supposedly finally achieved with Michelangelo (Danto 2000, 416–19).[10] But when Western art in the nineteenth century began to appreciate the value of non-Western art (such as Japanese prints), this commitment to mimetic fidelity as the goal of advanced art began to lose its grip. Art, painters began to discover, could be striking and compelling without such a commitment. According to Danto—and here he differs a

10. This would itself be a dubious claim if Danto means that the achievement of Michelangelo was all and only about the technical perfection of mimesis.

bit from conventional accounts (which, like Nehamas's, for example, emphasize the impact of still photography) — it was motion-picture technology and its *completely* successful mimetic illusionism that made such a commitment by painting irrelevant. And here Danto's account turns a bit Greenbergian, as he narrates an attempt to find the "essence" of painting as such, seeking subtraction and erasure as ways of eliminating what was merely contingent and inessential or borrowed from other media. Eventually, going well beyond and even against Greenberg (because Danto goes "beyond" paint, canvas, wood, stone, to a wholly formal-conceptual notion of the essence of art),[11] Danto claims that *any* sensible or "appearance" features taken to be constitutive of art as such were shown to be inessential and dispensable. Art as art became something like the concept of art, embodiable in a great "plurality" of ways (one version of which might be "not embodiable").[12]

There is no space here to do any justice to this or similar narratives. The point here is to see how internal to a highly formalized conception of art history it is. The advent of a modernist sensibility in such an account seems driven simply by a contingent need for "something new to do" after some sort of technical perfection in mimesis had been achieved mechanically, and the direction it took seemed determined by contingent, happenstance discoveries (Japanese prints) and something like a new, curiosity-fueled research project into the "essence" of painting as such, as if such a notion could be formulated in terms of such ahistorical essentiality. One can say simply that there is a great deal more at stake in Hegel when the question is the historical fate of art and, accordingly, a great deal more at stake in the accounts of Clark and Fried, something tied to the historical, civilizational project definitive of the world in which such art was made. The question that animates all three accounts and others like them is the simple, sweeping question of what it means that human beings make art, how it is that this activity is so significant to them, how it could be that this sense of its significance could change, often radically, and still be identified as the making of significant art. It is hard to detect

11. Although, to be fair, he does not go beyond "embodiment" as such. See Danto 1986, 179, on the kind of "soul" an art object has that others do not; see also Danto 1994. What Danto loses and Greenberg retains is the Hegelian notion of a distinct and even ineliminable notion of aesthetic intelligibility in itself and, insofar as it concerns the "highest" and most important issues in human self-understanding, an artistic-sensible meaning unlike any other modality of meaning. See Danto 1997, 36: "there is no way works of art need to look."

12. Danto 1992, 125; 1990, 340. For a more detailed and quite valuable account of Danto's position in relation to Hegel, see Houlgate, forthcoming. I also agree with Houlgate's criticisms of Danto's self-ascribed "Hegelianism" and with Seel's (1998) unease with Danto's various statements about the role of "appearance" (of the aesthetic) in art.

the presence of these concerns in Danto, and so hard to understand what he could mean when he calls himself a "born again Hegelian" (1992, 9).[13]

Now, of course, the worry about any such sociohistorical account is reductionism, not doing justice to the art as art; treating it as instances or examples or in other ways tied to, perhaps "caused" by, developments other than artistic—essentially epiphenomenal. And, of course, the nature of the "link" between the meaning of an artwork and the historical horizon of possible meaning within which an artwork or any material being or event could mean anything is clearly the key. But there *is*, there has to be, some such link. And Clark argues effectively against both materialist reductionism and idealist representationalism and claims that one can put this kind of emphasis on representations (representations "all the way down," as it is said) as *constitutive of a social order* and still remain true to the insights of historical materialism, as long as one is clear on the nature of that link between representations and the "totality" he (and Marx) calls "social practice." Thus:

> Society is a battlefield of representations, on which the limits and coherence of any given set are constantly being fought for and regularly spoilt. Thus it makes sense to say that representations are continually subject to the test in a reality more basic than themselves—the test of social practice. (1999b, 6)

That said, it is still the case that Clark wants to claim such things as the following:

> In capitalist society, economic representations are the matrix around which all others are organized. In particular, the class of an individual—his or her effective possession of or separation from the means of production—is the determinant fact of social life. (1999b, 7)

And in his later book, he says such things as

> I should say straightaway that this cluster of features [Clark is discussing a variety of features associated with the secularization of society] seems to me tied to, and propelled by, one central process: the accumulation of capital, and the spread of capitalist markets into more and more of the world and the texture of human dealings. (2001, 7)

And,

> Money is the root form of representation in bourgeois society. Threats to monetary value are threats to signification in general. (2001, 10)

13. In this passage Danto makes clear how cautious and self-consciously limited is his "Hegelianism," but he is concerned mostly not to subscribe to any of what he regards as dubious "metaphysical" and "systematic" claims.

These appeals to the "test" of a social practice, to a central "matrix" for which all else is periphery, to what is "determinant," what is at the "root," all obviously introduce large and extremely controversial issues in a philosophy of explanation to which Clark is, for the most part implicitly, appealing.

The key issue is the understanding of "representation" in these and other remarks, not just by Clark, but by many modernists themselves and the art historians who attempt to explain them. (A certain dissatisfaction with representation itself, or a dissatisfaction with the limitations of the ability of bourgeois modernity's "representational regime" to reach the actual life, or vital reality, still available for aesthetic embodiment, is an oft-cited element of pictorial modernism's general motivation.)[14] Sometimes in such discussions, the assumption seems to be that the available representational resources of such a historical form of life offer us *only* "representations" *instead of* "reality." Clark can sometimes sound at his most polemical on such an issue, as if he imagines that his representationalist opponents think this way. Here he is in collaboration with the Berkeley political collective Retort:

> It is only twenty-first century intellectuals who believe that everything human is always already representation. If we could take them back to a stockyard or a guildhall or a Glasgow "steamy"—or indeed to a "market" before the Right eviscerated the notion—they would soon see that human beings have other ways of making each other meaningful besides branding and signing. And it is the interaction of these different ways—of these different materialities and intentionalities—that make up a human world. (Clark and Retort 2008)[15]

This passage (with its specific target—"twenty-first century intellectuals") is, despite its apparent appeal to a materialist version of realism, ambiguous ("materialities *and* intentionalities") and so suggests a more flexible and variously interpretable notion of representation: not representations instead of reality, but differing, limited, and contesting representations of (in fact) reality, representations of aspects that, in their "absolute" use, the pretension to totality or completeness rather than such aspectuality, thereby distort (for specific purposes) what limited aspect of the real they do capture.

Finally, I argued in the last chapter in a Hegelian voice that we could also consider "representations" as the embodied actualization, realization, or some

14. See the discussion in the introduction to Todd Cronan's forthcoming book. I am indebted to Cronan for correspondence about the representation issue.

15. For his Hegelian gloss on this issue of a "test"—whether a proposed alternative representational regime (in this case, analytical Cubism) can become a "collectivity" (or not, as in this case)—see Clark 2001, 223.

putative ascription of meaning, in the way a deed can be said to "represent" (manifest) the intention of the agent, or in the sense in which I can be said to represent myself doing such and such *in* so doing such and such. The idea of a failure to represent can then be more nuanced and analyzable, much more than simply "succeeding or failing." This would be the way a deed can reveal the weakness or even falseness of a sincerely self-ascribed intention. Considering artworks as deed-like in this way invokes this third sense of representation. Representations are understood to represent only in a circuit of intentional representations, and their success depends on what else so representing allows one to do or say, or their failure consists in what incompatibilities taking something in such and such a way requires.[16] And there are indications that, for the most part, Clark has something like this in mind. Here is Clark from his introduction to a biography of Guy Debord. He is worrying that an abstract (or what Hegel would call an "indeterminate") objection to "representation" can be immediately problematic. "Do they [such objections] not lead us inevitably back to a Rousseau-and-Lukács realm of transparency and face-to-faceness and therefore usher in a politics of purity and purging to match?" Rather than "anathematizing representation in general," Clark sees Debord as "proposing certain tests for truth and falsity in representation and, above all, for truth and falsity in representational *regimes*." (Clark's repeated proposal about "tests" is one we shall discuss shortly.) And he asks,

> Why is it so difficult to think . . . "representation" as plural rather than as singular and centralized: representations as so many fields or terrains of activity, subject to leakage and interference . . . constantly crossed and dispersed . . . subject to retrieval and cancellation? Why should a regime of representation not be built on the principle that images are . . . transformable (as opposed to exchangeable)? (1999a, ix–x)

For our purposes, what is important is how this approach, understood this way, addresses the problems already sketched and especially the question of what *sort* of crisis Manet's paintings are responding to.

I will concentrate first on Clark's treatment of Manet's *Olympia* (figs. 2.2, 2.4). The two most important elements of the *Olympia* painting for Clark are (1) that this is a painting of a prostitute, one depicted in a way suggestive of the courtesan tradition, and (2) Olympia's nakedness and so the link between

16. I hope it is clear from the preceding chapter that I take this general view to be as far as possible removed from any semiotic theory of the sort identified with Rosalind Kraus or any enterprise of, as she says, "liberating our thinking from the semantic" (Kraus 1996, 105).

this painting and the tradition of painting nudes.[17] As such, the painting, he claims, functions as a challenge to bourgeois self-representation; it occupies a disturbing, even socially destabilizing, role in the represented social practices that Clark has suggested constitute the test of representational adequacy. There is a wealth of evidence presented by Clark to support reading Olympia as a prostitute, and the scene itself easily suggests a courtesan receiving a client, who, presumably, has sent the flowers that the maid displays. (This, of course, puts the beholder in the position of the potential client, generalizing the gaze of Olympia to anyone in that social world and thereby identifying anyone as complicit with the practice.)[18] Here are some representative passages from his account. In concentrating on the outraged critical reaction to the work when it was exhibited in the Paris Salon of 1865, he says,

> Thus the features defining "the prostitute" were losing whatever clarity they had once possessed, as the difference between the middle and the margin of the social order became blurred; and Manet's picture was suspected of reveling in that state of affairs, marked as it was by a shifting, inconsequential circuit of signs—all of them apparently clues to its subject's identity, sexual and social, but too few of them adding up. (1999b, 79)

In discussing the reasons for this bafflement and outrage, Clark notes,

> Prostitution is a sensitive subject for bourgeois society because sexuality and money are mixed up in it. There are obstacles in the way of representing either, and when the two intersect there is an uneasy feeling that something in the nature of capitalism is at stake, or at least not properly hidden. (1999b, 102)

What is at stake are such familiar issues as the commodification of human life, the spread of capitalist imperatives, as he said above, *into* "the texture of human dealings," and Manet's disruption of the regime of signification in capitalist life, and so his threat to signification in general. What Manet was "reveling in" was the frank exposure that the exchange of services (*any* service)

17. A perhaps unnecessarily paradoxical way of putting Clark's overall point is that the painting actually fails to be a representation of a courtesan, and that failure is what the painting is, what it accomplishes.

18. There are problems with this reading, however. The maid seems to have approached from the rear of the room, and if she is carrying the client's gift of flowers, it would be more natural to expect him to trail after the maid, from the rear. Cf. Clark (1999, 133): "Olympia, on the other hand, looks out at the viewer in a way which obliges him to imagine a whole fabric of sociality in which this look might make sense and include him—a fabric of offers, places, payments, particular powers, and status which is still open to negotiation. If all of that could be held in mind, the viewer might have access to Olympia; but clearly it would no longer be access to a nude."

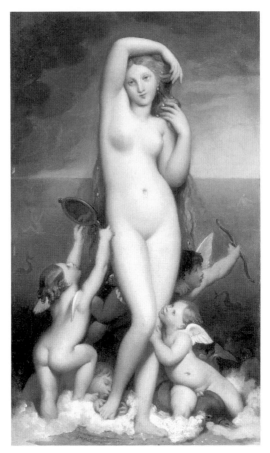

FIGURE 3.1. Jean-Auguste-Dominique Ingres, *Venus Anadyomene*, 1848.

for money is simply the most explicit version of the capitalist notion of exchange value:

> The category of "prostitute" is necessary, and thus must be allowed its representations. It must take its place in the various pictures of the social, the sexual, and the modern which bourgeois society puts into circulation. There is a sense in which it could even be said to anchor those representations: it is the limiting case of all three, and the point at which they are mapped most neatly onto one another. It represents the danger of the price of modernity; it says things about capital which are shocking perhaps, but glamorous when stated in this form; and by showing sexuality succumbing to the social *in the wrong way* (if completely), it might seem to aid our understanding of the right ones. (Clark 1999b, 103)

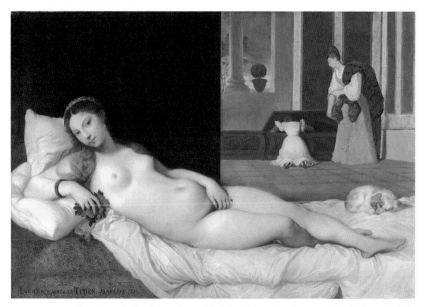

FIGURE 3.2. Jean-Auguste-Dominique Ingres, *Reclining Venus*, 1822. Courtesy of the Walters Art Museum, acquired by Henry Walters.

What is "shocking" is the suggestion that prostitution is not just consistent with capitalist exchange value but *paradigmatically representative of it*, and Clark's extensive citation of contemporary critical commentary is meant to establish how close to home such a disturbing suggestion hit.

The same sort of disruptive force in *Olympia* is made clear by Clark's compelling account of something like the impossibility (under the emerging conditions of a capitalist society's self-representation) of any continuation of the tradition of the nude in painting, the impossibility, the immediate lack of credibility, of that abstraction from particularity, the desexualizing idealization and so relatively innocent address to the beholder (figs. 3.1, 3.2). Continuing *this* tradition of painting *now* would have no credibility, and it can only be invoked in a certain way in quotation marks. This is what the painting does, achieves, according to Clark, and why that has now become necessary is his question. Olympia is not a nude; she is a naked individual, and that now assumes a different meaning in the context of modern Paris. Here is a fine summary account of Clark's position:

But if class could be shown to belong to that body; if it could be seen to remake the basic categories of nudity and nakedness; if it became a matter of the body's whole address and arrangement, something read *on* the body, in the

body, in ways the spectator could not focus discriminately—then the circuit
would be broken, and the category *courtisane* replaced by others less absolute
and comforting. The body and money would not be unmediated terms any
longer, interesting in the abstract, out there in the hinterland of images; they
would take their place in a determinate class formation. (1999b, 118)[19]

This, of course, is exactly what he argues happens with the appearance of
Manet's painting in the Salon of 1865.

Now it would be wrong to give the impression with these selected quota-
tions that Clark's approach to *Olympia* is a strictly "sociological approach," as if
in distinction to an aesthetic approach, or as if formulated in just the way one
might also want to explain coded representations in popular culture, religious
controversies, political language. He is most assuredly interested in *Olympia as
a painting*, in the unique and radically new painterly properties of the object,
and in the shifting status of paintings within what would become the society
of the "spectacle," as he puts it. So, for example, he quite rightly notes the at-
tention lavished on the "flatness," the refusal of depth, in Manet's paintings but
also quite aptly insists that we need to know *why* flatness became a concern
(what it meant that it was attended to), and he is willing to suggest possibili-
ties, all of which seem to me deeper and more interesting than any having to
do with photography or a sudden search for painting's essence as a medium:

> Flatness was construed as a barrier put up against the viewer's normal wish
> to enter a picture and dream, to have it be a space apart from life in which the
> mind would be free to make its own connections. (1999b, 13)[20]

And other such moments unique to the object as a painting—materiality,
unfinishedness—are addressed in the same way, as aspects of the inability of a
particular kind of culture, capitalist culture, to represent itself successfully to
itself, requiring wholly new forms of address to the beholder consistent with
that difficulty and that particularity.[21]

19. See also Clark's (1999b, 49) remarks about "the myth of modernity" and the contrasting
reality: that "the city was more inflexibly classed and divided than ever before," and that the era
experienced the "unmistakable sealing and quarantine of the classes." This formulation about
the visibility of class in, or read off, the body is one of the many extensions and implications of
the Hegelian denial of any strict separability between the conceptual and sensible or intuitional
elements in any experience and in aesthetic experience in particular.

20. Clark (2001, 204ff.) also has some interesting things to say about flatness (and its para-
doxes) in Picasso. On the differences between Greenberg on flatness and Fried on facingness, see
the interesting discussion in Melville 2000.

21. On materiality, see also Fried 1996, 138. Fried provides several good reasons for believ-
ing that this widely cited notion of flatness is more the result of a belated and retrospective

III

This approach seems to me compelling and extraordinarily illuminating. However, if, *finally*, this is to be something other than a moral categorization (as I am sure Clark would insist), as in expressive of or evidence of a social practice guilty of dehumanization or exploitation, and if the disruption in the circulation of the bourgeois system of signs is to be more than a case of some marker of that society's own moral hypocrisy, then I think we also need a complementary framework for understanding Manet's disruptiveness.

Like any other norm-governed social enterprise, explained in the way that Hegel does, painting, and modern painting in particular, must be understood as a self-constituting and self-regulating enterprise. How any art could be said to be both conditionally necessary in some way (if *Geist* is to be what it is and to understand itself properly, *there must be art*) and yet so mutable, so subject to crises in its development, and finally subject to a crisis that concerns its own possibility, is, as we have seen, an acutely difficult question. It does not mean, however, that art has to be understood as autonomously art or understood "purely aesthetically," since the range of terms relevant to its self-constitution need not be restricted to the aesthetic. But they must include the aesthetic, must take account of the struggle of painting, within the world of painting as a practice, let us say, to define, sustain, and renew itself successfully as painting, within the self-understanding of painting at a time, in terms of the historical body of work counted as art, and so must be everywhere animated, if sometimes also very derivatively, by the "why *art* at all?" issue. In order to understand the point of aesthetic activity—both the norms authoritative at a time for such a practice and the alteration of such norms (the breakdown and reinstitution of such norms)—the overall narrative must be comprehensive enough to allow the point of such a representational activity to emerge in the context of other related representational activities with which the arts belong together. (On Hegel's view, that is the only way they could emerge.) This means, in the account presented here, that stands of various sorts are always being taken on the possible sensible embodiment of meaning and the role of art in the realization of such possibilities.

view of Manet, noticeable as such (or *so* noticeable) from the point of view established by Impressionism, and that emphasizing it, as so many do, obscures, makes harder to see, the much more important strategy in Manet that Fried calls "facingness." See also ibid., 16–19. The same backshadowing effect from Impression can lead to an exaggerated emphasis on Manet's "optical idealism," Fried also argues.

Such a practice, then, is not intelligible if the point of the activity is considered *wholly* internally (as if there is a wholly "pure" art practice, complete unto itself, and something like a "purely" aesthetic response), and it is not properly understood if it is too abstractly allied with *any* system of representational self-reflection at a time. Hegel's suggestion is that painting and all the fine arts are properly understood only if inscribed within the self-constitution of human *Geist* writ very large, its becoming what it is and its related, retrospective attempt to understand what it is becoming. In what are today his nearly inaccessible terms, art must be understood as an intuitive representation of the Absolute (which, obviously, advertising, political cartoons, popular novels, and so forth are not).

This is quite an abstract formulation but the point of it is to suggest that the *explicans* Clark appeals to—the "test" of a social practice within a society that accumulates capital and organizes labor as wage labor—is not wrong or inappropriate but only one aspect of what we need to be able to understand in order to allow the significance of a painting like *Olympia* to be fully appreciated. (And as far as I can see, there is no reason Clark need object to this point.)[22] I argued in the last chapter that we ought to take seriously Hegel's linking of the intelligibility of human actions, the avowals by agents and the ascriptions of intentions and act descriptions by others, with the question of visual intelligibility in easel painting (and in the other arts), that we should always recall the thousand-eyed Argus image. On an account like Clark's, this would make it quite reasonable to argue that an emerging and potentially dominating framework for such avowing and ascribing in any modern social world would be *class* and, as would be expected with Hegel's presuppositions, that this dominance could begin to be "read" in painting as well. But as the above remarks about a more comprehensive narrative indicate, it would never be possible to assign to such an *explicans* an exclusive or even a predominant role. What societies are doing *by* organizing themselves into classes is not and cannot be limited to the economic ends of class organization itself (productivity, say), any more than the emphasis on subjective intention in the moral point of view could ever exhaust the possibilities inherent in the struggle to establish the status of agent across historical time. We need, that is, something like the latter framework to appreciate the grip *and the limitations* of the former notion.

What this means more concretely is straightforward. Any appeal to the

22. For that matter, the duality announced in the title of this chapter is like a Hegelian duality. It is important to make the distinction in order to see, finally, the deep inseparability of the distinguished terms. In his discussion of Picasso, Clark (2001, 211) is as concerned with ontology as Fried is with the political dimensions of theatricality. See Fried's remarks on Géricault in *Courbet's Realism*, cited below.

objective social conditions unavoidably assumed in any consideration of the subject's relation to the artwork must be comprehensive enough to allow some explanation of how the painting comes to mean what it does *to* the subject, the beholder. This means that the way the painting works as a painting, and especially the way in which the unique relation between painter and beholder is at issue in the work itself, must be understood to be as constitutive of what the object is as an artwork as any such appeal to the test of social practice. Without such a first-person phenomenology, we won't be able to discuss adequately what it would mean for a representational project to succeed or to fail.

Another way to put the point is that a mere *functional* correlation between a specific social organization and the production of a certain style of art (as when the latter can be shown to change as a function of changes in the former) is unsatisfying. Some way of *understanding* the social organization of one's world, its norms, shibboleths, ideals, and so forth—or in this case how a painter understands his relation to former painters, painting itself, the beholder, and "what is required now"—must be an integral part of the narrative explanation. This understanding is not a competitor with an emphasis on the social organization of power but a necessary complement to such an emphasis. What Clark refers to as the "test" of some representation's credibility, or especially the failure of that test, is not something that merely happens to beholders but must be, to revert to Hegel's term, "worked out" experientially, from the first-person perspective, in some way that we can track and interpret.

Accordingly, this manifesto-like broadside from Clark's later book, *Farewell to an Idea*, goes too far and ends up undialectical and just thereby borders on moralizing. He says that his book's "deepest conviction" is

> that already the modernist past is a ruin, the logic of whose architecture we do not remotely grasp. This has not happened, in my view, because we have entered a new age. That is not what my book title means. On the contrary, it is just because the "modernity" which modernism prophesied has finally arrived that the forms of representation it originally gave rise to are now unreadable. (Or readable only under some dismissive fantasy rubric—of "purism," "opticality," "formalism," "elitism," etc.) The intervening and interminable holocaust was modernization. Modernism is unintelligible now because it had truck with a modernity not yet fully in place. Post-modernism mistakes the ruins of those previous representations, or the fact that from where we stand, they seem ruinous, for the ruin of modernity itself—not seeing that what we are living through is modernity's triumph. (2001, 2–3)[23]

23. This is too telegraphic to do full justice to Clark's position. The pressure put on representational schemes and the experiments with alternative representative possibilities (e.g., in Cubism),

This is a terrific passage rhetorically, but even if modernity and modernization could be so sweepingly categorized (as a kind of moral "holocaust"), aesthetic modernism could count as "unintelligible" only if its fate were linked wholly with social modernization, where that means the development and global triumph of late capitalism and the utter lack of anything recognizably human in that triumph (hence the human "unintelligibility" of that event, according to Clark). But what could that mean? If the social order is *itself* only intelligible within some larger framework of meaningfulness (what could *be* meaningful) and *to* subjects, framing the possibility of embodied or sensible meaning in all its intentional dimensions must also be possible, and then this identification cannot be made. A "lack of anything recognizably human in that triumph" is, if it can be said to occur, a determinate "lack" at a time and for a community and painfully intelligible as such. A painterly reflection of its kind on such possibilities need not be exhausted by the contingent occurrence of social stasis or social bankruptcy of any sort.[24]

IV

Consider Clark's own tour de force, his masterful description of Manet's *Argenteuil* (figs. 2.9, 2.10). He notes in detail the many aspects of the painting that never quite add up, the "lack of order" in the painting that must have been so striking in 1875. He then turns to the issue raised briefly in the last chapter: the "deadpan" look of the woman and the general uncertainty about the activity of the couple. He notes that the two people seem to be "posing" and comments on their "lack of assurance" in the pleasure they are taking, as if (using a term of Veblen's) they were "performing" leisure or "rendering"

while, for Clark, inspired by the possibility of an "overall recasting of social practice," have to be understood in the light of the fact that "there was no such recasting in Picasso's time. Painting rarely dines well on the leavings of science. Here what it feeds on is mainly itself" (2001, 215).

24. In his discussion of Pollock, Clark (2001) suggests that there is a distinct pathos to modernist work, palpable in Pollock, "the unhappy consciousness," which he explicitly links to Hegel's account in *Phenomenology of Spirit*. Given the way Clark partially accepts, and heavily qualifies, Greenberg's use of the adjective "Gothic" to describe Pollock, there is something to that, since the absolute opposition between the Changeable and the Unchangeable that characterizes this section is usually taken to refer to medieval Catholicism, "tinkling bells," "incense" and all. But since Clark says that Hegel wrote that passage "with Diderot's *Rameau's Nephew* in mind" (2001, 329) and since there is no indication of that in the Unhappy Consciousness section of chapter 4, I assume he means also to refer to that passage in chapter 6 where Diderot is actually quoted. That is the discussion of "self-alienated Spirit"; and the frenzy and futility of the nephew's attempts at expression, together with his complicated love-hate relation with the bourgeois Moi, would also fit, in a different register, what Clark is saying about Pollock's pathos.

it (1999b, 168). There is a certain "joylessness" in the scene that results from the sense of people all dressed up "as they are supposed to be" or taking their pleasure "as one does." There is no "natural unity" between the figures and the landscape; the effect is rather one of sheer "contingency." Finally:

> The careful self-consciousness of the woman, her guarded attention to us, the levelness of her gaze: these are the best metaphors of that moment. It is Olympia's gaze; but lacking the fierce engagement with the viewer or the edge of insecurity. This woman looks out circumspectly from a place that belongs to people like her. How good it is, in these places, to find a little solitude on Sundays. How good, how modern, how right and proper. (1999b, 173)

Clearly, Clark means these latter phrases to be in quotation marks and to mark an aspect of the *falseness* in some sense of the posed or self-staged scene, a falseness he wants to trace back to the intrusions of capitalism into the texture of human life, and so the palpable sense he detects that the lives they are living are, paradoxically, not "theirs." But this all seems to me to touch on a much larger issue than the commercialization and so regulation of leisure, one that has been with us from the start with Manet, what Fried calls the "facingness" of the paintings themselves and the relation of that strategy to what Clark himself can be taken to be alluding to here—that is, to the problem of "theatricality."[25]

The issue of theatricality is at the center of both Fried's art-historical and his art-critical work for nearly fifty years, and I will be able to do his complex narrative no justice here, in half a chapter.[26] Briefly, there are three main books of art history involved, and four basic historical phases to the account he wants to give of the development of modernist art from the issues promi-

25. There is already a connection between Clark and Fried on this score: what Clark points out so well, the reemergence of class typologies in a world that thinks of itself as the home of the modern individual—that is, the impossibility of credibly portraying what the capitalist myth of free and equal bargaining agents requires—is obviously some sort of cousin to Fried's account of the "increasing difficulty" in finding credible antitheatrical strategies, given the plausibility of a link between theatrical typologies and class-bound conventions. This is something that Fried (1996, 259–60) himself points out. See also the discussion in Melville 2000, esp. 125n4.

26. I am concentrating here only on the most salient issues relevant to the Hegel/modernism issue. I have tried to give a somewhat fuller picture of Fried's project and of the philosophical dimensions and implications of his narrative in Pippin 2005a. The key issue in this account (in Fried and in my summary) is the way in which Fried is able to show that how a painting can be said to fail (fail to defeat theatricality but in other ways too) can teach us a good deal about the "ontological status" of artworks in themselves. I try to show how that issue is linked to the ontology of intersubjectivity in general, something raised in a painting's mode of address to the beholder.

nent at the invention of art criticism in the mid-eighteenth century. The first book was published in 1980, *Absorption and Theatricality: Painting and Beholder in the Age of Diderot*. It was followed in a continuation of the narrative by *Courbet's Realism* in 1990 and then by *Manet's Modernism; or, the Face of Painting in the 1860s* in 1996. In the first book, Fried concentrated on the period between Chardin and Greuze and the advent of David. The hero of the book is Denis Diderot and Diderot's argument that the success of painting (what made for a successful painting as a work of art) depended on its ability to devise means "of negating or neutralizing . . . the primordial convention that paintings (and stage plays) are made to be beheld; only if that could be done would the actual beholder be stopped, held and transfixed by the work" (2011, 93). This negation was achieved by the eighteenth-century painters at issue in that book largely by their depiction of the deep absorption of the subjects in their paintings. No one in these Chardin-genre paintings appears to be acting for effect, taking account of how they look to others, looking to normative acceptance by an audience, aiming to please or entertain an audience, conforming to the "normalizing gaze" of an audience; and in just that sense too, *neither is the painting* (see figs. 3.3, 3.4). What I want to say is that this evocation of "not being merely *for others*" lands us in the middle of the Hegelian recognition problematic, and the enterprise, defined only in terms of that "not," will prove to be quite unstable because so undialectical, helping to create the crisis of theatricality Fried discusses. The full claim is the following:

> The evolution of painting in France between the start of the reaction against the Rococo and Manet's seminal masterpieces of the first half of the 1860s, traditionally discussed in terms of style and subject matter and presented as a sequence of ill-defined and disjunct epochs or movements . . . may be grasped as a single, self-renewing, in important respects dialectical undertaking. (1988, 4)

Diderot and Fried have a great deal to say about why theatricality is ruinous for any art form, and for both (in a way that echoes aspects of Hegel's approach to art) the issue is not exclusively an aesthetic one.[27] For Diderot, the distinction is as important as that between "a man presenting himself in company and a man acting from motivation, between a man who's alone and a man being observed" (1995, 1:214). Likewise in *The Salon of 1767*, Diderot equates the theatrical with the "mannered," which he called a "vice of regu-

27. Fried distinguishes the art-historical dimensions of the theatricality issue (something like "these paintings represent the struggle with the problem of theatricality") from the art-critical issue ("this painting fails because it is theatrical").

FIGURE 3.3. Jean Siméon Chardin, *Soap Bubbles*. The Metropolitan Museum of Art, Wentworth Fund, 1949 (49.24).

lated society" in "morals, discourse or the arts" (1995, 2:320, 323). For Fried the stakes are also very high, for the defeat of theatricality is an essential condition of the work's *being an artwork*; it is, as he says, an "ontological" issue. The existence of painting *as an art* is at stake. (In this sense a "failed painting" is a failed work of art; i.e., *not* a work of art.) Moreover, in remarks on Géricault in *Courbet's Realism*, that painter is said "to have sensed in the theatrical a metaphysical threat not only to his art but also to his humanity" (Fried 1992, 23). And in *Absorption and Theatricality*, absorption is sometimes called an "unofficial morality" (1988, 51).

In art-historical terms, what is especially interesting is that Fried goes on to describe *the increasing difficulty* that artists seem to have had in continuing such antitheatrical strategies. The possibility of great art is under threat in other words, in a particular, historical social world where the chief danger to that possibility is a certain sort of falseness ever more prevalent *in that world*, ever more difficult to avoid. This is, of course, the sort of threat that is also

FIGURE 3.4. Jean Siméon Chardin, *Young Boy Playing Cards*, c. 1740.

of such concern for Rousseau and later for Kierkegaard, Nietzsche, and Hei-
degger, as well as for Hegel and his account of the modern struggle for mu-
tuality of recognition.[28] If understood in such a Hegelian way, what is at stake
in the proper or successful expression of a relation between the artwork and
beholder is inevitably also an expression of the problem of shareable intel-
ligibility in general, a subject-subject relation, not some sort of subject-object
relation. (We return here to the issue of the kind of claim made on one by a
work of art having much to do with the kind of claim on one made by another

28. I depart here from Fried's own formulations and state the matter in terms of more direct
relevance to Hegel. Fried's concerns stay (appropriately) art-historical, focused with great inten-
sity on the details of the paintings and their success or failure as paintings.

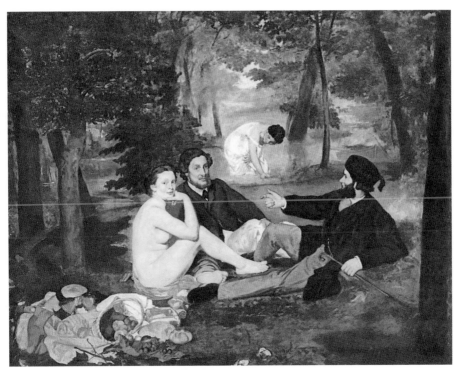

PLATE 1. Édouard Manet, *The Luncheon on the Grass*, 1863.

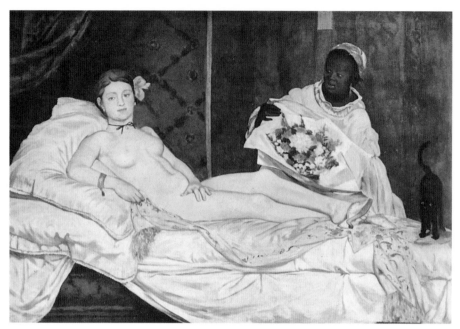

P L A T E 2 . Édouard Manet, *Olympia*, 1863–65.

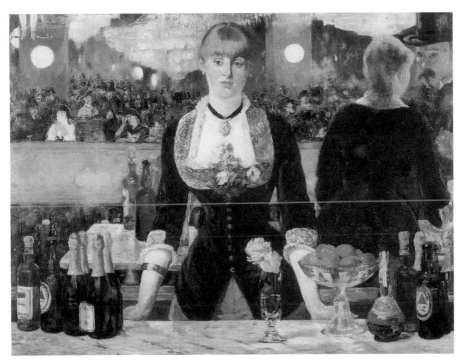

PLATE 3. Édouard Manet, *A Bar at the Folies-Bergère*, 1881–82.

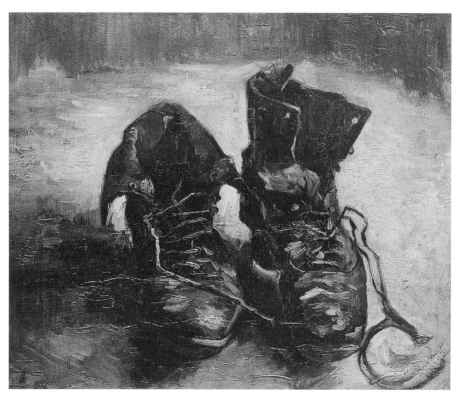

PLATE 4. Vincent van Gogh, *Pair of Shoes*, 1886.

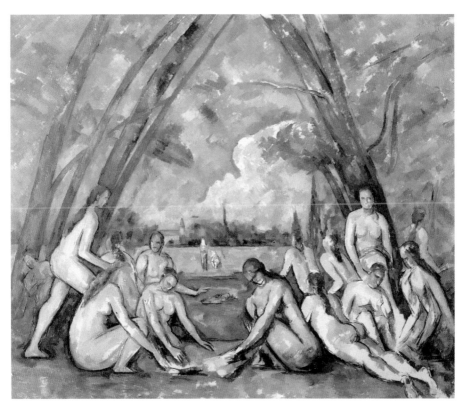

PLATE 5. Paul Cézanne, *Large Bathers*, 1906.

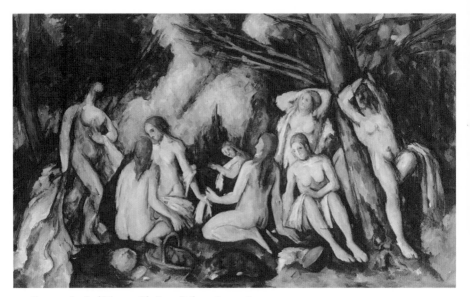

PLATE 6. Paul Cézanne, *The Large Bathers*, 1895–1906.

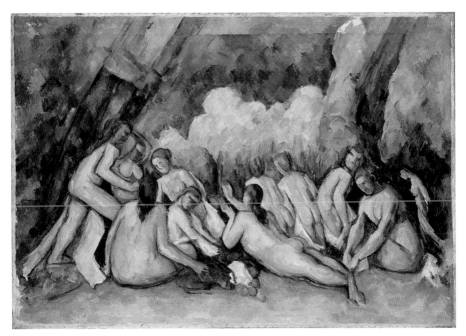

PLATE 7. Paul Cézanne, *Large Bathers II*, 1894–1905.

person, by the mere presence of other persons.)[29] If "theatricalized," that social relation is presented either in terms of submission to a collective subjectivity (in effect a self-objectification or an internalization of what "they" want) or as an attempt by the artist to dominate or overwhelm and so objectify the artwork's audience. (Think of Nietzsche's explicit charge of theatricality against Wagner, accusing Wagner of wanting to stun or overwhelm his audience.)[30]

There are four main historical phases in Fried's (1992, 15) explanation of what he calls "the peculiar instability of historical determinations of what is and is not theatrical,"[31] leading up to Manet's modernism. There is the everyday absorption depicted by Chardin and Greuze; then what appears to be the declining credibility that the tasks engaged in *could* be as absorbing or absorbing enough. There is already, in Fried's narrative, a great difference between Chardin and Greuze; the latter makes much more use of narrative constructions, powerful emotions, and appeals to sentiment and moral considerations to "grab" his viewer (fig. 3.5). Fried calls this "loss" of Chardin's world "one of the first in a series of losses that together constitute the ontological basis of modern art" (1988, 61).[32] And as we shall see, it is unlikely that this "loss" could be a matter *wholly* internal to the practice of art, the success of paintings. It must have something to do with the kind of representable activities available in a world at a time, which allow (or not) the credibility of the representation of such fully involved absorptive commitments. In Heideggerian terms, the issue concerns "the world," the horizon of presumed, shared significance that makes possible everyday familiarity, and the question of such a world is larger than and forms the basis for the "economic world," or "the world of art practices." Fried discusses next the prominence given genre hierarchies and dramatic history scenes to achieve antitheatrical effects. (The prime examples here are David's history paintings, such as the 1784 *Oath of the*

29. Fried is certainly aware of the larger stakes involved in the theatricality problematic. See his remarks about the "object-'subject' relation" in Fried 1988, 103–4.

30. Nietzsche 2005. Cf. Nietzsche's remarks on how Wagner "had considerable experience with falseness" (261) and about Wagner's "theatrocracy," "the sheer idiocy of believing in the priority of the theater," and that theater is not a form of art but "that it is below art" (256). He had earlier expressed, in a way that is stunningly close to Fried's art criticism, the hope "that theater not gain control over art" (254).

31. This is already a considerable simplification of Fried's narrative. For some of the further complications, see Fried 1996, 171ff. Or see the discussion of Legros's *Ex-Voto* and the treatment there of the theatricality problem in Fried 1996, chap. 3.

32. That a world could suffer such a loss, that there is a broad horizon of possible significance that constitutes a world, and *that it changes* (perhaps, contra Hegel, *simply changes*) are linked to themes in Heidegger (*das Ereignis*) that I shall discuss in the next chapter. For another link to Heidegger, see Fried's note about Greuze (Fried 1988, 200n120).

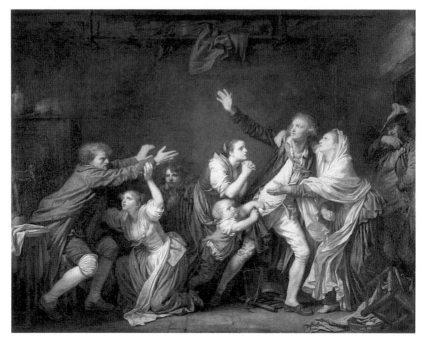

FIGURE 3.5. Jean-Baptiste Greuze, *The Father's Curse; or, The Ungrateful Son*, 1777.

Horatii [fig. 3.6], and then many paintings produced between the 1780s and 1814, when the goal was to portray scenes of such intensity and importance that the fact of absorption, wholehearted involvement, would be credible.)[33] In *Courbet's Realism* he shows how even such strategies were losing their power, and so Courbet adopted another, highly unusual, radical strategy for negating the beholder: creating the fiction of not being beheld, *even by the first beholder, the painter himself;* that is, creating the fiction of Courbet painting himself into the painting, suggesting an actual merging with it. (Thus, we have reached a quite non-Diderotian strategy, which relied on absorptive effects to close off the painting, wall off the beholder, but which in Courbet is still an antitheatrical effect. Instead of absorptive closure, we have this merging [fig. 3.7].)[34]

It is this difficulty—"*the increasingly desperate* struggle against the theatrical that we have followed in David's history paintings" (Fried 1992, 20) and how "with the passage of time the fiction of the beholder's nonexistence

33. See especially the compelling analysis of David's *Bélisaire* in Fried 1988, 152ff., and the general claim that after 1814 there occurred "a drastic loss of conviction in action and expression as resources for ambitious painting" (176).

34. See Fried 1996, 262ff.

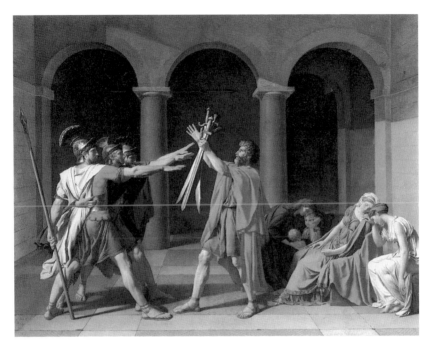

FIGURE 3.6. Jacques-Louis David, *The Oath of the Horatii*, 1784.

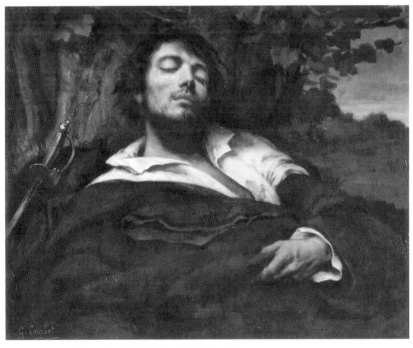

FIGURE 3.7. Gustave Courbet, *The Wounded Man*, c. 1855.

became *ever more difficult* to sustain" (1988, 153, my emphasis)—that brings us to a great radicalization of responses to the difficulty: Manet's modernism. Once again, any summary here will be a distortion, especially in this case, since one of the great achievements of Fried's account of Manet is to show in careful and exhaustive detail just how Manet placed himself in the long tradition of French painting before him, quoting and thereby commenting on his predecessors (in effect, "commenting" on the possibility of what his predecessors attempted, *now*), while at the same time "internationalizing" himself with multiple references to Italian, Dutch, and Spanish painting and thereby aspiring to a kind of painting universalism, one that would allow him to ascend to the regime, simply, of "painting altogether," as Fried puts it. Moreover, Fried has demonstrated how necessary it is to take account of Manet's involvement with what he has called "the generation of 1863," especially with the work of Fantin-Latour, Whistler, and Legros, before the distinctiveness of what Manet accomplished can be appreciated.

Important for our purposes are Manet's treatment of the painting's relation to the beholder and, yet again, the bearing of Manet's strategy on the modern attempt to achieve some sort of shareable intelligibility, the kind of attempt relevant to Clark's notion of a "test." Simply put, Manet appreciated how less and less credible absorptive antitheatrical strategies had become (or, said in a broader way at issue in this discussion, *how less and less credible it was that a subject was not* always *taking the other into* intimate *account in acting or speaking*) and so how much greater the threat of theatricality had become, and his response was to insist on a technique—turning the subject's gaze toward the beholder and directly, even aggressively, confronting the beholder—that would have seemed before Manet the very essence of theatricality, something like the effect of an actor stepping outside his role and addressing the audience. Fried calls this Manet's "facingness" technique, used to great effect by him in producing a dramatic "strikingness" that, in its intensity, its instantaneousness, its challenge to any narrative coherence, defeats any theatrical effect. Indeed, in general, Fried includes Manet in a generation of painters "whose respective responses to the problem of the theatrical differed from his [Manet's] but whose art, like his, signals the emergence of a new pictorial sensibility keyed to the values of excessiveness, willfulness, instantaneousness, intensity, strikingness" (1996, 266).

As Fried shows, this way of dealing with the danger of theatricality was already on view in other works by painters of Manet's generation, especially in one of the most striking paintings of that generation, Fantin-Latour's *Homage to Delacroix* (fig. 2.6). Contemporary observers noticed right away, of course, that in this gathering of painters and critics and connoisseurs in front of a

portrait of Delacroix, seven of the ten of them are gazing out at the beholder and no one is looking at the painting. Fried notes that this is "willfully non-absorptive" (1996, 202). Things are already even more direct and deliberate in Manet's 1862 *Old Musician* (fig. 2.5) and, of course, reach a kind of critical and ferocious clarity in famous paintings like *Olympia*, *The Luncheon on the Grass*, and the *Bar at the Folies-Bergère*. Here is a summary remark:

> Not only did he [Manet] systematically avoid or subvert absorptive or po-
> tentially absorptive motifs; he also deliberately courted unintelligibility on
> the plane of subject-matter and internal disparity on that of mise-en-scène as
> distancing and freezing, one might even say, medusizing devices. (1996, 405)

All of these—facingness, instantaneousness, strikingness, refusal of absorptive closure—were *now* needed to stave off theatricality and so to avoid the greatest threat to art's survival as great art. In other passages Fried notes that Manet had devised a kind of "presentational theatricality"[35] that could not ignore the beholder but could take him into account by confrontationally negating the significance of his presence, a strategy that "compelled the attention of contemporary viewers even as they experienced it as an act of sheerest aggression" (1996, 331).

<p style="text-align:center">V</p>

With this meager summary as background, we can return to our Hegelian framework. Paintings obviously do not make discursive truth claims, but great works of art clearly aspire to a kind of nonconceptual or preconceptual or not wholly or predominantly conceptual (depending on your theory and its relation to Kant) manifestation of truth. At the most basic level, the existence of the artwork alone assumes the possibility of some sort of defeat of skepticism about the shareability of meaning. The meaning at issue is at least the sort of meaning available in a distinctly artistic mode of intelligibility. The question of what sort that is remains a difficult one, but it is not a matter of representational meaning. A person who travels to Florence to see Michelangelo's *David* in order to see what David looked like has missed something. And, we have been assuming, a great painting, in its visible assumptions about its own relation to the beholder, can often be said to allegorize this possibility. But such a manifestation can also be understood to be subject to greater and greater pressures in the post-Hegelian world and, accordingly, in post-Hegelian aesthetic traditions. Fried's remarks about "desperation" and

35. As opposed to an "actional theatricality."

"increasing difficulty" point to that. By far the greatest pressure has been sum-marized as our amphibian problem, in the broadest sense that we have both natures and histories, are both finite members of a distinct species and yet capable of making ourselves into creatures only indebted to what those spe-cies or biological characteristics require in a historically mediated way. And by far the most difficult task we face in this situation is figuring out how to act toward others in a way that properly acknowledges both dimensions of what we are (or, even here we have to say, what we have come to determine that we are), subjects as well as objects. In what we have been looking at in this chapter in interpretations of art, that issue has emerged as the problem of class (or, one might say, the role of power) and the mediation of class in our self-understanding; as the problem of the beholder, our historically mutable understanding of the structure of the beholding relation; and as the avoidance of theatricality.

I have suggested that painting faced a problem with theatricality because the world of Diderot faced such a problem in new, unprecedented ways. (Avoiding theatricality may be a general condition of success in painting or in stage plays, but as a *problem*, it is not Dürer's or Titian's or indeed Caravag-gio's problem.)[36] Diderot and Rousseau were almost exact contemporaries, and so it is not surprising to find Rousseau worrying about how modern man lives "outside himself," "in the opinions of others" (1986, 199). The credibility of antitheatrical strategies cannot be isolated from the credibility of aspira-tions for social independence and genuine individuality, the great rallying cry of political modernity.[37] Such aspirations are themselves under threat if there is so little shared trust in institutions and common practices that one feels that one's will is inevitably subject to others if one does not struggle to subject theirs to one's own, and thus that everything that one does might not be one's own but rather everywhere already has taken account of others, so that one is a performer attempting to master an audience or be mastered. There is a great deal of pressure on absorptive strategies in painting because the actions and practices in the emerging modern world (the world of divided and rou-tinized labor) that *can compel genuine absorption* might now be few and far between (hence the idealization—of some sort—by Pissarro of farmers and

36. See Fried's remarks in Fried 1992, 13ff., and the strategy deployed in his Caravaggio book (Fried 2010), where the presence of absorptive motifs begins to surface without yet any crisis of theatricality.

37. See Fried's apposite remarks on intersubjective skepticism in Fried 2010, 103ff., especially the role of "empathic projection" in the appreciation of painting. For an example of how another visual art form can deal with this problem of mutuality, see my discussion of Nicholas Ray's film *In a Lonely Place* in Pippin 2012b.

peasants and the emerging interest by painters in the primitive as the mark of the genuine). Of course, there will always be work and leisure activities and athletic contests and reading that all require intense attention, concentration. But when painting such activities begins to fail to compel conviction, both aesthetic and, let us say, existential credibility are at stake. Absorption, as successfully depicted, would be *genuine* indifference to the beholder, and working, modern work, wage labor especially, is by and large working for someone, and usually in repetitive and stultifying ways. (Stultifying mindlessness is not absorption.) Even leisure and the kind of leisure available are inevitably a matter of income, class, status. No innocence, anywhere, in other words.[38]

None of this means that we have any reason to think that we have exhaustively understood this situation by categorizing it as a matter of class or alienation or some such. In the social situations where these issues are relevant, there is considerably more uncertainty and psychological variability for this to be satisfying, and as argued above, the issue involved (our amphibian issue) is a far broader one, of which social domination and exploitation make up only one dimension.

38. Fried's discovery of antitheatrical strategies in contemporary art photography could open up on to a broader discussion of this point. In several of the paradigmatic instances in the photographs of Jeff Wall, I wonder if the absorption or immersion in activity on view can be "innocent" in the sense just invoked. At least it seems that many of the photographs raise the question of absorption in a way that includes but is not exhausted by aesthetic credibility. In Wall's *Morning Cleaning*, the "magic" of absorption certainly does its job, but the contrast between the opulence and elegance of the room and the janitor's menial task (the striking fact that the room is not, could never be, "for him") allows such a concern to arise (with a hint of pathos), as does the fact that the two women in Wall's *A View from an Apartment* are "exposed" by a window and accomplish their domestic tasks in a harshly technologically structured world, as does the sterility and clearly administered world of Adrian Walker's *Drawing* (not to mention that the emotionally cold tonality of the absorptive drawing seems echoed by the desiccated, dead hand). This is a large topic, but in such contexts absorption, while vivid, can never be complete; one is always (at least in some sense) performing one's job or task. Even Richter's famous photograph of his daughter reading is clearly "posed." And so Fried does not claim that the absorptive motifs are the same as Chardin's, and he points out the differences between *Adrian Walker* and Chardin's paintings. Fried's treatment of Wall, Delahaye, diCorcia, Struth, and many others makes quite clear that he is well aware of the different "valence," one might say, in *contemporary* absorptive motifs. See also his important discussions of "to-be-seenness." See Fried 2008, 35, 43, and especially the accounts of Fischer (223–26) and, paradigmatically, of Gordon and Parreno's film *Zidane* (226–33). See especially the closing footnote discussing the recent McDowell-Dreyfus debate. This all also is relevant to the complex differences between something like a "good" everyday world of deep, genuine involvement and commitment and a "bad" absorption, more a kind of thoughtless and unreflective "going on as they do" or "as one ought," even a kind of paradoxical *absorption in performance*.

In this context, what should one say of Manet's facingness? (I mean beyond how it works aesthetically, which, it seems to me, Fried has expressed in a way not likely to be surpassed.) In one respect, its emergence, together with "excessiveness, willfulness, instantaneousness, intensity, strikingness," indicates the extremity of the problem, what it now took in the 1860s to compel conviction in the independence and genuineness of the painting as a painting, and so what it took to establish a genuinely aesthetic, not commercial or entertaining or theatrical, relation to a beholder in such a world. But that extremity, as a measure of the depth of the problem creating the extreme measures, does not mean that we are on the verge of some break with the possibility of such conviction altogether, as if on the outer edge of possibility, with nowhere to go next.[39] The existence of the great works of ge-

39. For Hegel's warnings about what he calls too "severe" a style, too challenging or confrontational an approach, consider:

> Producing effects is in general the dominating tendency of turning to the public, so that the work of art no longer displays itself as peaceful, satisfied in itself, and serene; on the contrary, it turns inside out and as it were makes an appeal to the spectator and tries to put itself into relation with him by means of the mode of portrayal. Both, peace in itself and turning to the onlooker, must indeed be present in the work of art, but the two sides must be in the purest equilibrium. If the work of art in the severe style is entirely shut in upon itself without wishing to speak to a spectator, it leaves us cold; but if it goes too far out of itself to him, it pleases but is without solidity or at least does not please (as it should) by solidity of content and the simple treatment and presentation of that content. In that event this emergence from itself falls into the contingency of appearance and makes the work of art itself into such a contingency in which what we recognize is no longer the topic itself and the form which the nature of the topic determines necessarily, but the poet and the artist with his subjective aims, his workmanship and his skill in execution. In this way the public becomes entirely free from the essential content of the topic and is brought by the work only into conversation with the artist: for now what is of special importance is that everyone should understand what the artist intended and how cunningly and skillfully he has handled and executed his design. To be brought thus into this subjective community of understanding and judgment with the artist is the most flattering thing. The reader or listener marvels at the poet or composer, and the onlooker at the visual artist, all the more readily, and finds his own conceit all the more agreeably satisfied, the more the work of art invites him to this subjective judgment of art and puts into his hands the intentions and views of the artist. In the severe style, on the other hand, it is as if nothing at all were granted to the spectator; it is the content's substance which in its presentation severely and sharply repulses any subjective judgment. It is true that this repelling may often be a mere hypochondria [depression] of the artist who inserts a depth of meaning into his work but will not go on to a free, easy, serene exposition of the thing; on the contrary, he deliberately intends to make things difficult for the spectator. But in that case such a trading in secrets is itself only an affectation once more and a false contrast to the aim of pleasing. (A, 1:619)

nius to come, and the critical commentary they inspired, are proof enough of that.[40]

But it also should indicate that we should now say that our "Hegelian problem" is not a "problem" of the sort that will ever allow a "solution." The Friedian problem of the "structure of beholding" involves at once both the problem of the modern logic of mutual subjectivity,[41] the avoidance of domination as objectification, and, as art, as a sensible material object, the continuing problem of the possibility of the sensible embodiment of shareable meaning, all in a context where the terms that set such a problem are not stable. In a Hegelian framework, at least one understood as I do, to face these issues, and, necessarily, to face them collectively, unavoidably, incessantly, is simply what it is, what it has come to be, to be "*Geist.*" When Hegel asserted so extravagantly that with him we have reached the "absolute standpoint," have achieved absolute knowledge, this is, I think, what he meant.

40. Fried's work on abstract art and, again, his recent work on photography show how such a discussion might be carried forward, and his work on Eakins and Menzel shows that the theatricality problem should not be assumed to be the only problem faced by ambitious art of the modern period.

41. Cf. Hegel's formulation: "But this independence the work of sculpture has to retain because its content is what is, within and without, self-reposing, self-complete, and objective. Whereas in painting the content is subjectivity, more precisely the inner life inwardly particularized, and for this very reason the separation in the work of art between its subject and the spectator must emerge and yet must immediately be dissipated because, by displaying what is subjective, the work, in its whole mode of presentation, reveals its purpose as existing not independently on its own account but for subjective apprehension, for the spectator. The spectator is as it were in it from the beginning, is counted in with it, and the work exists only for this fixed point, i.e. for the individual apprehending it" (*A*, 1:806).

4

Art and Truth:
Heidegger and Hegel

The painter recaptures and converts into visible objects what would, without him, remain walled up in the separate life of each consciousness: the vibration of appearances, which is the cradle of things. Only one emotion is possible for the painter—the feeling of strangeness—and only one lyricism—that of the continual rebirth of existence.
MERLEAU-PONTY, "Cézanne's Doubt" (trans. Smith)

I

My claim has been that the Hegelian picture of modern aesthetic intelligibility (i.e., the modern norms for successful art) puts us in the best philosophical position to understand the example I have chosen as a focus for this discussion: the crisis of visual modernism in the tradition of Western painting. Such art seems to place new, unprecedented demands on whatever understanding we have of whatever is distinctive of aesthetic intelligibility, demands not capturable in romantic or traditional aesthetics but more compatible with Hegel's picture of the historical de-aestheticization of art, or the declining relevance of the sensuously beautiful as an aesthetic ideal. This is so because Hegel understands the claims made on us by modern art to be inseparable from the kinds of claims made on us in any sensible embodiment of meaning, especially the meaning of bodily movements that count as actions (our amphibian problem), and because he understands artworks, by existing at all, to embody an assumption about the possibility of shared meaning (our thousand-eyed Argus problem). And he understands such claims as profoundly historical; their very sense changes. In visual works, the address to a beholder always has to embody some understanding of the work's relation to an audience, some determinate anticipation of the beholder's response, and this relation changes in Hegel's account as the general shared assumptions about such relations change in a society over time, as they come under various pressures and strains.

There is thus no reason, if we remain strictly focused on these Hegelian assumptions, the basic ones, that Hegel was compelled to claim that fine art in modernity had become, must become, "a thing of the past." Such a claim

is not primarily based on an evaluation of art practices but on a premature assessment of the nature of modern society and the state of modern philosophy. It is to his eternal credit to have argued that *these* considerations (about modern society and modern self-understanding in philosophy) are as essential to understanding the force and fate of art at a time as any strictly aesthetic criteria, but the denial of his conclusions about "where we are now," especially the denial of his conclusion that some need for art has been satisfied by philosophy, does not mean that the two major dimensions of Hegel's understanding of the possible comprehensibility of modernist art (captured in the images of the amphibian and the thousand-eyed Argus) lose their value or relevance.

This perspective then opens up the possibility of understanding the responses of those working in what I would call the post-Hegelian tradition on this issue, or the twin issues: what does it mean that the conventions of painterly credibility had clearly begun to fail in Manet, and what does that failure say about a parallel breakdown in the possibility of embodied and intersubjective intelligibility in the society in which such works were made and eventually appreciated? This would include Adorno's claim that the implicit rejection of conventional aesthetic norms in modernist art involves just thereby a "negation" of a whole regime of sense-making dominated by what he calls "identity thinking" and the totalization of instrumental rationality. It would include T. J. Clark's claim that painting can be understood as a kind of test of a society's capacity to represent itself to itself coherently, and that in visual modernism, it begins to fail that test; as well as Clark's more pessimistic claim that it is precisely by passing this test that the materialism, inhumanity, and reductionism of modern society become "visible."[1] And it would include Michael Fried's account of the growing crisis of theatricality, the declining credibility of antitheatrical strategies, culminating in the radicality, of decisive importance for all later modernist painting, of Manet's "facingness" strategy. This is especially so when this development is interpreted as a crisis of skepti-

1. There is a clear (Hegelian) statement by Clark of his approach in Clark 2001, 165: "Certain works of art . . . show us what it is to 'represent' at a particular historical moment—they show us the powers and limits of a practice of knowledge. That is hard to do. It involves the artist in feeling for structures of assumptions and patterns of syntax that are usually (mercifully) deeply hidden, implicit, and embedded in our very use of signs; it is a matter of coming to understand, or at least to articulate, what our ways of world-making most obviously (but also most unrecognizably) amount to. I think that such work is done with real effectiveness—and maybe can only be done—at the level of form. . . . What is it we do, now, when we try to make an equivalent of a world? And what does the form that such equivalence now takes tell us about the constraints and possibilities built into our dealings with Nature and with one another?" See also his comment on "modernism's metaphors" (179).

cism about the possibility of genuinely shared meaning, shared among sub-
jects in some sort of mutuality rather than in relations of subject to object,
independence and dependence.

<div align="center">II</div>

But it is also possible to identify a different kind of philosophical reflection
on art and the significance of art, one just as ambitious, in that artworks are
also said to be *bearers of truth* in some way. However, it is a tradition that
does not link such a truth either to propositional "correctness" (*Richtigkeit*)
or, as in the post-Hegelian tradition, to the reality and realization of freedom
(what it is or would be "truly" to be free).[2] Rather, on different assumptions,
one should understand the uniquely "disclosive" (*erschliessende*) power of
art in what is taken to be a much more fundamental, "ontological," even if
often still a radically historical way. A kind of fundamental truth, not for-
mulatable discursively (because always and everywhere presupposed in any
discursive claim), about the very possibility of meaningfulness, intelligibility
in all our dealings, is at stake in this tradition: the meaning of being itself.[3]
One can identify Schelling, Schopenhauer, the young Nietzsche, Heidegger,
and Merleau-Ponty as the most influential representatives of this tradition,
and it would not be an exaggeration to say that the single most representative
and influential text in this way of looking at art philosophically would be the
text of three lectures that Heidegger gave in 1936 in Frankfurt to the Freies
Deutsches Hochstift and published as "The Origin of the Work of Art."[4] The
work was preceded by two different versions of the lectures and was subject to
later qualifications and extra footnotes by Heidegger; it reveals considerable
internal tension, many obscure and not very clearly worked out claims; and

2. Heidegger is certainly also interested in the relation between his own ontological project
and the problem of freedom, but the issue does not allow easy summary. The key figure between
Hegel and Heidegger is Schelling and his 1809 freedom essay. A full consideration of that issue
would qualify somewhat the contrast between "event" and "action" as I am using it here to em-
phasize the differences between them, but not, I would want to argue, in any decisive sense.
For a discussion of Heidegger's treatment of Schelling and that essay, see Pippin 1997, 395–416.

3. I shall treat the issue of unconcealment (*Unverborgenheit*) only as it bears on "The Ori-
gin of the Work of Art" essay. But Heidegger's use and understanding of the term have a long
and complicated history (until he finally dissociates the notion from "truth") and have been
very badly misunderstood by critics. I am indebted to the discussion in Wrathall 2011 for my
sense of these historical and larger issues. See especially Wrathall's discussion in an appendix,
a Heideggerian response to critics like Tugendhat. Also indispensable is Dahlstrom 2001, esp.
chap. 5.

4. The three lectures were first published as an essay in 1950 in *Holzwege* (Heidegger 1950).

it is shadowed, like all Heidegger's work in the thirties, by the *Rektoratsrede* of 1933 and Heidegger's time in the Nazi Party, 1933–34. But for all of these difficulties in understanding and interpreting the text, Heidegger is struggling to say something of great importance about art and, somewhat indirectly in this work but more clearly later, something quite illuminating about modernist art, modernist painting especially.[5] The most famous example of art in the work (famous mostly because of the controversy it inspired)[6] is one of Van Gogh's paintings of peasant shoes, but later in his life Heidegger had a number of things to say about Cézanne that I shall try to understand in the context developed in these chapters.[7]

So for our purposes what is striking about the essay is that, as the epilogue (*Nachwort*) makes clear, Heidegger came to consider his great interlocutor about these matters to be Hegel. Heidegger calls Hegel's lectures "the most comprehensive reflection on the essence of art that the West possesses" (2008, 204), and

5. See Boehm 1989a, 271.

6. I mean the criticism by Meyer Schapiro (1994, 135–52). Schapiro never makes clear why the fact that the shoes most probably, in historical fact, belonged to Van Gogh, and not to a peasant woman, is of relevance to the *painting* as it stands, as a painting in which a certain "world" is "at work." The same could be asked (about relevance) with respect to the fact that Dutch farmers did not actually wear such shoes but rather wore clogs, which were better suited for their damp potato fields. See Thomson 2011, 117. One can think of the issue in the following way: if an art historian built an entire interpretation of some portrait by Titian assuming that it was of a certain prince, and someone discovered that it was instead a portrait of a merchant, then this sort of art-historical correction would be relevant. But if the interpretation had focused on some psychological characterization in the expression (haughtiness, say) or the relation between foreground and background and did not depend on a historical reference, it would be far less relevant. And all Van Gogh gives us in the 1886 painting is "a pair of shoes." And all Heidegger needs is that the shoes are presented in a way to suggest, with a quiet intensity, labor, toil, a daily routine of such struggle, and so forth. None of that seems to me Heideggerian fantasy or projection, although at some point all one can say is "Look at the *painting!*" as a response to Schapiro. On the other hand, Schapiro's frustration with Heidegger's inattention to the aesthetic details of the painting is understandable. Heidegger pays little attention to how the painting "does" what he says it does. Addressing one set of questions, though, needn't mean having to address all possible questions about an artwork.

7. It is also true, of course, that Heidegger was occasionally hostile to everything that would now be considered the heart of modernism in painting—all Cubist or abstract art for sure. See the summary of such remarks given in Jähnig 1989, 223–24. On the other hand, in personal remarks, he appeared more open and less skeptical. See Jähnig 1977 and Boehm 1989a. See Boehm's citation (1989a, 280) of the more hostile passages from *Denkerfahrungen* and *Der Satz vom Grund*. There is also some controversy about whether one or the other of the three examples is more important, more disclosive. Young (2004, 22) and Dreyfus (2005, 409) even consider the Van Gogh painting "anomalous." I agree with Thomson (2011, 71) that it is far and away the most important example, especially with regard to the fate of modern art.

he quotes Hegel's famous claim that art has become for us a thing of the past, *ein Vergangenes*. He agrees that Hegel's question remains the central question:

> Is art still an essential and necessary way in which that truth happens which is decisive for our historical existence, or is art no longer of this character? (2008, 205)

Heidegger agrees that at the time Hegel gave the lectures, and up until the present, the answer has been "no," but, contra-Hegel, he insists that the question is not finally decided, that art might yet again become a "way in which truth happens [*eine Weise in der die Wahrheit geschieht*]," indeed an essential and necessary way.[8]

So Heidegger agrees with Hegel that in the modern form of life there is and can be nothing "decisive for our historical existence" in artworks, but, contrary to Hegel, he counts this as a profound indictment of modern society, not a consequence of the rationalization of society itself and the superiority of the philosophical self-consciousness achieved by philosophy. This disagreement is a window onto the more fundamental disagreements, those that define the basic difference between the "realization of freedom" and the "ontologically disclosive" traditions in the philosophy of art, and they introduce us to the nearly incalculable influence that Heidegger's blistering criticisms of Western rationalism and metaphysics, and his corresponding notion of finitude, have had on what are now several generations of European philosophers.

Heidegger's account of *why* art has ceased to be able to play this important role is interwoven with sweeping claims that the Western metaphysical tradition had ended catastrophically in "nihilism," or the "age of consummate meaninglessness." In this metaphysical context, art, he says, has been understood from the point of view of "aesthetics," or the subjectivization of art's meaningfulness, the isolation of such meaning in the aesthetic or strictly sensual "lived experience" (*Erlebnis*) of individual subjects. (Such *Erlebnis*, he says, is the "element in which art dies" [2008, 204].) In an age where the possibility of truth is strictly limited to modern natural science or even "reason" and propositional knowledge in general, the artwork can accordingly *only* have such a subjective meaning, an occasion for a subjective experience of necessarily marginal, rather than central, importance.[9] If what is "real" are the material properties identified

8. Schwenzfeuer (2011) is no doubt right that Heidegger is paying such compliments to Hegel because he wants, out of "Schellingian motives" (160), to reject Hegel's approach and at the same time treat it as paradigmatic of "Occidental thought."

9. This assumption is based on the idea of an exclusive disjunction: either there are distinct aesthetic properties (like "beauty") in the world, or there are not and aesthetic characteristics are

by the sciences, then what makes a response to some such object a response to art can only be the subject's experience (*Erlebnis*), an experience that in no way bears on what there is and is instead merely responsive.

This characterization of the pernicious effects of an "aesthetic" view of art already does not sufficiently note Hegel's own dissatisfaction with a wholly aesthetic approach or the odd absence of much of any very robust aesthetic dimension to his own historicized philosophy of art. For Hegel the artistic modality of intelligibility is not discursive, but it is certainly not wholly sensual or subjective either, a mere pleasant experience.[10] For that matter, it is quite misleading to consider even *Kant's* aesthetics as a merely "subjectivist aesthetics." The Kantian experience in question is also contentful (an intimation of purposiveness), and that content can bear truth in a way (the intimation can be genuine). It is not confined within the notion of "aesthetics" and *Erlebnis* as Heidegger understands the notions.[11] *In what way* a content can bear truth will be an issue that will recur for the rest of this chapter, but Hegel's notion of an aesthetic experience cannot be the aesthetic experience Heidegger condemns if art is to be the expression and realization of the Idea, or the Absolute. (We see here the beginning of an implicit argument that is often at cross-purposes—fails to make proper contact—with the position criticized. At bottom both philosophers seek a "nonaesthetic" notion of art, and both do so in a way they think is required by the historical condition of modernity.)

Moreover, their approaches agree in two other crucial areas. Neither treats painting (for example) as tied in any essential way to representation or to the ideal of perfect verisimilitude (*Wahrhaftigkeit*) (and just thereby, for both, some way friendly to modernist experimentation is opened up). The sensible realization of the Absolute, the realization of freedom, is not something "represented" in a painting on Hegel's account but is "worked out" and thereby "realized." One could even make the Hegelian point in a Heideg-

subjectively projected. If artworks, however, are viewed more as events, the meaning of which must be interpreted as actions must be, then such events could illuminate something like what it is for meaningfulness even to be possible, and this in a way that avoids such disjuncts.

10. The thousand-eyed Argus passage from the second chapter gives us an intuitive model for this form of conceptually rich but not judgmental knowledge—what one can be said to know when one "sees in another's face" that he is lying or jealous or phony. It is probably no accident that Hegel's image is not one of the beautiful but is rather monstrous, ugly even.

11. I am suggesting that, certainly in the case of Hegel, one of the reasons that, as Bernasconi (1998, 378) puts it, "there has been relatively little scrutiny of Heidegger's attempt to free the concept of art itself from its status as an aesthetic category" is because Heidegger's characterization is too sweeping, indiscriminately catchall even. See Pippin 2008a on the "absence of aesthetics in Hegel's aesthetics."

gerian way by saying that freedom is "set to work" in a distinctive way in the reflective moment of a painting's relation to a beholder at a time. Likewise, for Heidegger, what is at issue in the Van Gogh painting is not the representation of shoes but what he calls the "world" of the peasant, again *at work* in what the painting "reveals," not in "what is represented."[12]

Similarly, in claiming that *artworks can bear truth*, neither Hegel nor Heidegger means that the works make claims or must be interpreted as making implicit propositional claims. We come close here to the heart of the matter for both of them, so we will be returning to this issue, but it is crucial at the outset to appreciate that Heidegger's ontology of the artwork is an "event" ontology, not a "thing" ontology. (Heidegger concentrates so much on the "work" character of the *Kunstwerk*, not so much to emphasize that it is worked *over* or worked *up*, but to stress what is "*at work*" in the *Kunstwerk*.) He spends a great deal of time at the beginning of his essay exploring whether a work of art is a kind of "thing," only to have it turn out that this was all a *reductio ad absurdum* of the notion. It is obviously, in some abstract, derivative sense, a thing, *just not qua artwork*.[13] A painting is some kind of embodiment of the "happening" of truth—basically, as we shall see, the happening or being at work of the "world" or horizon of possible significance that constitutes a world in various dimensions in the art of an age. The issue of "thingliness" is important to Heidegger because of his general argument (in *Being and Time* especially) about the priority, with respect to the meaning of Being, of our practical relation to objects as ready-to-hand (tools, equipment), and temples, fountains, and shoes obviously raise the issue of thingliness, but Heidegger is raising the issue to avoid misunderstandings and to reprise the *Being and Time* argument, all on the way to his real interest, this "event" ontology.[14]

Now, Heidegger is not the sort of philosopher who, having made such a point—that an artwork is not, qua artwork anyway, a thing but the "event" or happening of a kind of truth—will ask such questions as the following:

12. The relation to the beholder in this tradition is then obviously much more passive: the beholder is the one to whom the revelation occurs. There is even some sense in which this relation approaches what Adorno called a "mimetic" relation, as the beholder reexperiences what in the painting is the "*Ereignis*" of truth.

13. Heidegger (2008, 165) tells us later that this discussion of things was a mere "detour" (*Umweg*). We still need to discuss the "thingly" (*Dinghafte*) character of the work, but we need to understand it as an aspect of the "work-being of the work" (*Werksein des Werkes*) and so "by way of the work's workly nature" (*aus dem Werkhaften*). When he does so consider this aspect of the work, it will involve the most difficult and important term in the essay, the "earth" (194).

14. The bearing of the *Being and Time* treatment and artworks is brought out well in Han-Pile 2011.

How then would one individuate or identify the artwork? When, exactly, does the "event" happen? When the artist finishes the work? Each time the work is properly appreciated? What exactly is the difference between the original event, within the world that "worlds," and the event after that world has ceased to be? But for purposes of this discussion, let us assume that some satisfactory clarification of such issues can be provided by Heidegger.[15]

So Van Gogh's shoes, although they clearly do depict shoes, are, qua artwork, no more "representative" than the Greek temple at Paestum (the other example of a visual work that Heidegger uses in his exposition) was or is representative of anything, and this "architectural" notion of artistic significance—what is at issue in the temple is its embodiment of a world in a distinct way, "how things were for the Greeks," in an artistic way—is just how we are to understand what is at issue in the C. F. Meyer poem or the Van Gogh picture.[16] So the truth "happening" in the work is not any sort of correctness or adequacy but is true in the way an action can be said to "truly" manifest who a person *really is*, his true being, and possibly the world expressed in his action.[17] (Since a technological worldview can be at work in the intelligibility of a technological object, but in a "subjectivist" or "impositionist" way that distorts, undermines, closes down the comprehension of its own possibility, this situation is obviously quite complicated, and a number of distinctions have to be made.) As we saw in many ways in the second chapter, that is just how Hegel thinks of the expressive truth of an artwork, an "actional" or practical truth, let us say, a notion that also allowed us to connect the claim with Clark's notion of modernism as the "true" realization, the being at work, of the conventions of meaning available in a capitalist society and with Fried's notion of a kind of theatrical falseness in a painting's relation to a beholder. (The opposite of truth in *this* sense is not falsity but fraudulence [Cavell 1969, 213–37].)

To be sure, Heidegger wants to qualify (not, of course, reject) the notion

15. Complicated issues would obviously need to be addressed if this distinction were to be properly set out and analyzed. It is just as obviously a topic for another book. A very good and relevant one is Wollheim 1980.

16. See Heidegger's remark in the 1929 *Introduction to Metaphysics*: "A painting by Van Gogh: a pair of sturdy peasant's shoes, nothing else [*sonst nichts*]. The picture really represents nothing [*Das Bild stellt eigentlich nichts dar*]. Yet you are alone at once with what is there. As if you yourself were heading homeward from the field on a late autumn evening, tired, with your hoe, as the last potato fires smolder out. What is in being here? The canvas? The brushstrokes? The patches of color?" (Heidegger 2000, 37–38).

17. And so such a deed can end up revealing much more than what is intended by the agent, or even more than he could consciously acknowledge as "his." And just in this sense, the meaning of an artwork is also not tied to the consciously formulated intentions of the artist.

of truth as correspondence or correctness because, he argues, there is clearly a more basic or original or prelinguistic manifesting of how things are, about which we can then, secondarily, make a claim. Being able to know that the claim is true must obviously presuppose some sort of access to what is claimed that is prior to and informs, confirms, the claim itself. Heidegger's official name for this "access" is "unconcealment," or *Unverborgenheit* (at this point in his writing, his interpretation of the Greek word for "truth," *aletheia*), and it is the center of his account of how art bears truth. But first, we should not think that this can be understood in any "directly realist" sense, as if in tension with what was said above about a practical sense of truth. Such an unconcealing occurs within what Heidegger often refers to as the "horizon" of possible sense or meaning, the human world into which any subject is always already "thrown" (*geworfen*). This world should not be understood on the analogy of linguistic rules or Kantian categories or a conceptual scheme as necessary conditions. For Heidegger, any such world, on which the determinate unconcealing of any being depends and somehow brings into view, is a practical world of significance, a way in which things can be said *to matter* and are intelligible just in their mattering in the way they do. Only within such a practice-structured, historical world can the everyday familiarity we have with elements of our world be possible. Hence, there is no direct realism. (Since such a horizon of possible sense is also never directly available for persons and communities, an air of elusiveness, mystery, and sometimes vague gestures at such a horizon inevitably creep into Heidegger's account. As we shall see, this always-presupposed status is the main reason that any disclosure of a world is bound to and also *concealed* by "earth.") In *Being and Time* his chief example of such prepropositional familiarity, a kind of deeply implicit, familiar meaningfulness that is prior to any claim-making, is the being of "equipment" (*Zeug*), or tools like hammers and nails. We do not understand these objects as bits of matter on to which we project subjective uses, but we understand them originally by being able to use them, understand them by virtue of our familiarity with a whole interconnected network of "assignments" (*Verweisungen*) and interrelated possibilities. (The thought is that saying that we have beliefs about how they are to be used and that we apply those beliefs has everything backward.) But, again, we never have available for theoretical consideration that horizoned world as such, even while it is at work in us; much less could *we* ever be said to have available the ultimate horizon of any possible sense, the meaning of being itself.[18] Aspects

18. "World is never an object that stands before us and can be seen. World is the ever nonobjective to which we are subject as long as the paths of birth and death, blessing and curse keep us transported into Being" (Heidegger 2008, 33, 170).

of it show up explicitly only when, in artworks, say, such a dimension of significance "happens" in some sort of attentive, if indirect, appreciation (which Heidegger calls "preserving" [*bewahren*]).

That is, second, the "unconcealing" at issue is also understood by Heidegger as itself an event, a happening or *Ereignis* (or *Geschehen*), *not as a content of thought* or state of affair conceptually grasped. I shall have to say more about this as we go on.

III

Now we come to the great disagreement between Hegel and Heidegger, a difference that ultimately involves our basic question: the right way to think about the relation between art and philosophy. This difference concerns the details of Heidegger's account of how this event-like moment of a world's "worlding," as he calls it to emphasize this actional notion of truth, actually happens. ("The world worlds" [*Die Welt weltet*], he says [2008, 170].) Both Hegel and Heidegger, in other words, see art as an essentially historical phenomenon, a historical event (although Heidegger's narrative is declensionist, he *has* such a "grand narrative"), and for both, something of great philosophical significance is conveyed by great art, and for both, something about the modern form of life can be said to prevent, or at least make much more difficult, the continuation of this role. There is, to be sure, an obvious immediate difference between them, since Hegel understands this event as much closer to an intentional deed or action (a collective social practice), a *result* of some collective human effort, provisional in its meaning and subject to a great deal of possible social contestation, and Heidegger clearly means metaphorically something much more like an event in the normal sense, a storm or a blast of wind (more like something that happens to us than something we do). But what sets Heidegger off from Hegel most dramatically is that for him, any such philosophically significant revealing or "unconcealing" event, precisely because it is so much like a happening, is also just thereby a concealing or obscuring (*Das Entbergen im Sichverbergen*, as Günter Seuboldt [1987, 72] puts it). And as he explains this, it becomes clear that his privileging of *this* sort of manifesting—art's way of manifesting in this duality—*over* all traditional philosophy reveals as radical a critique as possible of that tradition, one that certainly, perhaps preeminently, includes Hegel's philosophy of art.[19] When Heidegger said that Hegel's reflection on art was the

19. That is, it is superior to traditional philosophy or metaphysics. Heidegger still wants a distinction between poetry and something like philosophy in his terms, postmetaphysical, which he calls simply "Denken."

most comprehensive in the West because "it stems from metaphysics" (*aus der Metaphysik gedachten*), he did not mean it as a compliment.

Heidegger, of course, concedes that an artwork is an artificial object created by a human being, but as regards what he calls its "essence" (*Wesen*), what is "at work" (*am Werk*) in the work is not the artist as such; at the most the artist's world is at work *through* the artist. And it will already be quite apparent that Heidegger insists on conducting his discussion of these matters in a somewhat mythic or poetic vocabulary all his own, inventing neologisms and new syntactical forms in order to avoid what he fears will be misleading interpretations of what he is saying. This means that there is no space here for anything like an adequate account of the details of his piece, and I shall have to omit consideration of a number of important issues. For our purposes, the main claims of the essay and the treatment of artworks come down to three claims: (1) that "truth *happens* in an artwork"; (2) that the truth that happens is the "unconcealing" of the "world" of the work, a world itself "at work" in the painting's core intelligibility; and (3) that this unconcealing is also at the same time a concealing, and in his quasi-mythic language, a "world" is in some kind of tension (*Streit*) with "earth." This last aspect is what makes the work both distinctly an artwork (the struggle is said to constitute beauty, *Schönheit*)[20] and of greater value ontologically than traditional philosophy.

As noted, Heidegger's two examples of visual works are Van Gogh's painting (fig. 4.2; pl. 4) and a temple at Paestum (fig. 4.1).[21] In interpreting the Van Gogh, Heidegger makes heavy use of his approach in *Being and Time*, pointing out that in everyday life the "equipmentality" of the shoes, their unique mode of being within an "equipmental" world, is largely inaccessible, even if also "understood" in one's appropriate, largely unthematic use of the shoes. Their mere thingness (*Dingheit*) is occasionally visible, but only when these objects cease to function and so obtrude on a subject as useless things.[22]

20. He says, with little clarification of the connection between this notion of beauty and anything recognizable in all past uses, that "beauty is one way in which the truth essentially occurs as unconcealment" (Heidegger 2008, 181). Cf. Schwenzfeuer 2011, 167, where Schwenzfeuer points out how difficult it is to understand why this "rift," or *Riss*, should be beautiful.

21. It seems that Heidegger is referring to the Poseidonia temple complex and to one of its three temples, two consecrated to Hera and one to Athena. Kockelmans (1985, 141–42) assumes that Heidegger is referring to the Poseidonia. But Harries (2009, 100) is right to point out that it is virtually impossible to identify the specific temple that Heidegger uses as an example. The point I want to make about this example does not depend on which temple in particular Heidegger is referring to.

22. Heidegger (1927, 74) speaks of various modes of failure like this: *Auffälligkeit*, *Aufdringlichkeit*, and *Aufsässigkeit*.

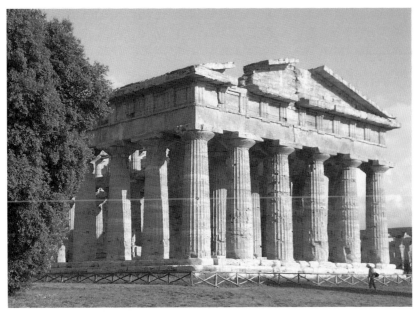

FIGURE 4.1. Second temple of Hera at Paestum. Photograph by Ballista.

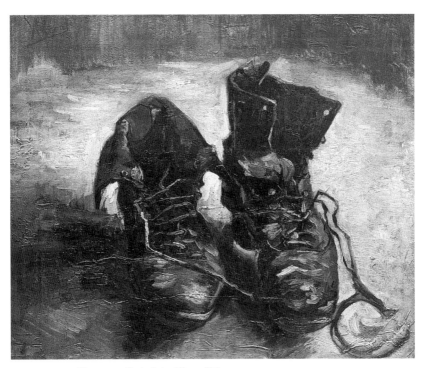

FIGURE 4.2. Vincent van Gogh, *Pair of Shoes*, 1886.

However, in the painting, this unique mode of being, these objects' funda-
mental mode of being and unique sort of familiarity, *is* in a way accessible,
even visible, apart from such use and without this obtruding. What the paint-
ing is about is not then these objects as objects but the peasant's world, within
which the shoes are what they (truly or fundamentally) are. (And, again, a
world, a horizon of possible sense, is much more something like "how" a com-
munity carries on, not what it believes in common or is committed to, etc. All
these formulations presuppose a view of what Heidegger is trying to get at.
The question of the meaning of being for Heidegger is a question about a way
or "mode" of meaningfully being. As we shall see, this is one reason that the
achievement of great painting lends itself so well to Heidegger's interests; he
interprets it as a kind of ontological poetry, revealing indirectly, in something
like its tonality or mood, what cannot be addressed directly in language or
thought.)[23] Here is a sample of Heidegger's interpretation:

> From the dark opening of the worn insides of the shoes, the toilsome tread of
> the worker stares forth. In the stiffly rugged heaviness of the shoes there is the
> accumulated tenacity of her slow trudge through the far-spreading and ever
> uniform furrows of the field swept by a raw wind. (2008, 159)

He goes on like this, and unfortunately Heidegger does not draw our atten-
tion to the many unusual sensible aspects of the actual painting (fig. 4.2): the
extraordinary vitality or even vibrations "pulsing" through the objects, their
oddly intimate and sensual relation to each other, an almost female (left) to
male (right) relation, the way the colors set up and intensify this dynamism
in the painting,[24] and the effect of the isolation of the shoes in a kind of place-
less nowhere, further dramatizing the way they carry their unique world with
them.[25] (We can see this by noting the differences with other pictures of shoes
by Van Gogh; see figs. 4.3, 4.4.) We shall have to ask shortly about Heidegger's
indifference to the painterly qualities of the work, thrust so visibly into the
foreground in modernist works like this. Moreover, it would be a mistake to
think that Heidegger wants to say that all the elements described in this sen-
tence make up something like the *content* of the *painting's* meaning. None of
this "rugged heaviness" or "slow trudge" is "happening" in the "event" of truth

23. I defend this interpretation (that the *Seinsfrage* for Heidegger is a question about the
"Sinn des Seins") in Pippin 2005c, 57–78; and forthcoming.

24. Cf. Boehm 1989a, 272ff., on the use of color and what has to be added to Heidegger's
account of the Van Gogh painting.

25. Heidegger does mention that we don't know where the shoes belong, that their location is
simply "ein unbestimmter Raum" (2008, 159). For more on the issue of what isn't in the painting,
the absence in the background especially, see Thomson 2011, 84–90.

FIGURE 4.3. Vincent van Gogh, *Shoes*, 1888. The Metropolitan Museum of Art, Purchase, The Annenberg Foundation Gift, 1992 (1992.374).

being "unconcealed." The event is more like *the event of meaningfulness itself*, inflected in a historical way, the being at work of the peasant's world, "set out" in the painting; and Heidegger is merely imagining aspects of *that world* for us.

Here are the kinds of things he wants to conclude from this:

> The equipmental quality of equipment was discovered. But how? Not by a description and explanation of a pair of shoes actually present . . . but only bringing ourselves before van Gogh's painting. The painting spoke. In the nearness of the work we were suddenly somewhere else than we usually tend to be.

And,

> The artwork lets us know what shoes are in truth. It would be the worst self-deception to think that our description, as a subjective action, had first depicted everything thus and then projected it into the painting. . . . Rather the equipmentality of equipment first expressly comes to the fore [*zu seinem Vorschein*] through the work and only through the work. . . . What happens here? What is at work in the work? Van Gogh's painting is the disclosure [*Eröffnung*] of what the equipment, the pair of peasant shoes, is in truth. This being emerges into the unconcealment [*Unverborgenheit*] of its being. The Greeks

FIGURE 4.4. Vincent van Gogh, *A Pair of Shoes*, 1887.

called the unconcealment of beings *aletheia*. . . . In the work of art the truth of beings has set itself to work [*ins Werk gesetzt*]. "To set" [*Setzen*] means here "to bring to stand" [*zum Stehen bringen*]. Some particular being, a pair of peasant shoes, comes to the work to stand in the light of its Being. The Being of beings comes into the steadiness of its shining [*seines Scheinens*]. The essence of art would then be this: the truth of beings setting itself to work [*das Sich-ins-Werk-Setzen der Wahrheit des Seienden*]. (2008, 161)[26]

We should note again that none of the *details* about the peasant's world interest Heidegger in this summary. Rather, he is interested in evoking with these remarks something much larger in scope than such empirical details. What is "at work" is solely the "equipmentality" of this piece of equipment, the *Zeugsein*, and that *Ereignis* cannot be said to have a "content" in the usual sense. It is what makes the "content" that Heidegger intimates possible and is what is important in his sense of the "riddle" of art (*Rätsel der Kunst*), as he had called it in the epilogue.[27] (Heidegger says that he is not trying to

26. Jähnig (1977) is right that this last sentence has to be counted as the core thesis of the essay, even if every key word—"das Werk," "setzen," and "die Wahrheit"—is deeply ambiguous.

27. It would be too much to say that for Heidegger art's "Ereignis" is contentless; it is rather that it has no content in the sense that a concept or a perception can be said to have content.

solve this riddle; the real task, which he clearly feels we have not at all accomplished, is to see the riddle or enigma as such in the first place.) This is why he is absolutely not trying to say that this peasant world is what is represented in the work. He claims to have chosen an example of "nonrepresentational" art (*das nicht zur darstellenden Kunst gerechnet wird*).[28] It is, of course, important that the world is a farmer's. Heidegger is certainly trying to evoke what it means that we occupy a world with both a nourishing and a resistant "earth" and is alluding to his own view of art, as if the painting allegorizes its own relation of materiality and disclosure, the work of the artist. But that is not represented or pictured. It "happens" in the painting. In the most general sense Heidegger is trying to reanimate the question of the relation between "beauty" and "truth," but where the beautiful is not understood as a matter of the subject's experience, or *Erlebnis*, and where truth is disclosure, *aletheia*, and not "correctness."[29]

What is perhaps most immediately interesting about these remarks is that they are in the essay at all. After all, Heidegger had agreed with Hegel that art is *no longer* of any decisive importance for our historical existence, and this means, repeating in the epilogue his own language from these remarks about Van Gogh, that art is no longer an essential and necessary way in which "truth happens." However, Heidegger appeals to a modernist and experimental work and one in which it apparently *does* "happen.[30]

To be sure, what he evokes in reflecting on the painting seems tinged with nostalgia for a world that barely exists anymore, a machineless, pre-

Nevertheless, his position still subjects him to some of the criticisms raised by Hyland (1971). Hyland's account is also relevant to the closing paragraphs of this essay, below.

28. Jähnig (1977, 130–31) gets this right. The best account known to me of the significance of the "work character" of the work of art, especially the temporal implications of such an ontology ("die prozessuale Existenzform des Werkes" [Boehm 1989a, 266]), is Boehm 1989a. Heidegger himself makes this relative indifference to determinate content explicit when he writes: "Das Bild, das die Bauernschuhe zeigt . . . bekunde[t] nicht nur, was diese vereinzelte Seiende als dieses sei, falls sie je bekunden, sondern sie lassen Unverborgenheit als solche in Bezug auf das Seiende im Ganzen geschehen" (1950, 44).

29. On this issue, see the interesting discussion by Taminiaux (1982, 179ff.).

30. I am continuing to call rather capaciously the "Manet-to-Pollock" cycle in painting "modernist," well aware that many reserve the term for a strain of European art, especially nonrepresentational art, after Cézanne. Also I am, for reasons of space, not treating here Heidegger's account of art's "founding" (*stiften*) role. He must mean something here like a new dimension or some new aspect of how a community goes on, not its literal coming into being; otherwise, as Harries (2009) points out, Heidegger would be claiming that an entire world is "founded" whenever a new temple is built.

modern, primitive peasant world that Heidegger always seemed fond of.
But even so, the way that world is "at work" is in a modernist painting of
remarkable, even revolutionary originality, and Heidegger does not treat
the artwork as a mere museum piece, a relic, or a work of mourning for lost
worlds. This is already an indication that we do not need to posit (as some
have)[31] a great change in Heidegger's thinking to a more modern-friendly ac-
ceptance of modernist work after the thirties. Already in "The Origin of the
Work of Art" essay, Heidegger seems to be accepting that, although art may
not have any world-historical significance, may not play any decisive role in
the "founding" (*Stiften*) of a world for a historical *Volk* (the focus of much
of his interest in these politically charged years), it still has a decisive role in
something like the nonpublic *preservation* of, an appreciation for, to use his
enigmatic words, *the way* truth happens. The implication is that this in itself
can help to block the forgetting of being or the totalization of the technologi-
cal worldview or "en-framing" (*Ge-stell*).

But there is also another side or element to his account of how this hap-
pens, and it is the decisive moment of disagreement with Hegel and the tradi-
tion of Western metaphysics. This element surfaced in his account of Van
Gogh but was not highlighted, as Heidegger concentrated there on the paint-
ing's capacity for unconcealment. But he remarked on the closeness to the
earth manifested in the peasant's world and suggested that the painting itself,
in its stillness and repose, something like the intimation of silence, mani-
fested another and more artistically significant notion of earth. The theme
also surfaces briefly in the allusions to semblance or "shining," in the fact that
the painting is *not* a part of the peasant world or any element of it but is its
appearance or shining through. This will come to mean that, as something
other than—*not*—that world, the painting has to be said to conceal as well as
reveal.

Heidegger's word for this "concealing" aspect of art is "earth" (*Erde*), and
he proceeds to develop a thesis that is not so prominent in his later work on
art: the "strife" (*Streit*) between world and earth, between unconcealing and
concealing, in the being at work of truth in any artwork. (That is, the "strife"
aspect is not emphasized, but the necessary belonging-together of reveal-
ing and concealing remains a decisive fixture, perhaps the defining aspect,
of Heidegger's later thought.)[32] The discussion of this is concentrated in his
remarks about the Greek temple at Paestum (fig. 4.1). His formulations about

31. See, e.g., Young 2004.
32. Compare on this point the approaches in Young 2004 and Harries 2009, and see the
narrative of Heidegger's development in Wrathall 2011.

this aspect are among his most difficult, but in his remarks on the stone of the temple or paint colors, he is interested not merely in what is often called "the medium" of the work. (The idea that the materials of the medium, by virtue of their limitations, impede or prevent or conceal the full "setting out" of a world is a version of Neoplatonist theories of art, not quite what Heidegger is after.)[33] Rather, he is after something crucial in any disclosing (any way of appreciating and acknowledging), through artworks, of the most fundamental and important human question—the meaning of being: that this unconcealing is also and necessarily an obscuring or concealing.[34]

As noted, Heidegger's language is elusive and is designed to prevent easy paraphrase:

> The setting up of a world and the setting forth of earth are two essential features in the work being of the work. They belong together, however, in the unity of work-being. This is the unity we seek when we ponder the self-subsistence of the work and try to tell of this closed, unitary repose of self-support. (2008, 173)

This is all so elusive that one might be tempted to interpret it as some commentators have, in a relatively anodyne way. Any revealing, or "unconcealing," is, after all, bound to be partial. By revealing any one aspect of the "world" or "destiny" of some "historical people" (*Geschick eines geschichtlichen Volks*), say the aspect of theological intelligibility manifest in the temple at Paestum, other aspects of their way of being are closed off, not in view, hidden from us in the way that the back side of the moon is hidden when we see its front; in this case, say, the social dimensions of the religion are much more available at festivals.[35]

33. Heidegger makes clear that he is not talking about merely the material of the medium, that the Greek equivalent for this term is not *hyle* but *physis*: "Dieses Herauskommen und Aufgehen selbst und im Ganzen nannten die Griechen frühzeitig die physis. Sie lichtet zugleich jenes, worauf und worin der Mensch sein Wohnen gründet. Wir nennen es die Erde" (1950, 31). On the other hand, he portrays the artist as guiding or steering the inherent potentials of the physical medium to an expression of what is implicit in it. See Boehm 1989a, 265, and at 268: "Die Physis des Werkes ist etwas anderes als Stoff." Cézanne's gardener (see the concluding discussion below) is something like the image meant, tending rather than forming.

34. Dreyfus (2005, 412) understands this struggle as an unavoidable conflict of interpretations, the result of the object's "materiality" resisting "rationalization." See also Thomson 2011, chap. 3.

35. This is the interpretation of Julian Young (2004). What Heidegger says is obscure enough that Young may be right that this is all that is involved. But Heidegger does say that the "concealment" he is interested in "is not simply and only the limit of knowledge in any given circumstance" (2008, 178–79, 42); that is, he does not mean untruth as the not-yet-known truth.

But this does not correspond to what appears to be an insistence by Heidegger that, by revealing anything, an artwork is *just thereby also* concealing *what* it is revealing, not merely concealing some *other* aspect that, in principle, is accessible in some other way. This is a hard thought, but what he says is much stronger than the anodyne or commonsense interpretation:

> The earth appears openly cleared as itself only when it is perceived and preserved as that which is *essentially undisclosable* [*wesenhaft Unerschließbare*], that which shrinks from *every* disclosure and constantly [*ständig*] keeps itself closed up [*sich verschlossen*]. (2008, 172, my emphasis)

He even goes so far in this emphasis as to say, "Truth in its essence is untruth" (*Die Wahrheit ist in ihrem Wesen Un-wahrheit*) (2008, 179).[36] This suggests that he does not mean by what remains unconcealed any limit beyond which there is a truth beyond our grasp, nor that there is always more to reveal, nor that the medium prevents a full "worlding."

What could all this be about?

IV

What is at stake for Heidegger, I want to suggest, is an aspect of his notion of human finitude that plays a large role in his profound dissatisfaction with the philosophical tradition and in his deep dissatisfaction with Western modernity, an aspect of his thought very much at play in these chaotic political years and in his enthusiasm for art. What he is suggesting is the unavoidability of a certain self-interrogation as distinctive of the human mode of being, but at the same time he wants to insist just as strongly on the fundamental impossibility of satisfying such an unavoidable self-interrogation—certainly not in philosophy or any other reflective discourse. (He also clearly wants to suggest that a proper way of *acknowledging* this situation has not been appreciated, that it requires a wholly different mode of exploration, which he often in his later phase simply calls *Denken*.) This is all especially so in modernity, where, given the arrogance of modern technological self-understanding, that question of this unique but limited self-interrogation threatens to be permanently forgotten, or would be, were it not for the "preserving" function of art. As

36. I note here the fact that Heidegger, in the marginal notes to the 1956 Reclam edition, while he never retracts anything essential in "The Origin of the Work of Art" essay, does express some regret about the confusions that arise from his treating *Unverborgenheit* and *aletheia* as "die Wahrheit." The real question, he says, is "inwiefern es Anwesenheit als solche geben kann" (1977b, 1).

noted before, that question is also an important beginning to a vast amount of European thought influenced by Heidegger—an insistence on the indeterminacy, unresolvability, and opacity of all language and thought and an indictment of "the metaphysical tradition" for ignoring this fundamental barrier to any fully self-reflexive and self-authorizing thought (that Hegelian dream).

There is thus something of the atmosphere of *Being and Time* surrounding his art theory. In that work, while *Dasein*—his word, approximately, for human being—is "called" to account with respect to the question of the ground of its own being, its ultimate responsibility for itself, it discovers that ground to be a "nothing." That is, no resolution of the problem of the meaning of its being, the point or purpose of human being that would support some way of things mattering and some way of their not, can be achieved by knowledge. So *Dasein* can be what it truly is only by being "guilty," or responsible (*schuldig*) by *not* being, or pretending it can ever be, in any final or substantial way at all. Likewise in his art theory one can note that Heidegger thinks it a great mistake (indeed, it is the original sin, in some sense, of Western metaphysics or philosophy as a whole after Plato) to try to separate what he has been calling here "world" and "earth," in effect *to correct for* the materiality and opacity of "earth," the body and its passions, finitude, so that "world" or the ideas or Reason can be transparently visible. Although the notion of some sort of "mistake" or hubristic resolve, a decision by Plato, is an odd notion, it is clear that Heidegger thinks that this insistence on the "belonging-together of world and earth" is what is rejected by philosophy after the Socratic enlightenment up through the modern scientific enlightenment, with nihilistic consequences.

We can bring this claim to a visual point and conclusion by concentrating on some of Heidegger's brief remarks about his deep admiration for Paul Cézanne. With the exception of one piece of writing, a kind of poem (*Gedichte*)—or a "*Gedachtes*," as he called it—to celebrate the birthday of René Char in 1963, the remarks are either in letters or secondhand, recorded by others, many by H. W. Petzet, from the first conversations in 1947 until the end of his life. We also, thanks to Petzet (1993), have a good sense of what Cézannes Heidegger saw and where, and how much he especially admired the late paintings of mont Sainte-Victoire. These remarks are extremely laudatory: that Heidegger's own path as a thinker can be understood as a response in his own way to Cézanne's path as a painter; that, speaking of being in Aix-en-Provence, "These days in Cézanne's home are worth more than a whole library of philosophical books. If only one could think as directly as Cézanne painted" (Buchner 1977, 47).

Moreover, many of the innovations in painting now associated with Cézanne already have a somewhat Heideggerian tonality. Cézanne's famous

remark that he "wanted to make Impressionism something solid and durable like the Old Masters" already indicates a dissatisfaction with the implied location of perceptual intelligibility in subjective impressions of light and color, in effect desubstantializing the object.[37] (As Merleau-Ponty put it, Cézanne rightly rejected the notion that what we see, as in Impressionism, is the outside of things, mere "envelopes," and that we then infer "insides." As he put it: "I do not see it [spatial relations and objects in space] according to its exterior envelope; I live it from the inside; I am immersed in it. After all the world is around me, not in front of me.")[38] The apparent absence of a human, or at least "subjectively" human, frame of significance in the paintings[39]—that is, the great stillness of the scenes (hardly ever any wind,[40] the water always calm, no credible motion anywhere), the gravity and solemnity of the mise-en-scène, the neutrality of light, the density and solidity of the objects just as objects—all make a kind of Heideggerian point about the brute "presence" of beings, a theme I shall return to (figs. 4.5, 4.6). Often, of course, this density and solidity and the sense of the perceptual world as "its own world," even its strangeness in its mute presence, not mere "material" for our visual organization, are striking in a disturbing way when we see what this means for human figures, who can appear as object-like, merely as present as beings (Seiende), as any object (figs. 4.7, 4.8).[41]

But this stillness is also accompanied by an extraordinary vitality or vibrancy, even a kind of vibration or pulsing life in the objects, somewhat more subtly and so more forcefully than in Van Gogh. No one has described how Cézanne achieves this better than Clement Greenberg. Consider first the phenomena that Greenberg is talking about (fig. 4.9):

37. Clement Greenberg has what must be the best, most economical summation of this point: Cézanne "was making the first pondered and conscious attempt to save the key principle of Western painting—its concern for an ample and literal rendition of stereometric space—from the effects of impressionist color. . . . Like Manet . . . he changed the direction of painting in the very effort to return it by new paths to its old ways" (Greenberg 1971, 50).

38. Merleau-Ponty 1993, 138. See also: "painting evokes nothing, least of all the tactile. What it does is entirely different, almost the inverse. It gives visible existence to what profane vision believes to be invisible; thanks to it we do not need a 'muscular sense' in order to possess the voluminosity of the world. This voracious vision, reaching beyond the 'visual givens,' opens upon a texture of Being of which the discrete sensorial messages are only the punctuations of the caesurae. The eyes live in this texture as a man in his house" (127).

39. "The objects (what is 'present') are no longer fixed in their significance by the horizons of a metaphysical world view or by a pragmatic frame of reference ('presence'). Objectivity is reduced to the basis that makes it possible, to its 'bestowal, generation, occurrence'" (Jamme 1990, 40–41).

40. A spectacular exception is The Great Pine (1895–96, now in São Paolo).

41. For an overview of these characteristics of Cézanne's work, see Novotny 1937. And on The Bathers, see Boehm 1989a.

FIGURE 4.5. Paul Cézanne, *Still Life with Apples and Pears*, 1885–87. The Metropolitan Museum of Art, Bequest of Stephen C. Clark, 1960 (61.101.3). Photograph by Malcolm Varon.

FIGURE 4.6. Paul Cézanne, *Still Life with a Ginger Jar and Eggplants*, 1890–94. The Metropolitan Museum of Art, Bequest of Stephen C. Clark, 1960 (61.101.4).

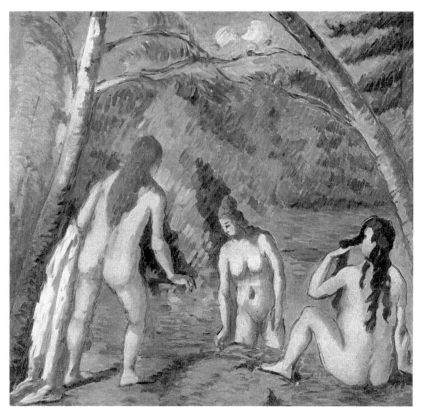

FIGURE 4.7. Paul Cézanne, *Three Bathers*, 1879–82.

Every brush stroke that followed a fictive plane into fictive depth harked
back—by reason of its abiding, unequivocal character as a mark made by a
brush—to the physical fact of the medium; and the shape and placing of that
mark recalled the shape and position of the flat rectangle which was being
covered with pigment that came from tubes. . . . The illusion of depth is con-
structed with the surface plane more vividly, more obsessively in mind; the
facet planes may jump back and forth between the surface and the images they
create, yet they are one with both surface and image. Distinct yet summarily
applied, the square pats of paint vibrate and dilate in a rhythm that embraces
the illusion as well as the flat pattern. (1971, 55)[42]

42. What Greenberg is describing here has more resonances and is of greater importance
than can be discussed here. Compare, for example, an equally arresting passage, with much the
same emphasis (about the relation between the "logic" of the painting as painting and what it
depicts), in Boehm 1989a, 274. And then see Clark's account of Picasso and the "aporias and
undecidables of illusionism" and what he calls the situation of "deadlock, faceoff, warlike coex-
istence of readings, intermittence, outright (uncanny) duality" (2001, 203).

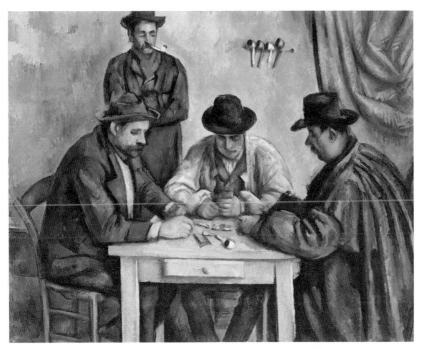

FIGURE 4.8. Paul Cézanne, *The Card Players*, c. 1890–92. The Metropolitan Museum of Art, Bequest of Stephen C. Clark, 1960 (61.101.1).

For philosophers like Heidegger and Merleau-Ponty, the meaning of this painterly effect, the "vibration," is some intimation of the object's actually *coming into being*, its "*birth*," as if composing itself (not its coming into *existence*, but its taking intelligible form). Here is how Merleau-Ponty describes it:

> The painter's vision is not a view upon the outside, a mere "physical-optical" relation with the world. The world no longer stands before him through representation; rather it is to the painter to whom things of the world give birth by a sort of concentration or coming-to-itself of the visible. Ultimately the painting relates to nothing at all among experienced things unless it is first of all "autofigurative." It is a spectacle of something only by being a "spectacle of nothing," by breaking "the skin of things" to show how things become things, how the world becomes world. (1993, 141)

And, "He [Cézanne] wanted to depict matter as it takes on form, the birth of order through spontaneous organization" (1993, 63). The painting realizes, makes actual from bits of paint and their spatial relation and material qualities, not just "what it is" to be a spatially located empirical object but, let us say, a meaningful object with its own tonal significance (majesty, sub-

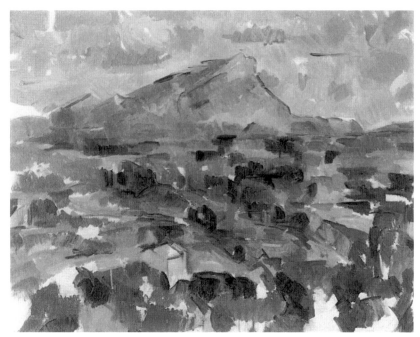

FIGURE 4.9. Paul Cézanne, *Mont Sainte-Victoire Seen from Les Lauves*, 1902–6.

limity, indifference, strangeness, and so forth), realized in paint *in the way* it is realized in and out of its sensible constituents in perception. (Once art begins to free itself from a mimetic realism, this different sort of realism, at the level of ontology and ontological meaning, is possible, and this is another otherwise unusual attraction of modernist art for Heidegger. And this is another reason he insists that Van Gogh's painting is not representational; what one "sees" in the painting is not what one can see either by looking at or using a pair of shoes. All one needs to enter the world of Heidegger is in effect a concession that this is true, and then one can entertain the idea that the painting can make present the "mode of being" of such objects of use in a way that a discursive account or even actual use cannot.) In a sense, a sense that will be stressed by Greenberg below, we can see such a relation between materiality and formal significance "happening." And *the painted object itself* is so constituted, has thus come to be; it is not a mere occasion for a subjective projection of such meaning. This is supposed to be the same process described in phenomenology, after a phenomenological reduction of the natural attitude, when the object, as it is for consciousness, as it means what it means for consciousness, is understood as both so materially con-

stituted and formally significant (and not a mere two-dimensional facing plane).[43]

Heidegger has serious reservations about this use of the matter-form structure, but Merleau-Ponty is certainly echoing what is important to Heidegger about the "event" of an artwork. Neither Cézanne nor Heidegger nor Merleau-Ponty, of course, believe that Cézanne is depicting objects literally coming into existence, as if popping up from nowhere. They mean to say that it is "as if" everything of relevance to the *bare* intelligibility of the object, its simply and meaningfully being there at all, occupying space, confronting us in a kind of mute presence, can be somehow "made visible" in the painting, in some way that cannot be attended to directly but is nevertheless powerfully present.

But the deepest connections between them are apparent in Heidegger's *Gedachtes*. Here is the "poem" (or poem-like "thought"):

> Das nachdenksam Gelassene, das inständig
> Stille der Gestalt des alten Gärtners
> Vallier, der Unscheinbares pflegte am
> Chemin des Lauves
>
> Im Spätwerk des Malers ist die Zweifalt
> von Anwesendem und Anwesenheit einfältig
> geworden, "realisiert" und verwunden zugleich,
> verwandelt in eine geheimnisvolle Identität.
>
> Zeigt sich hier ein Pfad, der in ein Zusdammen-
> Gehören des Dichtens und des Denkens führt? (1977a, 223)[44]

> The thoughtfully serene, the urgent
> Stillness in the form of the old gardener
> Vallier, who tended the inconspicuous on the
> Chemin des Lauves
>
> In the painter's late work the twofoldness
> Of what is present and of presence has
> Become simple,
> "Realized" and at the time intertwined,
> Transformed into a mysterious identity.

43. The best account of this similarity with phenomenology, and this feature of Cézanne, has been provided by Boehm (1988, 54–66).

44. The discussion in Seuboldt 1987 is quite helpful on this poem, as is the discussion of the Heidegger-Cézanne relation in Seuboldt 2005, 106–22.

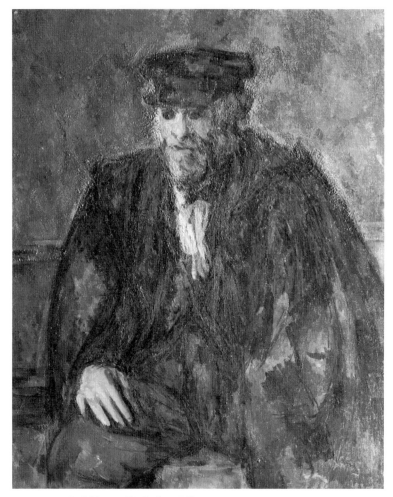

FIGURE 4.10. Paul Cézanne, *The Gardener Vallier*, 1905–6.

Is a path revealed here, that, in a state of
Togetherness of poetry and thought, guides?

It is clearly important to Heidegger that Vallier is a gardener, someone
who works with the natural world, tending rather than mastering it (figs.
4.10, 4.11).[45] But this also again means that Heidegger leaves unspoken the
fact that now, in the mid-twentieth century, the invocation of such a world is
a mere expression of nostalgia, a kind of relic (or, even worse, a hobby). The
only point Heidegger can be making in his homage is a metaphorical gesture

45. I have no idea which "Valliers" Heidegger might have actually seen.

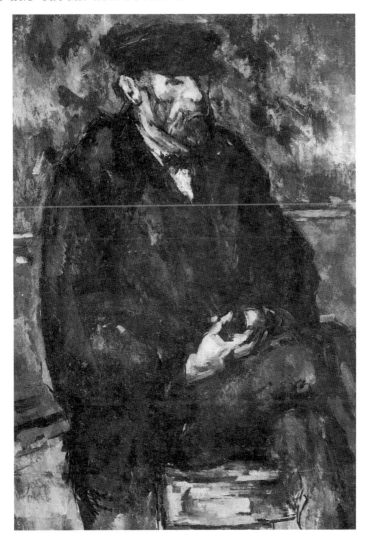

FIGURE 4.11. Paul Cézanne, *The Gardener Vallier*, 1906.

toward another mode of a fundamental relation to "there being anything at all," one that is, we seem compelled to say, more humble, less purely predatory than the stance of modern subjectivity—something like this gardening relation. But it is not clear, I want to say, that *the painting* is such a gesture.

And "mysterious identity" (*geheimnisvolle Identität*) returns us to the issue of what Heidegger means by "earth," the enactment in artworks of a human dependence on a source or condition of meaningfulness that cannot be revealed, or unconcealed, even as *its being at work can* be revealed. The heart of his homage to Cézanne occurs in the second stanza.

In the painter's late work the twofoldness
Of what is present and of presence has
Become simple,
"Realized" and at the time intertwined,
Transformed into a mysterious identity.

That the duality of what is present, visible at the same time as that which makes possible such present being—presencing, as it were, and presence, *Zweifalt von Anwesendem und Anwesenheit*—is Heidegger's way of making the point made above by Merleau-Ponty about the "birth of being": that Cézanne can intimate an elemental, even brutish, intimidatingly mute, level of "sheer" meaningfulness, as if coming in to the horizon of such possible, minimal meaningfulness, while also showing something of the condition of its possibility in the meaning of being in general, the "realization" of that possibility in various modalities, still lifes, landscapes, human figures, buildings.

And it is true that Cézanne's favorite word for what he was doing is what Heidegger explicitly echoes here—*réaliser*—that he did not want to copy nature but *realize it in painting*. As noted before (as Cézanne noted), he does not mean a mimetic realization but a making-present at an ontological level, a way of evincing the object's mode of being, the world within which it is, familiarly, what it distinctively is. However, that aspect of Cézanne's project— that *he* is realizing nature *in paint*—has dropped out of Heidegger's reformulation.[46] It is the *Zweifalt* that is realized, realizing itself, and this is happening "in" the late work of the painter, not by him. But as with the painting by Van Gogh, this means that Heidegger is ignoring that the elements of meaningfulness are dual in another way; they have a logic all their own *in paint*, and the tension between the logic of painterly composition (in the late landscapes— colored planes, essentially) and the image depicted (or in late Cézanne, more intimated than depicted) is, as Greenberg pointed out, what one is struck by immediately in especially the late Cézannes (as if our attempt to make meaning meets but cannot reveal its modern, and so ever less available and "living," prediscursive conditions).

If we take our bearings from this feature of the work, one would have to say that the elemental or fundamental character of Cézanne's paintings, the sense one gets of matters being stripped down to essentials, is rather an indication that this rather brute level of meaningfulness is, by implication, *all Cézanne can count on achieving, what is credibly available in Cézanne's*

46. Cf. Boehm 1989b, 26: "What these attempts have in common is that they seek not to represent things through art, but to illuminate the essence of reality by art."

"*world*," a minimum that can seem the result of some loss, a reduction to elementality, not a matter of some Heideggerian fullness of being, and this in a world where "nature" (as a potentially "living" source of meaning) might be said to be retrievable at all only in paint.

I mean first that in a kind of nice irony, *réaliser* is Hegel's word too, one of his most important, *verwirklichen*, and it echoes in Cézanne the Hegelian insistence that however "dependent" on a prior commonly shared "shape of Spirit" (*Gestalt des Geistes*), any such inheritance must also be "worked out" (*herausgearbeitet*), and this in a way also provisional, with a performative dimension that implicates as well its possible reception and revision in a public of beholders.[47] None of this simply "happens" *in the work*. It happens "in between" the relation between what is attempted by the artist (the idealized maker postulated in accounting for the work's intentionality) and the responsiveness of beholders. *The logic of aesthetic intelligibility is the logic, the social logic, of a deed, not a mere event, even a "happening of truth" event.* This was Hegel's account of the importance of art, and it is central to both the lack of any duality between *Natur* and *Geist* in Cézanne and their necessary cooperation in any "unconcealing" of meaningfulness in any sense.

Moreover, appreciating this point reintroduces a more concrete historical dimension to Heidegger's discussion. His account is historical in that it subjects human beings to a dependence on a kind of historical fate, how things happen to come to mean what they do, given some *Ereignis* or other. But such an account is quite deliberately portrayed as elusive, available only by also being absent, if, for Heidegger, something fundamentally ontological is to be at stake. "What" is unconcealed, insofar as such a notion gets any grip at all in Heidegger, is the event character of truth in his sense, its being such an *Ereignis*. The equipmentality (*Zeugsein*) of Van Gogh's shoes "shows up," but not in any way in which anything further should or could be said about shoes or work or agricultural labor under modern conditions, in an exchange economy, and so forth. (Anything further and we would not be respecting the duality of *Welt* and *Erde*, the closed-off character or unavailability of a determinate *Welt* as such.)

Appreciating this point will also allow one to note something Heidegger does not mention: the extraordinary strangeness of some elemental aspects

47. That said, it is not immediately clear if the sense in which Cézanne (and Boehm) means "*réaliser*" is Hegel's. We would first need a full understanding of what Hegel means by understanding Nature and *Geist* as the actualization (*Wirklichkeit*) of the Idea. In both cases, however, we can say that neither Cézanne nor Hegel means realization as a mimetic reproduction of the looks of things; rather, they understand it as a way of making present their reality as experienced. See Boehm 1988, 59–61, on "seeing" and "reading."

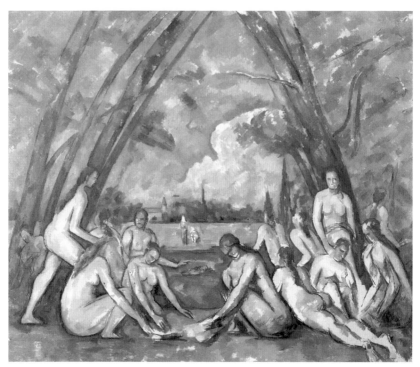

FIGURE 4.12. Paul Cézanne, *Large Bathers*, 1906.

of the *human* world, as it must have seemed to Cézanne, as it had become in the world to which Cézanne was trying to do justice. This strangeness is already intimated in the paintings of human figures we have already seen, the card players, and indeed in the wholly depsychologized figure of Vallier himself. But that strangeness reaches a wholly bewildering point in the three large paintings that Cézanne labored over so long at the end of his life (figs. 4.12–4.14; pls. 5–7).

One can only suggest here that the elemental or alien, brutish, either absolutely isolated or bizarrely merging (fig. 4.15), barely gendered figures,[48] figures who look more like flesh sacks (they don't appear to have bones or joints), who often appear indistinguishable from one another, and who do

48. See Boehm 1989b, 28: "The articulation of the picture replaces that of the body." I wouldn't, though, call this transposition a "paradise," as Boehm does in the title to this piece. See also the helpful discussion of "*réaliser*" in Boehm 1988, especially the citation of Musil's notion that the "*Möglichkeitssinn des Künstlers*" underlies the "*Wirklichkeitssinn*" he is able to evoke (59). "Realisieren meint eine malerische Verwirklichung, die keine andere Mittel der Dingwerden besitzt als die der Farbe" (63).

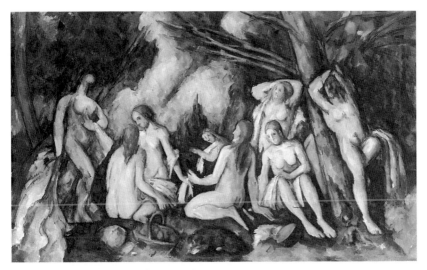

FIGURE 4.13. Paul Cézanne, *The Large Bathers*, 1895–1906.

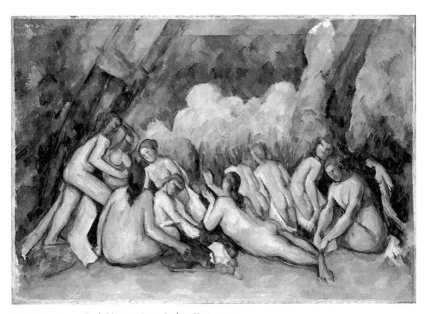

FIGURE 4.14. Paul Cézanne, *Large Bathers II*, 1894–1905.

not occupy space as much as are laid flat onto a plane. The figures whom we see in these three great paintings of bathers are not a manifestation of any ontological truth as much as they are simply "what remains" as a possible level of shareable intelligibility in a situation of ever greater "worldlessness," or, as Heidegger himself says about animals, the world-poor

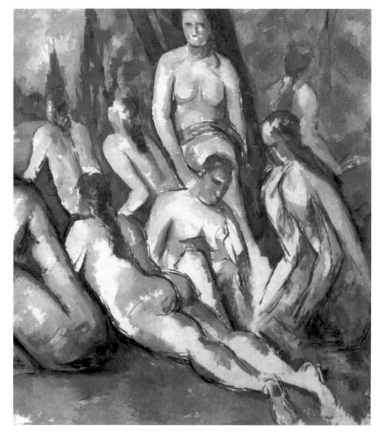

FIGURE 4.15. Detail from *Large Bathers*, 1906.

(*Weltarm*) contexts for such art. We seem pressed into intimations of a level of materiality[49] and quite basic but primitive and merely gestural meaning (of a sort that would be ever more apparent in modernist sculpture and later experimentations in painting) that are at once striking, recognizable, and, in Cézanne's context, frightening because *so* minimal, elemental, and just thereby resistant to any determinate interrogation. It would be flippant and somewhat cartoonish, but not wholly incorrect, to say that if there is something to the notion of a struggle, or *Streit*, between earth and world in painting, then in Cézanne's paintings of bathers (in a way that evinces something

49. Clark constructs an interpretation of the "Bathers" series of paintings and materiality that invokes Freud: "It shows us the moment of inconsolable clinging to infantile sexuality" (2001, 149). And he must be on to something, especially given the rather brutal sexuality of the Barnes *Bathers*. See also in this regard Schapiro 1982.

of the resources of Cézanne's historical world), earth is "winning." Or, one dimension of the amphibian status of the bathers seems in the process of "taking over," the distinctly human world now "far off," across the river.[50]

Using Hegel's characterization, I suggested in the first chapter that the striking gazes in Manet's paintings in the 1860s and beyond were best understood as interrogative. They raise at once the question of the point of modern easel painting and at the same time the possibility of social relationships responsive to the challenge raised in the gazes, a challenge to the possible embodiment of mutually achieved meaning in sensible materiality. This question is as crucial for any possible mutual intelligibility of action as it is for a possibly successful art in emerging modern, capitalist, mass consumer societies. Manet's foregrounding of the painterly details of his works (his suspension of some of the norms of pictorial illusionism and his willingness to concede the flat, rectangular reality of the framed object) is of a piece, from this Hegelian perspective, with his foregrounding of the challenge in those gazes. (The intimation is of mere materiality—brutally minimal meaningfulness.) Cézanne's late bather paintings could be understood as expressing the ever more limited possibilities of *answering* those questions, or perhaps intimations of the suspicion that they cannot be answered or that they can be answered only at the level of the shareability of a rather brutish material meaning. (Said in a more Hegelian way: we have not brought about, realized, a world in which Manet's challenge can be met.) They are nevertheless extraordinarily powerful, effective *paintings* despite those limitations because Cézanne has found a way of keeping those questions alive, and so continuing to draw the beholder into the paintings and so into those questions. Moreover, the paintings, all of them, the still lifes, the landscapes, and the figural paintings, exude such an immense self-confidence in the possibility of even a much more reduced or narrower frame within which Manet's questions can continue to be interrogated, and in the continuing distinctness and importance of such a unique form of visual or gestural intelligibility, that the mysteriousness of the paintings never evinces a hint of skepticism or despair.

As I have noted, Hegel did not anticipate such a widespread experience of ever greater worldlessness, and that failure limits his availability, or at least the historical Hegel's availability, for an assessment of art like this. But I have also tried to say why I think that projecting him forward and comparing his approach with Heidegger's can be useful as a contrast. Given what we have

50. That this can be read in many ways, some much more affirmative than that suggested here, is obvious. See, e.g., Clark 2001, 139ff.

been discussing, one glaring contrast is already apparent in a remark by Hegel
that seems addressed to Heidegger's appeal to *die Erde*:

> What through art or thinking we have before our physical or spiritual eye as
> an object has lost all absolute interest for us if it has been put before us so com-
> pletely that the content is exhausted, that everything is revealed, and nothing
> obscure or inward is left over any more. For interest is to be found only in the
> case of lively activity [of mind]. The spirit only occupies itself with objects so
> long as there is something secret, not revealed, in them. (*A*, 1:604)

This is a perfect foil for Heidegger's (1950, 66) remark on "the riddle that art
itself is" (*das Rätsel, das die Kunst selbst ist*).

Even more striking is Hegel's confirmation that this is the situation we
find ourselves in:

> We may well hope that art will always rise higher and come to perfection, but
> the form of art has ceased to be the supreme need of the spirit. No matter how
> excellent we find the statues of the Greek gods, no matter how we see God the
> Father, Christ, and Mary so estimably and perfectly portrayed: it is no help; we
> bow the knee no longer. (*A*, 1:103)

Art, I have been claiming, has clearly not ceased to be a supreme need
of *Geist*, but the value of this passage is that it is an almost personal or even
confessional expression of the differences between Hegel and Heidegger on
a large number of issues. It is easy to understand Heidegger's anxiety about
the hubris or, as he would say, the willfulness in these expressions of what
amounts to a radical statement of the basic principle of Western philosophy
since Greek metaphysics: to be is to be intelligible; there *cannot* be anything in
principle unknowable. (The failure of meaning is therefore, for Hegel, always
itself determinately comprehensible, for a historical society, at a time, in a
certain relation to its own past. And, ultimately, there is no Hegelian equiva-
lent for Heidegger's *Erde*. Whatever *Erde* turns out to be, it too is a concept,
a *Begriff*, ultimately fully transparent.)[51] However, from this Hegelian point
of view, it is even more dangerous to respond to such an anxiety by inviting
us "to bend the knee anew," as Heidegger, viewed from this perspective, is
encouraging with his "destruction" of the philosophical tradition. Such a pi-
ous gesture would also be false to much of the spirit of the modernist art that
Heidegger, despite these tensions, had the good judgment to admire.

51. Schwenzfeuer (2011, 168) points this out, as well as pointing out the Schellingian nature
of the approach Heidegger is taking, especially in the terms of Schelling's freedom essay, where
Schelling sets up his own *Urstreit*.

5

Concluding Remarks

Art shouldn't be overrated. It started to be in the latter 18th century, and definitely was in the 19th. The Germans started the business of assessing the worth of a society by the quality of the art it produced. But the quality of art in a society does not necessarily—or maybe seldom—reflect the degree of well-being enjoyed by most of its members. And well-being comes first. The weal and woe of human beings comes first. I deplore the tendency to over-value art.

CLEMENT GREENBERG, *Collected Essays and Criticism*

I

The chief art-historical assumption about modernism in the preceding discussion was borrowed from a widely accepted narrative: that, in retrospect, for the most ambitious painters and a few critics, in French painting around the time of Manet, the continuation of a certain style or school of premodernist painting apparently ceased to be able to compel conviction, arrest attention, maintain credibility; ceased, for such astute artists and observers, to be "lively" (*lebendig, belebt*), in Hegel's covering term, and so no longer offered appropriate paradigms. Such a characterization about the familiar succession of artistic styles (some style "goes stale," "becomes mannered") would not be false. Again retrospectively, we *can* see that a certain approach to painting, in this era as in many others, seemed to have something like an organic cycle of birth, fruition, and death, or decline into irrelevance, and some new cycle, intuitively responsive to such a decline, began, generating a style that was challenging, likely controversial at first, but eventually decisive and widely influential for the most ambitious artists.

Retrospective periodization like this, however familiar in art history, is always fraught with controversy and is not easy to justify persuasively. It is largely a question of what "*turned out* to be decisively responsive," and even that kind of post facto claim is often disputed. (Some think that it is wrong even to try to make such sense out of historical change like this. By contrast, one hears it said that "miracles of originality," the appearance of geniuses, just keep happening.) But the stakes are even higher in any characterization of the origins of modernism (of the absolutely unprecedented, much more radical "culture of rupture"), so this sort of characterization does not go far or

deep enough, and the controversies are, accordingly, even more complicated. Following again the general contours of a widely invoked narrative, painting itself, its very point and significance, seemed to have become at issue for painting, for certain ambitious painters (as, eventually, in different but related ways, the other arts were for the other arts). It seemed—to some artists and critics and, later, for many authoritative narrators—that, at this moment in French painting, Manet's moment, such issues of point and significance could now not be taken for granted, had to be addressed anew, since older, long-assumed answers no longer seemed to have much grip in the new social world rapidly coming into being. Initially, to many even astute commentators, it literally looked like the prior conventions of meaning and artistic success were simply being denied or, at the very least, ironized, more quoted than confidently used. But even so, the paintings, in their subsequent success and influence, turned out to have succeeded somehow as paintings, just *in* whatever ways they also seemed to fail to make conventional sense. If the prior historical conditions for the possibility of painterly success could, for some reason, no longer be satisfied, some new self-understanding of the relation between painting and beholder, and some embodied aspiration about the significance, the seriousness, of that new relation, was being established.

From such a retrospective position, what has seemed most significant is some sort of decline in the authority of the beautiful as an artistic ideal, and a corresponding alteration in what we have been calling an artwork's address to the beholder, still sensibly and affectively oriented but now promising a different and more complicated artistic content. The beautiful as an ideal was, of course, never merely an aesthetic ideal. The significance of the beautiful in art, its importance, has been tied to such things as an intimation of an ideal world, perhaps even such an ideal world as reality in itself. Or, as natural beauty, it has been linked with some intimation of an overall purposiveness, perhaps a divine purposiveness, intimating a natural home for human aspirations. Or the aesthetic experience was understood as intimating a harmony of intellectual and sensible faculties, inspiring the expectation of some possible unity of the fundamental human duality. Or it was a way of appealing to a prediscursive, unifying "common sense," such that failing to appreciate the beautiful was failing to place oneself properly among "us."

Accordingly, such an ideal could not have the credibility it once had if the hold of some such notion of the objectively ideal, or some grand purposiveness, had largely lost its grip, and if some mere indeterminate feeling of pleasure alone came to seem deeply inadequate as any way of acknowledging properly our "amphibian status," or if the deracinated and more anonymous nature of emerging mass consumer societies made the notion of a genuinely

common sense seem simply quaint. After the decline of the beautiful's shift-
ing authority, the striving "after the beautiful" would thus naturally come to
seem more properly much less significant, the domain of craft, fashion, deco-
ration, entertainment; still extraordinarily pleasant and desirable, a powerful
factor in human life, but not any longer significant, of philosophical impor-
tance. And so to understand this shift in normative ideals for art, we have
to also understand a great deal else about the social authority of norms in
general, the conditions for the intelligibility of normative change, and the
sociohistorical details that might plausibly fit those conditions. We need an
approach like Hegel's.

That is, the link between "how matters came to look" retrospectively, how
something could seem (later) to have been a provocation and a successful
response, all even though it could have never been formulated that way by
the participants, lands us squarely in the heart of Hegel's enterprise and in-
troduces the philosophical assumptions at issue in making his kind of sense
out of normative change in general. This dialectical approach to historical in-
telligibility is the most controversial element in his project, and I shall return
to it below for a final summation. But there are several other controversial
dimensions that I want one last time to emphasize.

As has been clear in the preceding, Hegel ties art-historical developments to
a much larger process that he mostly calls the "actualization" (*Verwirklichung*)
of various nonaesthetic norms, summarized comprehensively as "the Idea."
Or, in other words, he links the meaningfulness and significance of art-
historical developments to both social history and philosophical history. The
aspiration, of course, is to do this without any reduction of aesthetic norms
to merely thematic issues, but the scope or sweep of Hegel's ambition opens
up a way of considering what it *meant*, or how important it is, that, in the
example I have chosen to focus on, pictures began to look so different than
they ever had. (Without something of this ambition, all changes in art prac-
tices might ultimately have to look like shifts in fashion, of no more real sig-
nificance than hemlines and tie widths.) That common Hegelian narrative
is supposed to concern the "realization of freedom," and the role of art in
such an enterprise is as a historically sensitive and sensible-affective mode of
collective self-knowledge, the collectively available, sensibly mediated self-
knowledge necessary for a free life in common. The credibility or compelling-
ness of some sensible embodiment of such self-understanding (even about
what is now no longer credible as such self-understanding), in Manet's gazes
or Cézanne's bathers, while, because prediscursive, multiply interpretable, is
yet also determinately contentful in its unique way, thus requiring, as well as
making possible, interpretation (a struggle for genuineness in interpretation,

the ring of truth, if not propositional truth). It is in such a mode of address, and in such an interpretive response, that such self-knowledge is "realized."

The actual culmination of Hegel's official narrative does not leave much room for art as a significant vehicle of meaning, as a sensible-but-still-reflective mode of self-knowledge. He thinks we are left with either the subjective humor, or irony, represented in the work of Jean Paul or technically admirable mimetic treatments of a form of life that Hegel keeps describing—as if in resignation—as "prosaic." The former, he says, is mere play, and such subjective play, with nothing serious at stake or everything serious mocked, is not, in truth, art. The latter amounts to "technical tricks, not works of art" (*A*, 1:45). It is possible however, he insists, for art to have a proper subject in the postromantic world, human being itself, what he calls "Humanus":

> Yet in this self-transcendence art is nevertheless a withdrawal of man into himself, a descent into his own breast, whereby art strips away from itself all fixed restriction to a specific range of content and treatment, and makes Humanus its new holy of holies: i.e. the depths and heights of the human heart as such, mankind in its joys and sorrows, its strivings, deeds, and fates. Herewith the artist acquires his subject-matter in himself and is the human spirit actually self-determining and considering, meditating, and expressing the infinity of its feelings and situations: nothing that can be living in the human breast is alien to that spirit any more. This is a subject-matter which does not remain determined artistically in itself and on its own account; on the contrary, the specific character of the topic and its outward formation is left to capricious invention, yet no interest is excluded—for art does not need any longer to represent only what is absolutely at home at one of its specific stages, but everything in which man as such is capable of being at home. (*A*, 1:607)

One could take Hegel here to be talking about the realist-fiction novels and domestic dramas and tragedies of the nineteenth century, but "capricious invention" already reveals that Hegel is not thinking of very lofty goals for such arts in such a passage. It reflects a kind of Protestant respect for the ordinary in all its diversity, but in a way that is almost like damning with faint praise. (One hears again the echoes of the word "prosaic"—Murillo's beggar boys romping about cheerfully, the peace and security of Dutch interiors, that sort of thing.)

More importantly, as already noted, very few art historians or philosophers believe any more that there is any governing narrative to Western sociopolitical history or Western philosophy, whatever it can be said to culminate in, so if the sense of Hegel's art theory depends on such claims, then Hegel's art theory looks like a nonstarter before we get to such issues. This all depends, though, on an interpretation of Hegel's view of historical change and of the modern world, and that depends on some interpretation of Hegel's overall

philosophical project. In my view most of the objections to both have long traded on a straw man, built up out of years of uncharitable and philosophically simplistic mischaracterizations.[1] I cannot demonstrate all that here, of course, but I shall briefly address the most skeptical hesitations about taking seriously the prospect of a Hegelian view of modernist art: that is, reservations that concern his notion of a historical dialectic and the potential in his position to provide a serious interpretation of the significance of modernity of relevance to the arts.

But first I want to complete the summary of Hegel's approach invoked in the preceding account. There are two more extremely ambitious elements. The first is that Hegel, in a way I want to understand as radicalizing Kant's approach in *Critique of Judgment*, claims that art objects make sense to us in a unique way, that aesthetic intelligibility is a distinct sensible-affective modality of intelligibility. The terms used at the beginning of this chapter are good places to start in understanding this modality: credibility, compellingness, conviction.[2] These are in effect sensible-affective markers of truth, or at least truthfulness, genuineness, in the embodiment of some concrete form of self-understanding or in the embodiment of a self-understanding under some historical pressure. I have claimed that such a picture (most famous in his account of tragic art) is also relevant to a possible or "projected" interpretation of later modernity and is echoed in Fried's tracking of the increasing difficulty in "art's defeating theatricality," in Clark's notion of the "test" of social practice and so, according to him, the ultimate failure of modernism, and even in Heidegger's account of the "unconcealment" of a work's "world." This is, in a way, his own version of the historical realization of an ontological truth within a community (for him a *Volk*) at a time.

Second, Hegel's view of the intelligibility of artworks is parasitic on his general view of social intelligibility, our intelligibility to each other, and is especially parasitic on his understanding of the intelligibility to each other of our bodily movements as actions. The common terms for his account of the possibility of both are, unfortunately, idiosyncratic, not part of the lingua franca of the philosophical tradition: the "speculative relation between inner and outer" (speculative, because he is fond of formulations like "the inner is

1. For a particularly striking example of such uninformed and uncharitable interpretive method applied to Hegel's theory of art, see Wyss 1999.

2. This has been my gloss on what remains of a traditional aesthetic dimension in Hegel's account of art: liveliness (*Lebendigkeit*). Indeed, it is all that remains. This departure from the notion of the centrality of pleasure means that Hegel's infrequent invocations of "the beautiful" not only have lost virtually all connections with rationalist and empiricist accounts but are only tenuously linked to the idea in Kant and Schiller. For further discussion of this issue, see Pippin 2008a.

the outer and vice versa"). I have tried to present a full interpretation of that position elsewhere,[3] but I hope I have said enough here to make it plausible that this is a fruitful way of approaching aesthetic intelligibility and especially the intentionality of artworks. It again involves the social dynamic presupposed (I tried to show) in Fried's account of theatricality and, more directly, in Clark's assumptions about the tight relation between forms of sociality and forms of pictured mindedness. And there is an echo (in the common anti-Cartesianism of the position) in Heidegger on the dependence of aesthetic meaning on a common world "worlding."

<div align="center">II</div>

As noted above, Hegel's understanding of the essentially historical nature of art as a norm-governed social practice, part of his overall treatment of all norms as essentially historically effective and interrelated, might seem generally plausible if we remain at this level of abstraction. But, as a reasonable objection might go, what Hegel (if we want in any credible sense to refer to the historical Hegel) has to mean by history in such a claim involves a dialectical and progressive narrative that now seems an anachronistic product of Idealist, systematic ambitions that can no longer be taken seriously. What could be more obvious than that history is not teleologically progressive and that the modern world cannot be considered, even incipiently and incompletely, the "realization of freedom"? In the case of art, this picture of art coming over time to be what it always implicitly was, and finally transcending itself in romanticism (becoming what it is not, philosophy), all seems to attribute far more internal teleology to developments in art history in particular than there is any reason to believe. Perhaps, in the preceding account, so the objection continues, some elements of Hegel's understanding of a historically sensitive and socially normative notion of aesthetic intelligibility might plausibly help illuminate some aspects of the grandfather and father of modernism, Manet and Cézanne, but that is as far as plausibility goes, and so there is no reason to think of this framework as of any further use or independent power.[4]

3. Pippin 2008b. There are analogues in other philosophers that help. See Cavell 1999, 108: "Knowing oneself is the capacity, as I wish to put it, for placing-oneself-in-the-world." Cavell is responding to and giving his own inflection to those several passages in Wittgenstein like "The human body is the best picture of the human soul." See also the references to Anscombe in Pippin 2008b. She is also developing Wittgenstein's multifront dismantling of the standard understanding of the inner-outer duality.

4. It should go without saying that I don't take myself (or anyone) to have made some decisive case for the supremacy of these two moments alone as the pivots on which modernism

These objections—about a developmental notion of human history, "propelled" by "contradictions" in normative requirements ("deaths" and "births"), and about the status of freedom in the Hegelian account of modernity—are obviously fit subjects for ambitious independent studies. But I would like to conclude by sketching some possible reactions to such dissatisfactions.

The most contentious claim at issue is that Hegel treats modern (for him, romantic) art as in some state of contradiction: because it is no longer able to be what it is, it is unavoidably in some process of self-transcendence as art itself. The contrary claim is that art can no longer credibly be *what it had been* (not what it essentially is), given altered conditions of meaningfulness and significance, but the point of some considerable resistance to Hegel's approach involves this appeal to "contradiction." The ontological status of that notion in Hegel is the most complicated in his whole project, and he is happy to say such things as "All things are in themselves contradictory" (2010, 381), but for our purposes we can consider only one aspect of what it means, fortunately the most plausible: what we can call *practical* contradictions.[5]

Consider first the issues of contradiction and dialectic in history. Hegel certainly famously believed that societies might actually and unavoidably come to require commitment to self-contradictory normative principles. This is what he thought happened at the end of the classical period in Athens. According to his interpretation of Sophocles's play *Antigone*, Creon's claim for the supremacy of civil law and Antigone's for the supremacy of divine law were not just different sides of an argument, of the sort that would allow some compromise. According to his much-discussed view, both claims were, had come to be, justified and binding by the governing norms of the time, even though they were not jointly satisfiable in the case of the body of Polyneices and so were "contradictory," since both were equally and, given

decisively turns. One could get a lot out of focusing on Picasso in 1911 or on some other moment. I only want to say that one can see a very great deal following on these two moments, for all that there are many others.

5. Michael Wolff (1981, 1986) has, in my view at least, definitively established that whatever Hegel might have meant by "objective" contradictions, he certainly did not mean that it can be asserted of everything that both some predicate and the negation or absence of that predicate apply to that thing in the same sense at the same time. He certainly did not mean to affirm, in other words, logical contradictions. Wolff shows the heritage of Hegel's usage in Kant's doctrine of "real opposition" and in the emerging debate about the puzzling aspects of negative numbers. More broadly, as Wolff also shows, the notion of such objective contradiction is not foreign to us; we can say that reality contradicts what you say about it, that a person contradicts himself, that someone has a contradictory nature, etc. I am relying only on this informal sense here. For the details of the more technical version, Wolff's work is strongly recommended.

the communal self-understanding at the time, really binding. In this sense, Greek society at the time could be said to have come to contradict itself, to exist in a self-contradictory state, and, in its shared understanding, to require of its citizens impossible commitments. The controversial premise he needs to add to this analysis is that societies that find themselves in such situations place something like a practically painful and motivating burden on their participants and so require some sort of revision to the understanding of normative principles themselves if they are to avoid such a burden. This is not a predictive claim; it may well be that some societies can in fact manage to live with such situations, however painful and disruptive, indefinitely. All Hegel is claiming is that, if and when these comprehensive reformulations and revisions occur, we can understand them as much more than contingent events or lucky guesses.

It might therefore seem that Hegel disagrees with, say, Spinoza or Kant or other rationalists in their claims that even practical contradictions are always, must always be, only apparently contradictory and cannot "really" be so. But that is not exactly the case, even though Hegel remains a rationalist. The practical contradiction is *real*; such a society *has* gotten itself into a position, given its own self-understanding, where it has to require what both Creon and Antigone argue for, and so that society is "stuck." At a formal level this is no more difficult in principle to understand than clear cases of what are called "performative" self-contradictions (e.g., "I never say 'never'"). However, Hegel was one of the first to appreciate the deeply historical character of normative principles, to note that any such principle is appropriate for a kind of society at a time, a society organized in a certain way, the principle understood in a certain way, and that such conditions for the appropriateness of some such principles change, requiring what are often radical revisions. As just noted, he even thought that situations like that between Creon and Antigone place an enormous amount of pressure on such a society for change and that such situations thus already could help explain a complex and largely implicit "working out" and reassessment under such pressure, leading to a revision responsive to, and looking to avoid, the "partiality" or one-sidedness that produced the original contradiction. (Sophocles's play is itself one form that such a "working out" took.) Looking at the structure of Hegel's depiction of major, normative historical change this way would then mean that his explanation should be assessed by, simply, whether it accounts for what it tries to account for, whether it renders such changes and their provocations more intelligible or not. And those issues have to do with those details, not with an a priori theory about historical necessity, the kind of details, for example, brought to bear by Clark and Fried on the attempt to render the development more intelligible.

This historical change, or the whole notion of historical change as the result of practical contradictions, might then best be viewed as like the abstract picture of development sketched without the apparatus of dialectical theory in, for example, Hobbes's story about the state of nature, reformulated in terms of more general norms, not just prudential ones, and rationally developmental and in effect self-educative in just the sense that Hobbes thought his account required, all without any theodicy. I mean this in the following way, expanding now the notion of a practice and a practical contradiction at the center of Hegel's account.

The simple statement of the claim is that it is possible for societies, as if they were themselves subjects, to be mired in some way in practical self-contradiction. We might be in the situation where whatever we (any of us in a community under certain conditions at a time) do, and do in as rational a way as possible, in order to avoid an undesired outcome, even if it is *the one thing* we must do in order to achieve the end, actually makes the undesired outcome *more likely*, even brings it about. Whatever we do, we thus "practically contradict" ourselves. Hobbes thought the state of nature was like this. The most rational thing to do to avoid a violent death was to preemptively attack and eliminate others before they attack. But everyone knows this and does likewise, and the result of acting rationally (in this sense of individual rationality) is the war of all against all, the worst possible outcome, given what one wants to avoid. This is a contradiction that is practically painful, and so, given that for Hobbes the chief motivator in human life is fear of a violent death, it will be rational for everyone to lay down their arms and empower a monster, or Leviathan, state.

So, on similar reasoning, say, on the assumption that societies exist in order to organize the production of the means of their sustenance so as to produce the most ease, security, and comfort with the least effort, it might be that by achieving this at some stage or level of accomplishment, such a society may, just by doing so, thereby also make impossible a higher stage that would accomplish such an end better. Maybe there are economic reasons for this, having to do with how the division of labor and class privilege are necessary for the achievement of one stage but also block any development to another, higher, more productive stage (which, it can be presumed, everyone must be assumed to want, given our general anthropological premise). Not only might this sort of contradiction become very severe (in striving to be better off people might become worse off or immiserated), but it also might become *known* that this is happening and the analogue to Hobbes's weapon-laying-down might occur, a revolution.

Crudely put, what I have tried to show is that Hegel believes that in the de-

velopment of romantic art, art itself had become essentially self-contradictory in this practical sense. Art is the attempt by *Geist* to understand itself by means of a distinctly (though, of course, not exclusively) sensible mode of intelligibility. On Hegel's account, which I have not accepted, the very *attempt* to do so ultimately reveals that *Geist cannot be so understood at all*, and art itself must become a thing of the past, *ein Vergangenes*, with such a realization. That is the ultimate "contradiction" he claims art is "stuck" in, but along the way the very possibility of the sensible embodiment of shared meaning is what is at issue in the various practical attempts that lead to this supposed transcendence. I have suggested that if we look at art and art history as a component of a collective attempt at social intelligibility—how we attempt to make ourselves intelligible and answerable to each other—and this in a uniquely sensible-affective modality, the success and failures of such a project continue to be available to us in an indispensable way in visual and in the other arts. This is something, again, available only retrospectively, and in a way that depends on whether illuminating details can be marshaled to support such claims of partial success and self-undermining "failures."

This obviously leads to the second problem: the standing of those very details that, I said above, should be the basis for any assessment of Hegel's account. I have already argued that Hegel had no persuasive argument to support the claim that the particular character of modern (Western, Judeo-Christian, capitalist, ever more democratic) societies embodied a form of self-understanding and so a form of actualized freedom that rendered art only marginally significant as a vehicle of self-understanding, and that his characterization of art as wedded to a sensible-affective mode of intelligibility that has been rendered superfluous by the achievements of speculative philosophy was a claim at odds with the deeper insights of his own project, as well as with the simple fact that we had not in modernity become somehow less the sensible, finite creatures we always have been, nor is modern capitalist society the realization of human freedom.

Where, then, does this leave us with respect to modernist pictorial art? I have suggested that the issues most at stake in Hegel's own narrative of the encountering and partial overcoming of practical contradictions in historical change are helpful. In the first place, as attested everywhere in modernist arts, not just in painting, the logic of social intelligibility achieved in modern societies does not reflect the kind of mutuality of recognitive status crucial to Hegel's understanding of achieved freedom, the overcoming of relations of mere dependence and independence. This situation has a distinctly aesthetic inflection, if we follow Hegel's account, and that inflection is embodied very differently by different modernist artists. And I have not been able

to say much more than that this is reflected in art-historical and theoretical accounts that take the history of art seriously in understanding modernism, especially in understanding Manet, and have not been able to suggest how the implications of such an approach might be extended to interpretations of other artists like Seurat or Pissarro or Matisse, and so forth. But from this point of view, any modern artwork's own embodied "mindedness" or meaning will be caught up in such a struggle (commodification is only one name for it) both as itself an object and as resistant, in manifold ways, to such objectification. What is uniquely visible in the crisis of modernism is that this struggle has reached a stage of such novelty and criticality that the dominant aesthetic norms for painting altogether were (ultimately, so it turned out) no longer credibly relevant (they were imbricated in a whole project of meaning-making that had begun to fail), as well as that the successful visual embodiment of this state of affairs ensures that the situation remains dialectical. A *form of art*, a sensibly embodied and socially shareable meaning, has emerged, even under such pressure.

And Hegel's amphibian problem has clearly not been "transcended"; no satisfying way of "living in both worlds" has been given a credible sensible aesthetic meaning. This is so even while, again, kinds of failures at such a mediated resolution can still be aesthetically powerful just *as* such failures, the very embodied meaning of which resists any notion of the finality of those failures, even, in the case of Cézanne's bathers, when the results are rather terrifying failures.

But I have also suggested that both of these issues are wrongly understood if understood simply as "unsolved problems" (and that they were sometimes so misunderstood by Hegel). The "problem" of defeating theatricality or representing ourselves intelligibly to each other under changing social and economic conditions, all of which represent particular versions of the struggle for independence, and even the problem of appreciating properly what might be made available, "unconcealed," by art, even in the "age of the world picture," are not problems that have sociohistorically achieved decisive, revolutionary "solutions." They do not—any more than problems such as trying to understand under what conditions it is possible to trust an other, how to respond to a genuinely self-deceived self-representation, what significance there is in a disagreement of taste with someone with whom that has never arisen, how the nonreligious should understand the religiosity of their friends—have anything other than provisional, always revisable, tenuous, and fragile "solutions" in historically specific worlds. These are "problems" of mutual social intelligibility, under conditions where the shared commonalities, traditions, and fixed verities of the premodern world are no longer available, at least not in

anything more than ever more locally shared and so mutually exclusive com-
monalities, and with fading, uncertain authority, or available only in commer-
cially created commonalities, the ultimate effects of which are cynicism and
paranoia. It is thus appropriate that, read with historically projected Hegelian
assumptions, the most arresting and striking feature of Manet's "inaugural"
gazes is that they all seem to be *challenges*, not refusals or expressions of in-
difference or contempt or signs of only oppression or alienation. In the new
context, the proper *acknowledgment* of each other in any of these above senses
and many more (and I mean the word to come freighted with all the unusual
significance given it by Fried and Cavell)[6] involves, cannot but involve, an
uncertain, unstable social task for the future, not anything that can finally
resolve this past instability. Modernist art enacts, or realizes, this fate.[7]

How we come to render ourselves intelligible to each other in Hegel is
inextricably linked with how we render each other answerable to each other
too, and there is certainly an air of that demand in the challenge embodied in
the gazes (a gaze that allegorizes the challenge posed by the painting, not just
the figure depicted). For all the limitations of Hegel's position on the fine arts,
it is *art* that best manifests the unavoidably amphibian status of the human
and so best attests to the struggle for mutual intelligibility and reconcilable
freedom without masters and slaves, experts and objects of expertise. (That
the challenge has not been met, that we have not created the kind of social
world in which the challenge can be answered, is suggested by the almost
literal "amphibians" of Cézanne's great bathers paintings.)

Or at least it is art that could best manifest how this now-unending "prob-
lem" is to be understood. But art too is, of course, a social practice subject
to historical change. And it is possible, especially in his final remarks to his
students at the end of what must have been an absolutely exhausting tour of
the structure and history of art, to see Hegel as of two minds about his own
position. The speech (and that is what it is, a rhetorical flourish) is much
like, and I think is meant to call to mind, Prospero's farewell to *his* "arts," to
his magic, at the end of *The Tempest* ("Now my charms are all o'erthrown /
And what strength I have's mine own . . . Now I want / Spirits to enforce, art

6. See the discussion of modernist art in Cavell 1979, 108–18, citing Fried on "acknowledg-
ment," and, of course, Cavell's "Knowing and Acknowledging" (1969, 238–66).

7. This brings us back again to Cavell's issue of "fraudulence" and sincerity and his oft-
quoted summary of the situation as it bears on the critic: "He is part detective, part lawyer,
part judge, in a country in which crimes and deeds of glory look alike, and in which the public
therefore not only confuses one with the other, but does not know that one or the other has been
committed" (Cavell 1969, 191). See the helpful discussion of Fried's *Manet's Modernism* and these
issues in Mulhall 2001.

to enchant / And my ending is despair"). There is first what appears to be a resolute farewell to art, and a reminder of what has been gained with its loss, although even here doubts seem to creep in. He summarizes the historical narrative and reminds us that we have ended with *Geist* understanding itself as absolute subjectivity, satisfied only in its own inwardness:

> Satisfied in itself, it [absolute subjectivity] no longer unites itself with anything objective and particularized and it brings the negative side of this dissolution into consciousness in the humor of comedy. Yet on this peak comedy leads at the same time to the dissolution of art altogether. (A, 2:1236)

But this means that the Absolute—in this context the absolute realization of freedom and the right self-understanding of this realization—is no longer available for sensible appearance, for art:

> But if comedy presents this unity only as its self-destruction because the Absolute, which wants to realize itself, sees its self-actualization destroyed by interests that have now become explicitly free in the real world and are directed only on what is accidental and subjective, then the presence and agency of the Absolute no longer appears positively unified with the characters and aims of the real world but asserts itself only in the negative form of cancelling everything not correspondent with it, and subjective personality alone shows itself self-confident and self-assured at the same time in this dissolution. (A, 2:1236)

This is a remarkable thing for a philosopher with a theory of "objective spirit," the author of a "Philosophy of Right," the man who thinks the "real is the rational," to say. It gives another tonality to his frequent remarks about the "prosaic" character of modernity and seems to border on regret about this "art-less" new world.

But then he seems to recover, and comedic negation of the "real world" as unsuitable as an embodied vehicle for the Absolute appears to be overcome in a different formulation:

> For in art we have to do, not with any agreeable or useful child's play, but with the liberation of the spirit from the content and forms of finitude, with the presence and reconciliation of the Absolute *in what is apparent and visible*, with an unfolding of the truth which is not exhausted in natural history but revealed in world-history. (A, 2:1236, my emphasis)

His final valedictory then embodies both moments. He seems to say that the link (*Band*) that had united them has been broken, apparently not just that the semester is over but that the link that art used to provide among all of them is now unavailable. And yet the lectures close with a ringing *reasser-tion* of the link, not only the link between "beauty and truth" that the offi-

cial legacy of the lectures is supposed to have shown to be now "overcome" but, much more tellingly, given the thesis of this discussion, *just thereby* (in the unbreakable [*unzerstörliches*] bond between beauty and truth) the link between *them*, the social bond, which has also been preserved. As our Prospero seems to move to reclaim what he had just discarded, it is only fair to give Hegel the last word.

> I hope that in this chief point my exposition has satisfied you. And now when the link forged between us generally and in relation to our common aim has been broken, it is my final wish that the higher and indestructible bond of the Idea of beauty and truth may link us and keep us firmly united now and for ever. (*A*, 2:1237)

Bibliography

Adorno, T. 1984. *Aesthetic Theory*. Translated by C. Lenhardt. Edited by G. Adorno and R. Tiedemann. London: Routledge and K. Paul.

———. 1997. *Gesammelte Schriften in zwanzig Bänden*. Frankfurt a.M.: Suhrkamp.

Bann, S. 2007. *Ways around Modernism*. New York: Routledge.

Bataille, G. 1955. *Manet*. Geneva: Skira.

Baudelaire, C. 1973. *Correspondence*, vol. 2. Paris: Gallimard.

Beaulieu, J., M. Roberts, and T. Ross, eds. 2000. *Refracting Vision: Essays on the Writings of Michael Fried*. Sydney: Power Publications.

Beiser, F. 2005. *Schiller as Philosopher: A Re-examination*. Oxford: Clarendon Press.

Bernasconi, R. 1998. "Heidegger's Displacement of the Concept of Art." In *Encyclopedia of Aesthetics*, edited by M. Kelly, 2:377–79. Oxford: Oxford University Press.

Bernstein, J. M. 1992. *The Fate of Art: Aesthetic Alienation from Kant to Derrida and Adorno*. University Park: Pennsylvania State University Press.

———, ed. 2003. *Classic and Romantic German Aesthetics*. Cambridge: Cambridge University Press.

———. 2007. "Freedom from Nature? Post-Hegelian Reflections on the Ends of Art." In Houlgate 2007, 216–43.

Biemel, W., and F.-W. von Hermann, eds. 1989. *Kunst und Technik: Gedächtnisschrift zum 100. Geburtstag von Martin Heidegger*. Frankfurt a.M.: Klostermann.

Boehm, G. 1988. *Paul Cézanne: Montagne Sainte-Victoire*. Frankfurt a.M.: Insel Verlag.

———. 1989a. "Im Horizont der Zeit: Heideggers Werkbegriff und die Kunst der Moderne." In Biemel and von Hermann 1989, 255–86.

———. 1989b. "A Paradise Created by Painting." In Krumrine 1989, 11–30.

Bubner, R. 2003. *Innovations of Idealism*. Cambridge: Cambridge University Press.

Buchner, H. 1977. "Fragmentarisches." In Neske 1977, 47–51.

Cavell, S. 1969. *Must We Mean What We Say?* Cambridge: Cambridge University Press.

———. 1979. *The World Viewed: Reflections on the Ontology of Film*. Cambridge, MA: Harvard University Press.

———. 1999. *The Claim of Reason: Wittgenstein, Skepticism, Morality, and Tragedy*. 1979. Oxford: Oxford University Press.

Clark, T. J. 1999a. Foreword to Jappe 1999, vii–x.

———. 1999b. *The Painting of Modern Life: Paris in the Art of Manet and His Followers.* Rev. ed. Princeton, NJ: Princeton University Press.

———. 2001. *Farewell to an Idea: Episodes from a History of Modernism.* New Haven, CT: Yale University Press.

Clark, T. J., and (the collective) Retort. 2008. "Capital, Spectacle, and Modernity: An Interview with Retort" (November 1, 2008). Last accessed June 17, 2011. http://platypus1917.org/2008/11/01/capital-spectacle-and-modernity-an-interview-with-retort/.

Clay, Jean. 1983. "Ointments, Makeup, Pollen." *October* 27:3–44.

Cronan, T. Forthcoming. *Against Affective Formalism: Matisse, Bergson, Modernism.* Minneapolis: University of Minnesota Press.

Dahlstrom, D. 2001. *Heidegger's Concept of Truth.* Cambridge: Cambridge University Press.

Danto, A. 1981. *The Transfiguration of the Commonplace: A Philosophy of Art.* Cambridge, MA: Harvard University Press.

———. 1986. *The Philosophical Disenfranchisement of Art.* New York: Columbia University Press.

———. 1987. *The State of the Art.* New York: Prentice Hall.

———. 1990. *Encounters and Reflections: Art in the Historical Present.* New York: Farrar, Straus, and Giroux.

———. 1992. *Beyond the Brillo Box: The Visual Arts in Post-historical Perspective.* Berkeley and Los Angeles: University of California Press.

———. 1994. *Embodied Meanings: Critical Essays and Aesthetic Meditations.* New York: Farrar, Straus, and Giroux.

———. 1997. *After the End of Art: Contemporary Art and the Pale of History.* Princeton, NJ: Princeton University Press.

———. 2000. *The Madonna of the Future: Essays in a Pluralistic Art World.* New York: Farrar, Straus, and Giroux.

———. 2003. *The Abuse of Beauty: Aesthetics and the Concept of Art.* Chicago: Open Court.

———. 2005. *Unnatural Wonders: Essays from the Gap between Art and Life.* New York: Columbia University Press.

Diderot, D. 1995. *Diderot on Art.* Translated by J. Goodman. 2 vols. New Haven, CT: Yale University Press.

Donougho, M. 1999. "Hegel's Art of Memory." In *Endings: Questions of Memory in Hegel and Heidegger,* edited by J. McCumber and R. Comay. Evanston, IL: Northwestern University Press.

———. 2007a. "Art and History: Hegel on the End, the Beginning, and the Future of Art." In Houlgate 2007, 179–243.

———. 2007b. "Must It Be Abstract? Hegel, Pippin, and Clark." *Bulletin of the Hegel Society of Great Britain* 55/56:87–106.

Dreyfus, H. 2005. "Heidegger's Ontology of Art." In *A Companion to Heidegger,* edited by H. Dreyfus and M. Wrathall, 407–19. Oxford: Blackwell.

Elkins, J. 2005. *Master Narratives and Their Discontents.* New York: Routledge.

Foucault, M. 2010. *Manet and the Object of Painting.* London: Tate.

Fried, M. 1988. *Absorption and Theatricality: Painting and Beholder in the Age of Diderot.* Chicago: University of Chicago Press.

———. 1992. *Courbet's Realism.* Chicago: University of Chicago Press.

———. 1996. *Manet's Modernism; or, The Face of Painting in the 1860s*. Chicago: University of Chicago Press.

———. 1998. *Art and Objecthood: Essays and Reviews*. Chicago: University of Chicago Press.

———. 2008. *Why Photography Matters as Art as Never Before*. New Haven, CT: Yale University Press.

———. 2010. *The Moment of Caravaggio*. Princeton, NJ: Princeton University Press.

———. 2011. *Four Honest Outlaws*. New Haven, CT: Yale University Press.

Gehlen, A. 1960. *Zeitbilder: Zur Soziologie und Ästhetik der modernen Malerei*. Frankfurt a.M.: Athenäum.

Gethmann-Siefert, A. 1998. "Einleitung: Gestalt und Wirkung von Hegels Ästhetik." In Hegel 1998, xv–ccxiv.

Gombrich, E. H. 1984. "The Father of Art History." In *Tributes: Interpreters of Our Cultural Tradition*, edited by E. H. Gombrich, 51–69. Ithaca, NY: Cornell University Press.

Greenberg, C. 1971. *Art and Culture*. Boston: Beacon Press.

———. 1995. *The Collected Essays and Criticism*. Vol. 4, *Modernism with a Vengeance*. Chicago: University of Chicago Press.

Han-Pile, B. 2011. "Describing Reality or Disclosing Worldhood? Vermeer and Heidegger." In *Art and Phenomenology*, edited by J. D. Parry, 138–61. New York: Routledge.

Harries, K. 2009. "Art Matters." *Contributions to Phenomenology* 57:1–167.

Hegel, G. W. F. 1969. *Hegel's Science of Logic*. Translated by A. V. Miller. London: George Allen and Unwin.

———. 1975. *Aesthetics: Lectures on Fine Art*. Translated by T. M. Knox. 2 vols. Oxford: Clarendon Press.

———. 1978. *Hegels Philosophie des subjektiven Geistes / Hegel's Philosophy of Subjective Spirit*. Edited and translated by M. Petry. 3 vols. Dordrecht: Reidel.

———. 1991a. *Elements of the Philosophy of Right*. Edited by A. Wood. Translated by H. B. Nisbet. Cambridge: Cambridge University Press.

———. 1991b. *The Encyclopaedia Logic*. Translated by T. Geraets, W. Suchting, and H. Harris. Indianapolis, IN: Hackett.

———. 1995. *Vorlesungen über die Ästhetik: Berlin 1820/1: Eine Nachschrift*. Vol. 1, *Textband*. Frankfurt a.M.: Peter Lang.

———. 1998. *Vorlesungen über die Philosophie der Kunst: Berlin 1823*. Nachgeschrieben von H. G. Hotho. Hamburg: Felix Meiner.

———. 2010. *The Science of Logic*. Edited and translated by G. Di Giovanni. Cambridge: Cambridge University Press.

———. 2012. *Phenomenology of Spirit*. Translated by T. Pinkard. Online, facing-page edition. http://web.mac.com/titpaul/Site/About_Me_files/Phenomenology%20of%20Spirit%20 %28entire%20text%29.pdf.

Heidegger, M. 1927. *Sein und Zeit*. Tübingen: Niemeyer.

———. 1950. "Der Ursprung des Kunstwerkes." In Heidegger 1977b, 7–68.

———. 1966. *Einführung in die Metaphysik*. Vol. 40 of *Gesamtausgabe*. Tübingen: Mohr.

———. 1977a. *Aus der Erfahrung des Denkens*. Vol. 13 of *Gesamtausgabe*. Frankfurt a.M.: Klostermann.

———. 1977b. *Holzwege*. Vol. 5 of *Gesamtausgabe*. Frankfurt a.M.: Klostermann.

———. 2000. *Introduction to Metaphysics*. Translated by R. G. Fried and R. Polt. New Haven, CT: Yale University Press.

————. 2008. *Basic Writings*. Edited by D. Krell. New York: Harper.

Henrich, D. 1979. "Art and Philosophy of Art Today: Reflections with Reference to Hegel." In *New Perspectives in German Literary Criticism*, edited by R. Amacher and V. Lange, translated by D. H. Wilson et al., 107–33. Princeton, NJ: Princeton University Press.

————. 1985. "The Contemporary Relevance of Hegel's Aesthetics." In *Hegel*, edited by M. Inwood, 199–207. Oxford: Oxford University Press.

————, ed. 1986. *Probleme der Hegelschen Logik*. Stuttgart: Klett-Cotta.

————. 1992. *Aesthetic Judgment and the Moral Image of the World*. Stanford, CA: Stanford University Press.

————. 2001. *Versuch über Kunst und Leben: Subjektivität—Weltverstehen—Kunst*. Munich: Hanser Verlag.

————. 2003a. *Fixpunkte: Abhandlungen und Essays zur Theorie der Kunst*. Frankfurt a.M.: Suhrkamp.

————. 2003b. "Subjektivität als Prozess und Wandlung in der Kunst der Moderne." In *Dimensionen ästhetischer Erfahrung*, edited by V. J. Küpper and C. Menke, 16–36. Frankfurt a.M.: Suhrkamp.

————. 2006a. "The Contemporary Significance of Classical German Aesthetics: A Discussion with Arthur Danto." *Internationales Jahrbuch des deutschen Idealismus* 4:21–56.

————. 2006b. "Subjektivität und Kunst." In *End of Art—Endings of Art*, edited by G. Boehm und G. Seel, 61–91. Basel: Schwabe.

Hilmer, B. 1998. "Being Hegelian after Danto." *History and Theory* 37, no. 4: 71–86.

Houlgate, S. 1975. "Hegel and the Art of Painting." In *Hegel and Aesthetics*, edited by W. Maker. Albany: State University of New York Press.

————. 2007. *Hegel and the Arts*. Evanston, IL: Northwestern University Press.

————. Forthcoming. "Hegel, Danto, and the End of Art." In *The Impact of Idealism*, edited by N. Boyle and L. Disley. Cambridge: Cambridge University Press.

Hyland D. 1971. "Art and the Happening of Truth: Reflections on the End of Philosophy." *Journal of Aesthetics and Art Criticism* 30, no. 2: 177–87.

Jähnig, D. 1977. "Die Kunst und der Raum." In Neske 1977, 130–48.

————. 1989. "'Der Ursprung des Kunstwerkes' und die moderne Kunst." In Biemel and von Hermann 1989, 219–54.

Jamme, C. 1990. "The Loss of Things: Cézanne—Rilke—Heidegger." *Kunst und Museumjournal* 2, no. 1: 33–44.

Jappe, A. 1999. *Guy Debord*. Translated by D. Nicholson-Smith. Berkeley and Los Angeles: University of California Press.

Kockelmans, J. 1985. *Heidegger on Art and Art Works*. Dordrecht: Nijhoff.

Koerner, J. 1997. *The Moment of Self-Portraiture in German Renaissance Art*. Chicago: University of Chicago Press.

Kraus, R. 1996. "'*Informe*' without Conclusion." *October* 78:89–105.

Krumrine, M. L. 1989. *Paul Cézanne: The Bathers*. Basel: Museum of Fine Arts / Eidolon.

Lacoue-Labarthe, P., and J.-L. Nancy. 1988. *The Literary Absolute: The Theory of Literature in German Romanticism*. Translated by P. Barnard and C. Lester. Albany: State University of New York Press.

Marx, K. 1913. *The 18th Brumaire of Louis Bonaparte*. Translated by D. Deleon. Chicago: Charles Kerr.

Melville, S. 2000. "The Difference Manet Makes." In Beaulieu, Roberts, and Ross 2000, 97–128.

Merleau-Ponty, M. 1993. *The Merleau-Ponty Aesthetics Reader: Philosophy and Painting*. Edited and translated by M. B. Smith. Evanston, IL: Northwestern University Press.

Mulhall, S. 2001. "Crimes and Deeds of Glory: Michael Fried's Modernism." *British Journal of Aesthetics* 41, no. 1: 1–23.

Nehamas, A. 2007. *Only a Promise of Happiness: The Place of Beauty in a World of Art*. Princeton, NJ: Princeton University Press.

Neske, G., ed. 1977. *Erinnerungen an Martin Heidegger*. Pfullingen: Neske.

Nietzsche, F. 1975. *Gesamtausgabe*. Edited by G. Colli and M. Moninari. Berlin: de Gruyter.

———. 2005. "The Case of Wagner." In *The Anti-Christ, Ecce Homo, Twilight of the Idols and Other Writings*, translated by J. Norman, 231–62. Cambridge: Cambridge University Press.

Norman, J. 2000. "Squaring the Romantic Circle: Hegel's Critique of Schlegel's Theories of Art." In *Hegel's Aesthetics*, edited by W. Maker, 131–44. Albany: State University of New York Press.

Novotny, F. 1937. *Cézanne*. Vienna: Phaidon.

Petzet, H. W. 1993. *Encounters and Dialogues with Martin Heidegger, 1929–1976*. Chicago: University of Chicago Press.

Pile, E. 2004. "Une beauté expérimentale: Manet et le pragmatisme." *Revue Esthetique* 45:156–66.

Pinkard, T. 1996. *Hegel's Phenomenology: The Sociality of Reason*. Cambridge: Cambridge University Press.

———. 2007. "Symbolic, Classical, and Romantic Art." In Houlgate 2007, 3–28.

———. 2012. *Hegel's Naturalism: Mind, Nature and the Final Ends of Life*. Oxford: Oxford University Press.

Pippin, R. 1989. *Hegel's Idealism: The Satisfactions of Self-Consciousness*. Cambridge: Cambridge University Press.

———. 1996. "The Significance of Taste: Kant, Aesthetic and Reflective Judgments." *Journal of the History of Philosophy* 34, no. 4: 549–69.

———. 1997. *Idealism as Modernism: Hegelian Variations*. Cambridge: Cambridge University Press.

———. 1999. *Modernism as a Philosophical Problem: On the Dissatisfactions of European High Culture*. 2nd ed. London: Wiley-Blackwell.

———. 2002. "What Was Abstract Art? From the Point of View of Hegel." *Critical Inquiry* 29, no. 1: 1–24.

———. 2004. *Henry James and Modern Moral Life*. Cambridge: Cambridge University Press.

———. 2005a. "Authenticity in Painting: Remarks on Michael Fried's Art History." *Critical Inquiry* 25, no. 3: 575–98.

———. 2005b. "Concept and Intuition: On Distinguishability and Separability." *Hegel-Studien* 40:27–39.

———. 2005c. *The Persistence of Subjectivity: On the Kantian Aftermath*. Cambridge: Cambridge University Press.

———. 2006. "'Philosophy Is Its Own Time Comprehended in Thought.'" *Topoi* 25, nos. 1–2: 85–90.

———. 2008a. "The Absence of Aesthetics in Hegel's Aesthetics." In *The Cambridge Companion to Hegel and Nineteenth Century Philosophy*, edited by F. Beiser, 394–418. Cambridge: Cambridge University Press.

———. 2008b. *Hegel's Practical Philosophy: Rational Agency as Ethical Life*. Cambridge: Cambridge University Press.

———. 2010a. "Hegel on Political Philosophy and Political Actuality." *Inquiry* 53, no. 5: 401–16.

———. 2010b. "The 'Logic of Experience' as 'Absolute Knowledge' in Hegel's *Phenomenology of Spirit*." In *Hegel's "Phenomenology of Spirit": A Critical Guide*, edited by D. Moyar and M. Quante, 210–27. Cambridge: Cambridge University Press.

———. 2010c. "The Paradoxes of Power in the Novels of J. M. Coetzee." In *J. M. Coetzee and Ethics*, edited by P. Singer and A. Leist, 19–41. New York: Columbia University Press.

———. 2011a. *Hegel on Self-Consciousness: Desire and Death in the "Phenomenology of Spirit."* Princeton, NJ: Princeton University Press.

———. 2011b. "The Status of Literature in Hegel's *Phenomenology of Spirit*." In *Inventions of the Imagination: Interdisciplinary Perspectives on the Imaginary since Romanticism*, edited by R. T. Gray, N. Halmi, G. Handwerk, M. A. Rosenthal, and K. Vieweg, 102–20. Seattle: University of Washington Press.

———. 2012a. *Fatalism in American Film Noir: Some Cinematic Philosophy.* Charlottesville: University of Virginia Press.

———. 2012b. "Passive and Active Skepticism in Nicholas Ray's *In a Lonely Place*." *Nonsite* 5. http://nonsite.org/issue-5-agency-and-experience.

———. Forthcoming. "Heidegger on Nietzsche on Nihilism." In *Political Philosophy Cross-examined: Perennial Challenges to the Philosophic Life*, edited by J. Lomax and T. Pangle. London: Palgrave Macmillan.

Rousseau, J. J. 1986. *The First and Second Discourses and the Essay on the Origin of Languages.* Edited by V. Gourevitch. New York: Harper and Row.

Rush, F. 2007. "Art, Aesthetics and Subjectivity." *European Journal of Philosophy* 15, no. 2: 283–96.

Rutter, B. 2010. *Hegel on the Modern Arts.* Cambridge: Cambridge University Press.

Saville, A. 1993. *Kantian Aesthetics Pursued.* Edinburgh: Edinburgh University Press.

Schapiro, M. 1982. *Modern Art.* New York: George Braziller.

———. 1994. *Theory and Philosophy of Art: Style, Artist, and Society.* New York: George Braziller.

Schelling, F. W. 1993. *System of Transcendental Idealism.* Translated by P. Heath. Charlottesville: University of Virginia Press.

———. 2008. *The Philosophy of Art.* Translated and edited by D. W. Stott. Minneapolis: University of Minnesota Press

Schiller, F. 1982. *Letters on the Aesthetic Education of Man / Über die aesthetische Erziehung des Menschen in einer Reihe der Briefen.* Edited and translated by E. Wilkinson and L. Willoughby. Oxford: Oxford University Press.

———. 2003. "Kallias; or, Concerning Beauty: Letters to Gottfried Körner." In Bernstein 2003, 145–84.

Schlegel, F. 1971. *Friedrich Schlegel's "Lucinde" and the "Fragments."* Translated by P. Firchow. Minneapolis: University of Minnesota Press.

———. 2003. "Letter about the Novel." In Bernstein 2003, 287–96.

Schwenzfeuer, S. 2011. "Vom Ende der Kunst: Eine Betrachtung zu Heideggers Kunstwerkaufsatz vor dem Hintergrund des deutschen Idealismus." In *Heideggers Ursprung des Kunstwerks: Ein kooperativer Kommentar*, edited by D. Espinet and T. Keiling, 160–72. Frankfurt a.M.: Klostermann.

Seel, M. 1998. "Art as Appearance: Two Comments on Arthur C. Danto's *After the End of Art*." *History and Theory* 37, no. 4: 102–15.

Seuboldt, G. 1987. "Der Pfad ins Selbe: Zur Cézanne-Interpretation Martin Heideggers." *Philosophisches Jahrbuch* 94:62–87.

———. 2005. *Kunst als Enteignis: Heideggers Weg zu einer nicht mehr metaphysischen Kunst.* Bonn: DenkMal Verlag.

Speight, A. 2001. *Hegel, Literature, and the Problem of Agency.* Cambridge: Cambridge University Press.

Stemmrich, G., and A. Gethmann-Siefert. 1986. "Hegels Kügelgen-Rezension und die Auseinandersetzung um die 'eigentlichen historischen Stil' in der Malerei." In *Welt und Wirkung in Hegels Ästhetik*, edited by A. Gethmann-Siefert and O. Pöggeler, 139–68. Hegel-Studien, Beiheft 27. Bonn: Bouvier.

Summer, D. 2007. "E. H. Gombrich and the Tradition of Hegel." In *A Companion to Art Theory*, edited by P. Smith and C. Wilde, 39–49. Oxford: Blackwell.

Taminiaux, J. 1982. *Recoupements.* Brussels: Ousia.

Thomson, I. 2011. *Heidegger, Art, and Postmodernity.* Cambridge: Cambridge University Press.

Wellbery, D. 2009. "'*Geist*' as Medium of Art in Goethe's *West-östlicher Divan*." Unpublished manuscript.

———. 2010. "Romanticism and Modernity: Epistemological Continuities and Discontinuities." *European Romantic Review* 21, no. 3: 275–89.

Wolff, M. 1981. *Der Begriff des Widerspruchs: Eine Studie zur Dialektik Kants und Hegels.* Meisenheim: Hain.

———. 1986. "Über Hegels Lehre vom Widerspruch." In Henrich 1986, 107–28.

Wollheim, R. 1980. *Art and Its Objects.* Cambridge: Cambridge University Press.

Wrathall, M. 2011. *Heidegger and Unconcealment.* Cambridge: Cambridge University Press.

Wyss, B. 1999. *Hegel's Art History and the Critique of Modernity.* Cambridge: Cambridge University Press.

Young, J. 2004. *Heidegger's Philosophy of Art.* Cambridge: Cambridge University Press.

Index

The letter *f* following a page number denotes a figure.

18th Brumaire of Louis Bonaparte, The (Marx), 69

"Absence of Aesthetics in Hegel's Aesthetics, The" (Pippin), 101n11

the absolute, 6, 44, 66; and art, 5, 7, 80, 101, 143; and literature, 68n7; as love, 22; and presentness, 4n8; problem of (*see* Problem of the Absolute [subject and object]); as unconditional knowledge, 5, 6

absolute idea, 6; and Adorno, 66

absolute knowledge, 6, 95; and art, 8

absolute spirit, 6; and art, 22, 35n13

absolute standpoint, 95

absolute subjectivity, 143

Absorption and Theatricality (Fried), 84, 85

acknowledgment, 4n7, 92, 113, 114, 132, 142, 142n6

actualization (*Verwirklichung*). *See* realization

Adorno, T., 10, 54, 64, 66, 67, 97, 102n12

aesthetic experience: and the absolute, 101; and action, 32, 39, 61, 68; and determinacy, 4, 5, 14, 15; and events, 102, 102n12, 119; and experience of oneself, 11, 13, 14, 15, 32, 61; and experiential capacities, 4, 5, 11, 12, 13, 14, 15, 16n21, 38, 39, 78n19, 132; and freedom, 1, 5, 11, 13, 14, 15, 46, 132; and harmony, 48, 132; as hedonic, 10, 12, 15, 40; and intelligibility, 4, 10, 11, 13, 14, 15, 16, 16n21, 17, 39, 65, 68, 101; and interpretation, 35, 49, 65, 68; and judgment, 11, 12; and Kant, 4, 5, 10, 11, 11n13, 12, 13, 14, 15, 101; and lived experience, 100, 101, 111; and liveliness, 65; of Manet, 91; and nature, 13; as noncognitive/nondiscursive, 11, 12n13, 15; as normative, 5, 12; as objective, 17; and painting, 66, 81; as play, 5, 13, 15; and pleasure, 4, 5, 10;

and purposiveness, 11, 14, 15, 132; and Schiller, 11n13; as sensuous 14, 15; as subjective, 10, 13, 14, 15, 100, 101, 111; of things, 119, 125n47; and truth, 102, 102n12, 111; and unity of subject and object, 46

aesthetic intelligibility: and action, 39, 68, 136; and concept-intuition distinction, 15, 16n21, 101; conditions of, 38; Danto and Greenberg on, 71n11; and freedom, 10; and Hegel, 39n18, 49, 65; and Kant, 10, 11, 14, 15, 39n18; logic of, 125; and Manet, 64, 129; and meaning, 91; and modernism, 2, 22, 96; of objects, 37, 69; and painting, 66, 80, 106; and social intelligibility, 135

aesthetic judgment: and determinacy, 12, 14; and intelligibility, 12, 14; logic of, 12; and reason, 10n11; as reflective, 5, 12, 13; as subjective, 94n39; and subjective universal validity, 11, 12

Aesthetics: Lectures on Fine Art (Hegel), 7, 20, 39, 40, 49

aesthetics: Adorno's, 67; classicist, 14, 39; empiricist, 39; Hegel's, 3n6, 8, 46; and Heidegger, 101n11; Kantian, 39, 47, 67, 101; and lived experience, 100, 101; modern(ist), 67; and nature, 40; objectivist, 11n13, perfectionist, 14, 39; vs. philosophy of art, 8; Platonic, 47; post-Kantian, 13n15, 17; rationalist, 39; romantic, 96; and Schiller, 11n13, 39; subjectivist, 10, 100, 101

aesthetic theory: and modernism, 1n1, 51

antiessentialism, 44n26

Antigone (Sophocles), 137, 138

Argenteuil (Manet), 54f, 55f, 82

Argus, thousand-eyed, 3n6, 49, 55, 61, 80, 96, 97, 101n10

Printed in Great Britain
by Amazon